'In *Cézanne and the Post-Bionian Field: An Exploration and a Meditation*, the author succeeds in conveying the idea of a living, *"multiversal"* field by bringing together elements pertinent to the field concept in painting, philosophy, and literature, and by providing them with a space where they can breathe together. The fascination of the book lies in the way it constructs novel pathways and tools for exploring a temporal space in perpetual expansion. The structure of the field can be expressed in different languages, each bound by its own stockade that someone, like our author, has dared to break down, resulting not in chaos but in the suggestion of new concepts. Whilst reading Robert Snell's work, I was struck over and over again by his extraordinary capacity to juxtapose Cézanne's visual concepts with Bion's oneiric models and field theory. I cannot overstate the value of this extraordinarily fecund meeting between art and psychoanalysis.'

—*Antonino Ferro, President of the Italian Psychoanalytic Society, training and supervising analyst in the Italian Psychoanalytic Society, the American Psychoanalytic Association, and the International Psychoanalytical Association*

'The reading of this book absorbed me. I really admired Robert Snell's writing style and the skill of the composition—the transitions from one perspective to the other, so as to always keep the reader's attention. The book shows a deep understanding of the Italian theory of the analytical field, and creates a perfect interplay of reflections and resonances between this theory, Cézanne and Merleau-Ponty. All three come out of it enriched, because each one is reflected in the other two (not to mention Bergson, Ogden and many others). It is a beautiful book.'

—*Giuseppe Civitarese, psychiatrist and training and supervising analyst in the Italian Psychoanalytic Society, member of the American Psychoanalytic Association, editor of the* Rivista di Psicoanalisi *and author of* Sublime Subjects, Aesthetic Experience and Intersubjectivity in Psychoanalysis (2017)

Cézanne and the Post-Bionian Field

By inviting a 'conversation' between them, this book offers a nuanced introduction both to Cézanne—the 'father of modern art'—and perhaps the most vital body of theory in contemporary psychoanalysis, 'post-Bionian field theory', as it has been evolving in Italy in the hands of Antonino Ferro, Giuseppe Civitarese, and others.

Cézanne and Bion, each insisting on his own truths, spearheaded quite new directions in painting and in psychoanalysis. Both point us towards a crucial insight: far from being isolated, self-contained 'subjects', we fundamentally exist only within a larger interpersonal 'field'. Cézanne's painting can give us a direct experience of this. For the Italian field analysts, building on Bion's work, the field is accessed through reverie, metaphor, and dream, which now come to occupy the heart of psychoanalysis. Here primitive 'proto-emotions' that link us all might be transformed—as Cézanne transformed his 'sensations'—into aesthetic form, into feelings-linked-to-thoughts that in turn enrich and expand the field.

The book draws on the words of artists (Cézanne himself, Mann), philosophers (Merleau-Ponty, Bergson), art historians and theorists (Clark, Smith, Shaw), as well as psychoanalysts (Bion, Ferro, Civitarese, and others), and it is the first to focus on one particular—and seminal—painter as a way of exploring this aesthetic and 'field' dimension in depth and detail. Aimed at psychoanalysts, psychotherapists, artists, art historians, and the general reader, it suggests how far art and contemporary psychoanalysis are mutually generative.

Robert Snell is the author of *Théophile Gautier: A Romantic Critic of the Visual Arts* (1982), *Uncertainties, Mysteries, Doubts: Romanticism and the Analytic Attitude* (2012), and *Portraits of the Insane: Théodore Géricault and the Subject of Psychotherapy* (2016). He is an analytic psychotherapist in private practice.

7/5/21

o Need to make pt. + create a
field linking this to RS ideas

Need a summary of what
he is saying. Also pt. out
that the field I'm creating
is different from his notions.
It's borrowed from physics
and tends toward the
abstract a conceptual
Altho' the field he accredits
to Cezanne, the perception who
is unaware of the field is creating
a field physically, simply
say the practical, hypothetical
I'm creating a field in real
time bringing people together
to create a new understanding the
matrix (linked to my painting)
Spatially, not a field in
round the room bec. online, in a
another field 4 kind of field is
created in the zoom screen
Not embodied but cell'ous
people to see each other's
together create an online
field. Flat images but
people think in 3-D spaces
If there is an overall stage
saw/tangible field altho virtual
for Emphasis zoom as a virtual
field.

[handwritten: X On Being Able to Paint]

Cézanne and the Post-Bionian Field

An Exploration and a Meditation

[handwritten: He decides to [field] that it there? X]

[handwritten: Pt is that I ... the opportunity to construct a field embracing the subject & myself]

Robert Snell

*[handwritten: what's helpful is Bordino that I am creating a field that connects & showing my work & in something direction. This is literally a field in time & space as opposed to the abstract field it is ...

X Bc makes me aware that I now have almost no connection in any artistic lineage or a similar artistic field. I am creating my own lineage & field ... so I am a strand of my own.]*

Routledge
Taylor & Francis Group

LONDON AND NEW YORK

First published 2021
by Routledge
2 Park Square, Milton Park, Abingdon, Oxon OX14 4RN

and by Routledge
52 Vanderbilt Avenue, New York, NY 10017

Routledge is an imprint of the Taylor & Francis Group, an informa business

© 2021 Robert Snell

British Library Cataloguing-in-Publication Data
A catalogue record for this book is available from the British Library

Library of Congress Cataloging-in-Publication Data
Names: Snell, Robert, 1951 – author.
Title: Cézanne and the post-Bionian field: an exploration and a meditation / Robert Snell.
Description: New York: Routledge, 2021. | Includes bibliographical references and index. |
Identifiers: LCCN 2020036046 (print) | LCCN 2020036047 (ebook) | ISBN 9780367645458 (hardback) | ISBN 9780367645472 (paperback) | ISBN 9781003125020 (ebook)
Subjects: LCSH: Psychoanalysis. | Psychology—Philosophy. | Postmodernism.
| Bion, Wilfred R. (Wilfred Ruprecht), 1897–1979. | Cézanne, Paul, 1839–1906.
Classification: LCC BF173.S5694 2021 (print) | LCC BF173 (ebook) | DDC 150.19/5--dc23
LC record available at https://lccn.loc.gov/2020036046
LC ebook record available at https://lccn.loc.gov/2020036047

ISBN: 978-0-367-64545-8 (hbk)
ISBN: 978-0-367-64547-2 (pbk)
ISBN: 978-1-003-12502-0 (ebk)

Typeset in Times
by Deanta Global Publishing Services, Chennai, India

Contents

Illustrations

Preface

Writing this essay has been an attempt to explore what it is about post-Bionian field theory that, as a psychotherapist working with individuals, I find so illuminating and engaging. At the same time, I wanted to register certain echoes I thought I could hear between this lively, invigorating body of theory within psychoanalysis and the work of Paul Cézanne, and to try to listen to what they might have to say to each other.

For a long time, I have also been fascinated by a remark Jean Laplanche made at the ICA in 1992, that the analytic cure can have 'neither sense nor results' if it does not tap into something pre-existent in human nature and human culture. I wanted to use my experiences of Cézanne, of reading the Italian field analysts, and of supervision conducted very much in the light of their work, to explore this profound idea further.

The book aims to work as a broad introduction to post-Bionian field theory, although it cannot claim to be comprehensive (the reader might also want to turn to Giuseppe Civitarese and Antonino Ferro's *A Short Introduction to Psychoanalysis*, 2020); aspects of this theory, for example, the ideas of 'casting' and of 'narrative derivatives', do not have immediate resonance with Cézanne, although I think they can be linked to a central argument about the importance of the 'proto-mental'.

In the process of writing, I also ran with some force against a central problem, which is perhaps a problem of all analytic writing, how to use the discursive and sequential, which I felt committed by background and training to try to respect, to convey the simultaneity and spiralling of unconscious and field phenomena.

For in writing about analytic field theory one is dealing, as Giuseppe Civitarese has put it, with 'an assemblage of concepts which continually refer to each other and which acquire meaning only in this interlinking', and in which

> one concept turns back into another like the delicate cogs of a clock to the point where it is impossible or factitious to separate them. Each is necessary to the other, and all belong to an articulate and coherent symbolic matrix.
>
> (Civitarese, 2014a, p. 1082)

Whether or not I have proved this marriage of the discursive and the simultaneous to be an impossible one, at least for me, readers will decide. For there may, I fear, be times when what I hoped might be experienced as a subtle shift of vertex becomes simply tedious repetition. Such, on the other hand, is the quality of a spiralling conversation, and my best hope is that the reader will wish to engage with the book as if this is what it were.

Warmest thanks to Roger Bacon and Frank Gray, and to Graham Alexander, Rod Harman, John Laycock, Del Loewenthal, and Rod Tweedy, from all of whose insights and encouragement I have greatly benefitted. Thank you too to Kate Hawes, Hannah Wright and Abigail Stanley at Routledge, and Sushmitha Ramesh at Deanta, for their patience and their confidence in the project.

I owe a special debt of gratitude to my friend the late Dennis Creffield (1931–2018). In our conversations of nearly forty years, Cézanne was rarely out of the frame.

The generous and enthusiastic responses of Antonino Ferro, Gillian Jarvis, and Giuseppe Civitarese to the manuscript have been wonderful sources of encouragement, and it is a delight to acknowledge them here.

Richard Morgan-Jones has added whole new dimensions to my analytic learning; without him, it is unlikely I would ever have embarked on this adventure at all. For this, and for all kinds of challenge and stimulus over the years, I am hugely grateful.

But my biggest thanks of all go to Kim, and I dedicate this book to her, with love.

Translations from French are my own unless otherwise signalled in the References.

Introduction

'Old as I am, I am just starting out', Cézanne told a visitor towards the end of his life (Borély, 1902, p. 19). Another guest, anticipating later commentators, remarked on how hard it was to speak about the painter with any kind of precision (Denis, 1907, p. 167, Appendix 1). Yet it is for just these reasons that Cézanne—the lifelong beginner, forever reaching for something elusive—can teach us. The painter and his work can help psychotherapists.

For as Antonino Ferro and Giuseppe Civitarese have put it, art 'should serve to interpret psychoanalysis', in a collaborative meeting that can open up new meanings in both arenas (Ferro and Civitarese, 2015, p. 63). The meeting I aim to convene in this book is between Cézanne and a branch of contemporary psychoanalysis known as 'post-Bionian field theory'. This is a rather forbidding name, but my hope is that bringing this theory and this particular painter into contact may generate new light under which to consider theory, artist, and important aspects of the analytic and human encounter themselves.

I shall be exploring the 'field' set up by this meeting. In it, multiple voices claim a hearing: those of artists, art historians, psychoanalysts, philosophers, some contemporaries of Cézanne and, of course, that of the painter himself. I draw on texts by, among others, W. R. Bion and Maurice Merleau-Ponty, and in particular on the work of Ferro and Civitarese, who from their base in Pavia in Northern Italy are prime movers in the development of field theory as it has evolved in psychoanalysis under the influence of Bion's ideas.

Cézanne in fact provides us with an introduction to the field that is live in its own right: his painting can give us a direct experience of it. In his later work, he locates us as viewers *in* the field and thereby gives us an opportunity to develop our understanding and appreciation of what living and working therapeutically 'in the field' can mean. The paintings can prepare and attune us. For Cézanne was discovering and exploring—in the very activity of painting itself—precisely the phenomena of human experience that post-Bionian field theory seeks to draw upon: our mutual and in the end 'aesthetic', that is, potentially and profoundly pleasure-giving, participation with the world and each other. The aesthetic experience, Ferro and Civitarese write, is 'the deepest element of psychoanalysis ... the psychoanalytic experience is fundamentally an aesthetic experience' (Ferro and Civitarese, 2015, p. 6). The aesthetic is, however, never

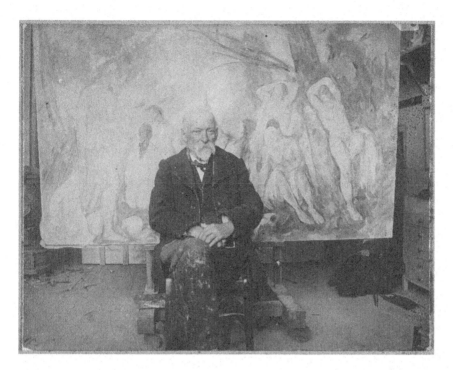

Illustration 0.1 Emile Bernard, *Paul Cézanne in his studio at Les Lauves seated in front of the Large Bathers* (now in the Barnes Foundation), 1905. Photograph, 60.3 × 88.6. Musée d'Orsay, Paris. Photo © RMN-Grand Palais (Musée d'Orsay)/René-Gabriel Ojéda.

a conflict-free zone, and this conflict is a theme that runs through the exploration that follows.

Cézanne's death at the age of 67, halfway through the first decade of the twentieth century, came at a time of ground-breaking enquiry across many different fields. Cézanne was already being hailed as a foundational figure, the pioneer of something radically new in painting [illus. 0.1]; a succession and grouping of founding fathers may suggest itself. The painter's chronicler Joachim Gasquet, the son of an old friend of Cézanne's from his native Aix-en-Provence, recorded him as saying that in painting well,

> in spite of yourself, you speak for your age in terms that register its most advanced awareness ... A painter who knows his grammar and pushes his language to the limit without destroying it ... inevitably translates onto his canvas whatever ideas the best-informed brain of his time has conceived or is in the process of conceiving. Giotto answers to Dante, Tintoretto to Shakespeare, Poussin to Descartes, Delacroix to ... whom?
>
> (Gasquet, 1991, p. 169, and 1921 and 1926, pp. 125–6)

[handwritten annotations in top and left margins]

As a witness, Gasquet was more poetic than scrupulous, and it is often difficult to disentangle his views from what may have been the painter's; there is something about the above, something self-consciously 'literary', that does not quite have the ring of Cézanne.[1] Nevertheless, the passage is suggestive, and Cézanne, a man of wide education and reading, profoundly familiar with the history of painting, would not have been indifferent to the idea of locating himself within an art-historical and cultural lineage. So if Giotto answered to Dante, and Poussin to Descartes, to whom, from our vantage point over a hundred years on, might Cézanne himself answer in this sequence? Freud himself perhaps?[2] For the revolutions Cézanne and Freud started more or less at the same time were comparable in magnitude and substance; at stake were the fundamentals of how we experience the world and ourselves in it. If Monet and the Impressionists still essentially answered to Descartes, positing a world-out-there waiting to be apprehended by a sensitively calibrated eye ('Monet is only an eye', said Cézanne [Vollard, 1914, p. 74], 'but good Lord what an eye!'), Cézanne, like Freud, puts us *in* the picture and challenges our claims to mastery.[3] There is no magisterial perspective; depth must be sought by other means. The ego, for Freud, was 'first and foremost a body-ego' (Freud, 1923, p. 27); Cézanne implicates us not just as seeing eyes but also as experiencing bodies. In front of a painting by Cézanne, we find ourselves in and of the landscape, conscious of our immersion and participation in it. Cézanne, I want to argue, helps us to an awareness that we are part of a field.

The very idea of a psychic 'field' is ultimately the product of a paradigm shift no less profound than the Freudian; it is borrowed from electromagnetic and gravitational field theory (Civitarese and Ferro, 2013, p. 195). In 1865, in his theory of electromagnetic radiation, James Clerk Maxwell demonstrated for the first time that light is an electromagnetic wave and that electricity, magnetism, and light are all part of the same phenomenon. 'The electromagnetic field is, for the modern physicist, as real as the chair on which he sits', wrote Albert Einstein and Leopold

1 Joachim Gasquet (1873–1921) was twenty-three when he and Cézanne met. He was a Provençal revivalist, a rightist, and a royalist, his attitudes tinged with racism. In the judgement of Cézanne's biographer Alex Danchev, he was 'preciousness personified, at once superior and ingratiating' (Danchev, 2012, p. 292). In his novel *Il y a une volupté dans la douleur* (1897–98), Gasquet represented Cézanne as a mystical Provençal painter, and while he and Cézanne never quite saw eye to eye, Cézanne was for a few years eager for his company. 'Cézanne's enthusiasm for Gasquet was something of an aberration, born of nostalgia [for his own youth] and a deep love of Provence, but also of a loneliness', writes another historian (Smith, 2007, p. 56). Yet there is a vividness and directness about some of Gasquet's extensive conversations with the painter which, if accounts of Gasquet's own preciousness are to be believed, must be authentically Cézanne's.

2 In *Freud and Cézanne* (1993), Alexander Jasnow made a comparison between the two his starting point. His book contains useful accounts of the philosophy and working methods of both; but it is mostly a wide-ranging discussion of parallels between psychotherapy and modern art in general.

3 T. J. Clark did not shy away from noting the 'strict coincidence of the ten years spent on the three large Bathers with those of the founding of psychoanalysis' (Clark, 1995, p. 97).

Infeld (1938, p. 151).[4] Within the old Newtonian model, which had held sway for more than two hundred years, the focus would have been on the electrical charges themselves rather than the field between them; it took time for the new field concept to establish itself in physics as a reality for which the mechanical model had no place.Other disciplines have gradually been catching up.[5]

Maxwell's was, after Newton's, the second great unification in physics; the third revolution, giving birth to relativity, quantum theory and all that has followed, was effected by Einstein, Planck, Heisenberg, and others in the years around and following Cézanne's death, and it has made itself more widely felt in two particular ways. Firstly, through the principle of uncertainty or undecidability established in 1927 by Werner Heisenberg, in which the speeds, directions, starting and end points of observed phenomena (electrons) are impossible to specify accurately.[6] Jacob Bronowski preferred the term the 'Principle of Tolerance': knowledge and information between human beings too 'can only be exchanged within a play of tolerance' (Bronowski, 1973, p. 365). Secondly, through the insight that the observer or experimenter can no longer claim to be outside the phenomena observed, but has to accept being part of the field, with an effect upon it.

For all the profundity of the Freudian revolution, with its own demonstration of the existence of unseen forces, there has been a further paradigm shift within psychoanalysis, in a process that is comparable to the successive revolutions that have taken place in physics. In the Freudian two-person model, the analyst's task was to decode the disguised, repressed contents of the patient's unconscious. 'Everything is transparent for Freud', writes Civitarese. 'If it is not, the reason lies in the intrinsic difficulty of the material, not in the investigating eye' (Civitarese,

4 In the beginning, the field concept was no more than a means of facilitating the understanding of phenomena from the mechanical point of view. In the new field language it is the description of the field between the two charges, and not the charges themselves, which is essential for an understanding of their action. The recognition of the new concepts grew steadily, until substance was overshadowed by the field. It was realised that something of great importance had happened in physics. A new reality was created, a new concept for which there was no place in the mechanical description. Slowly and by a struggle the field concept established for itself a leading place in physics and has remained one of the basic physical concepts. The electromagnetic field is, for the modern physicist, as real as the chair on which he sits. (Einstein and Infeld, 1938, p.151)

5 Within contemporary neuroscience, an exemplary commentator on this shift, or rather the urgent need for it, is the philosopher Iain McGilchrist, who has comprehensively explored the complex and dynamic relations between left and right brain hemispheres. In particular, he has analysed how left-hemisphere functioning, focussed, ordering, reasoning, necessary for survival, has in the West displaced the right hemisphere from its essential guiding, intuitive, 'dreaming' role, with potentially disastrous consequences (McGilchrist, 2009; Tweedy, 2012). The left hemisphere tends to think like a Newtonian; the right hemisphere is able to entertain 'unimaginable' scenarios, and connects us to our collectivity.

6 '[T]he matters with which I am concerned continue, and evolve, but they do not "begin"' (Bion, 1961, p. 88).

2014a, p. 1068). One if not the key means for this decoding was the way the patient related to the analyst, on the basis that in this way of relating the patient would unconsciously be replicating patterns of much earlier relationships with foundational figures in the patient's life, or, more accurately, of unconscious versions of these relationships. It was the analyst's task to report back to the patient the nature of this present 'transference' relationship in as complete a way as possible, in the hope that, over time, this would bring relief from conflicts generated in the first relationships that had been internalised and repressed, made unconscious, but that continued to structure the patient's emotional life. The whole operation was to be undertaken with relative detachment, like, as Freud wrote, a surgeon's (Freud, 1912, p. 114). As well as the 'transference' relationship to the analyst himself, the tools for accessing this conflictual unconscious were dreams, and the patient's 'free associations' to them, with the idea of 'counter-transference' added a bit later. This idea that the analyst's own feelings and thoughts might not so much be hindrances as sources of information about the patient was developed by Melanie Klein and her followers, of whom Bion began his career as one.

For the later Bion, the aim of psychoanalysis grew to be radically different, as did the role of the analyst. Analysis, for Bion, was now directed towards maintaining and enlarging the very channels of communication themselves, both intra- and inter-psychic: those through which the patient conversed with herself, and those between analyst and patient; thus the analyst too needed to be open to undergoing changes. Rather than a closed personal system and a repository of the repressed waiting to be made conscious, the unconscious, Bion came to feel, was something under constant construction and development. It was, at the same time, under constant threat of atrophy, for the mind could also degenerate. In Bion's later thinking, the key tool—if 'tool' does not sound too instrumental—would now be the very quality of attention itself; the attention analyst and patient are able to foster together, to create a sort of hospitable environment for imagination and for dreaming, dream being both the primary means of access to this unconscious and the medium for its growth. Quality of attention becomes not just a necessary prerequisite for analytic work, part of a more traditional 'analytic attitude', but transformative *in itself.*

More than implicit in this way of thinking was the idea—beyond 'counter-transference' and the idea of a to and fro between two bounded, monadic minds— that the 'unconscious' is something not individual but co-generated. For the post-Bion Italian field analysts, the idea of an analytic *field* is what underlies this. It is a metaphor for what is generated by the analytic pair from the moment they get together (Civitarese and Ferro, 2013). Phenomenologically, it is as real as the chairs on which they sit (Einstein and Infeld, 1938, p. 151; Neri, 1998, p. 154). It is a force field, and the analytic setting a potentially expanding universe.

The 'I-Thou'—the reality that we meet, in hope and in dread, as desiring beings in search of mutual recognition—is not abolished within the terms of this metaphor. But since the field is a co-creation and belongs exclusively to neither participant, a merely two-person model, while not exactly superseded, can no longer be held as sufficient. Decoding and symbolic interpretation are not redundant—any

more than Newtonian mechanics have suddenly ceased to have validity—but they no longer occupy a central explanatory or transformative, place.

Two particular consequences follow from this. Firstly, an increase in the play of tolerance and a decrease in the danger of analyst and patient falling into supposed and impossible certainties (interpretative, diagnostic …); secondly, a different quality of engagement on the analyst's part, an acceptance of her participation in the intersubjective field, and her effect upon it. In contrast to practitioners of relational psychoanalysis, as pioneered in the United States in the 1980s (Greenberg and Mitchell, 1983), Ferro, Civitarese, and their colleagues emphatically do not wish to break down the essential asymmetry of the analytic couple in favour of some spurious relational equality. But to work analytically, for them, is to develop both the patient's and the analyst's capacity to dream, or, more accurately, to draw from and enrich the oneiric capacity of the interpersonal, intersubjective field itself. Perhaps this brings us closer to the idea of a collective or social unconscious, to which, in the neurologist Iain McGilchrist's terms, our 'primitive', more collectively oriented right-brain hemispheres (re)connect us (McGilchrist, 2009). In Bion's language, this would be the area of the 'protomental', before speech, before the Oedipal, and there will be more to say about this later.

Ferro, adopting a political metaphor, sees Bion's achievement as 'comparable to the French Revolution' (Ferro, 2019a, p. 56). Bion is the central figure in the paradigm shift within psychoanalysis, and it is a shift as seismic as that which Cézanne brought about in *his* field over a hundred years ago. Cézanne's challenge has certainly not lost its edge. And Bion's is perhaps only now beginning to find its own wider and adequate response.[7] If it would be too much to assert that Cézanne predictively answers to Bion, it is not fanciful to suggest that he rehearses key aspects of the complex and fascinating development within psychoanalysis in which Bion was a prime mover. In what follows, we shall find ourselves, in the best Bionian tradition, 'shifting vertices', at one moment trying to look through the painter's eyes and those of his commentators and seeing how this might nuance our understanding of theory, and at the next seeing if post-Bionian field theory might further our appreciation of Cézanne.

I shall start with a schematic four-part outline of Cézanne's journey, as suggested by the 2017–18 Cézanne Portraits exhibition at the National Portrait

NB. CAESURA

7 Echoes between Bion and McGilchrist are not hard to hear. One of Bion's central concepts is the notion of the 'caesura', that which both divides and links all binaries, from pre- and post-natal to inside and outside to, of course, right and left—an equivalent to the longitudinal fissure or the corpus callosum, in the language of physiology. 'Investigate the caesura' was Bion's instruction to analysts, in the hope of 'transcending' it. This seems to be just what Iain McGilchrist is doing in his great project to help us fertilise and reinvigorate the interactions between left and right hemispheres, in particular through investigating and transcending the caesura by which left-hemisphere functioning has been so privileged in Western culture.

Gallery, London, which was the initial stimulus for this book.[8] This outline is also a record of the sorts of conversation between painting and psychoanalysis that the exhibition set off in my mind at the time and in the days that followed. For like analytic interpretations, especially 'unsaturated' ones in the Bion tradition, the portraits generate mental activity, conscious and unconscious, through the challenges they offer. As the art historian T. J. Clark wrote at the time of the exhibition, 'still, more than a century after they were painted, these images so effortlessly keep their distance, resisting our understanding, refusing (as the philosophers say) to "come under a description"' (Clark, 2018a, p. 13).

One such internal conversational prompting, which I shall follow here, was to liken Cézanne's career to that of a psychoanalyst who sets out as a humanistic, person-centred learner, then, with the help of an analyst/supervisor/mentor (the Impressionist painter Camille Pissarro, in Cézanne's case), finds his way deeper into himself and into contemporary theory and practice, and then, like Bion, spends the rest of his life confronting the unrelenting difficulties, the uncertainties, mysteries, and indeterminacies inherent to his art, the doubts they engender in him, and what he might learn from them. It is a career that might offer food for thought for therapeutic education.[9] Cézanne's trajectory is not everyone's, of course, and I do not wish to prescribe a linear progress. But on this journey—Bion's biographer Gérard Bleandonu similarly divided his career into four 'seasons', commenting on a continuity between work and life (Bleandonu, 1994, p. 2)—nothing was lost: each phase subsumes and builds on the one preceding. My emphasis will necessarily be on the later years, the 1890s and early 1900s.

8 Remarkably, this exhibition, which travelled from Paris to London to Washington, DC, was the first ever to focus on the portraits. See Elderfield, 2017.

9 The trajectory I am suggesting, especially in its earlier stages, loosely corresponds to that outlined in Loewenthal and Snell, 2006.

1 Cézanne's journey

Notes on an exhibition

✗ Portraits : Artists

First Cézanne gets to know something about his own corporeal, instinctual, and impulsive life, about libido and its terrors. See, for example, early paintings such as *The Rape* (1867, Fitzwilliam Museum, Cambridge), or *The Murder* [illus. 1.1]. From his first figure paintings, and, in a less brutal but nonetheless raw and factual way, in his first portraits, he wants to depict some of the more extreme moods, feelings, and emotional states that the human mind and body, above all his own, can (or cannot) contain. As the exhibition's curator John Elderfield says, the young Cézanne had little to learn about psychological intensity (Elderfield, 2017, p. 47). He is diving headlong into his own erotic and psychosomatic world. As John Berger put it, he is finding out about what being flesh means: 'our desires, blind longings, and aptitude for gratuitous violence' (Berger, 2015, p. 253). ✗

But it is portraiture, the exhibition suggests, that enables Cézanne to find his artistic voice (Elderfield, 2017, p. 13). From 1866 onwards, in portraits executed in what he called his 'manière couillarde', his 'ballsy manner', Cézanne registers the sheer physical presence of others in their particularity and aliveness, the unself-conscious self-assurance with which they can inhabit their bodies. This is echoed too in the undeniable physicality of the heavy slabs of paint. When first applied, Cézanne's patches of paint would, as Elderfield notes, have been pockets of liquid paint: 'representation of bodily substance was a matter not only of creating a resemblance but also an analogy in the paint, its surface an epidermis implying flesh underneath', for it was 'body work that Cézanne was doing' (Elderfield, 2017, p. 17).

We know that like his friend Zola he took the idea of temperament and 'ballsiness' very seriously. I revisit a fine book by the art historian Dore Ashton and read this:

> [H]is conviction [was] that only 'temperament' could propel an artist. His special notion of temperament [was] born in a turmoil of emotional responses to life and to painting … For Cézanne, temperament was identified with an elemental force … which, although reshaped during his mature painting years, always came first … Cézanne believed, as he often said, that the painter has to have 'quelque chose dans l'estomac' … The most frequently

Bollac —

"*Evocative objects*"

'*Being a character*

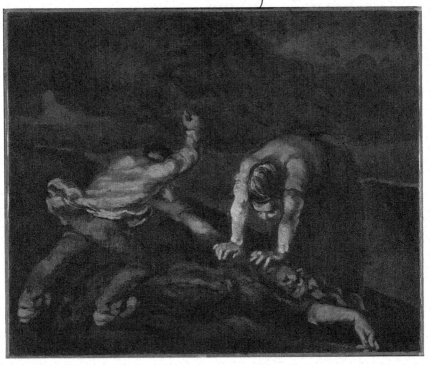

Illustration 1.1 Paul Cézanne, *The Murder*, 1867–70. Oil on canvas, 64 × 81. Liverpool
National Museums, Walker Art Gallery. Purchased with the assistance of
the Art Fund, 1964

reported phrase used to fend off sycophantic admirers would be equivalent to
'a painter has to have balls'.

(Ashton, 1980, p. 33)[1]

Perhaps he was also referring to the kind of guts required to stick to one's task,
just to keep going.

Cézanne's *Uncle Dominique* [illus. 1.2] might be a sort of mirroring recep-
tacle (like one of Anish Kapoor's mirrored, concave containers) for the young
man's sense of his own physicality, potency, and potential. Perhaps the portraits
Cézanne makes of his uncle become self-created versions of what Christopher
Bollas has termed 'evocative objects' (Bollas, 1993), vital contributors to the

1 '[I]t is only this initial force, that is, temperament, that can carry a person towards the goal he
 must reach', he was telling Gasquet and others towards the end of his life (Gasquet, 1921 and
 1926, p. 111).

[handwritten: X "painting like a dialogue with a person" (Smith 2007)]

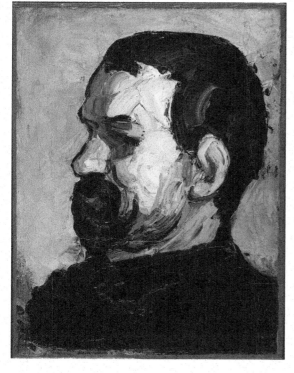

Illustration 1.2 Paul Cézanne, *Uncle Dominique*, c. 1886. Oil on canvas, 39.5 × 30.5. On loan to The Fitzwilliam Museum from King's College, Cambridge. © Reproduced by the kind permission of the Provost and Fellows of Kings College, Cambridge

processes of his own emotional coming into being. Perhaps Cézanne was discovering that a painting, particularly a portrait, was finished, 'realised', when it returned this sense to him—something akin perhaps to the experience of a patient in therapy or analysis for whom a new way of relating and responding might be accompanied by a certain shock of recognition and a feeling of expansion, not easily put into words. *[handwritten: in Salas-life work]*

A little later, I read that for certain modern commentators—Adrian Stokes and Richard Schiff among them—Cézanne's dialogue with the painting was like a dialogue with a person; the paintings 'cohere fluidly like a body, they possess an expressive tactility, they stand and look back at the artist' (Smith, 2007, pp. 61–2).

From the late 1870s, Cézanne is more concerned with resolving the portrait as an aesthetic organisation or organism in its own right, as a means of refining the registration of the particular human presence and relationship. For example, in the sumptuous *Madame Cézanne in a Red Armchair* [illus. 1.3], with its highly

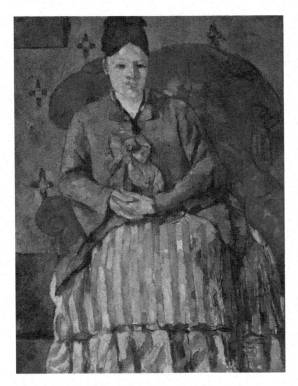

Illustration 1.3 Paul Cézanne, *Madame Cézanne in a Red Armchair,* c. 1877. Oil on canvas, 72.4 × 55.9. Museum of Fine Arts, Boston. Bequest of Robert Treat Paine, 2nd 44.776

evolved structure, it is as if, in a playful, buoyant dance of lines, shapes, and colours, the painter were dancing with delight around his mistress (Hortense Fiquet and Cézanne do not in fact marry until 1886). Everything in the frame is important. The painting prompts reflection on how shape, form, and structure can in themselves be sources of multiple possible meaning—and what an important step in therapeutic learning too this discovery is.

This aesthetic structuring opens Cézanne's painting to new ambiguity. The vertical stripes of Madame Cézanne's dress work to anchor her as a stable presence. But this raises questions: stable in her own right? Or merely as a figment of *his* world? One can hardly write 'vertical bars' without evoking the idea of imprisonment, but perhaps this is more an effect of language than it is of the painting. Here might be a good example, for the analyst, of the hazards of relying too much on ideas and a sort of 'knowingness', and of insisting on the purely conceptual or symbolic. There is the interpretative possibility that Hortense is somehow imprisoned, and this cannot be overlooked. But if one listens to its visual music, the joyful feel of the painting also subsists. We must be open to the presence

of both these possibilities, one more rational, one more affective. They seem to inform each other, in ways that are not easy to analyse.

In *Madame Cézanne in a Red Armchair,* everything presses up against the picture's surface, and no one element seems to have priority over another. Time too seems concertinaed; from the tip of Madame Cézanne's nose to the skirting board that is nominally below and behind her, there is little to detain or distract the viewer's eye on its journey across space, which seems simultaneously two- and three-dimensional. Within this physical-imaginative space, which contains no suggestion that objects of perception belong within a hierarchical order, there is equally no sense that events in time are sequential. 'Consciousness is motionless', said the eighty-one-year-old Tolstoy, reflecting that he experienced the same consciousness of himself *as* a self as he did when he was five or six (Leon, 1944, p. 327). Madame Cézanne and her armchair collapse time-space distinctions and definitions.

A back-and-forth in time, adding up to a similar blurring of past/present, finds more concrete expression later within the frame of the exhibition. The *Man in a Blue Smock* (c. 1897) stands in front of a pseudo-eighteenth-century screen to which, as a young man some thirty years earlier, Cézanne had added figures of his own. The painting gives us the simultaneous co-existence of things separated in time and space, as in the space-time of the session, dream, the unconscious.

In the mid-1880s, a greater sense of doubt, even of mystery, starts to make itself felt in the portraits, or, to put it another way, seems to be registered as part of the phenomenology of the painter's experience, both of the sitter and of the act of painting itself.

In his review of the exhibition, T. J. Clark writes about how Cézanne in his mature work set out from a position of uncertainty, and this for Clark was the ultimate message of the exhibition: 'uncertainty, guardedness and suspicion came to be felt, in practice, in painting, as realities a painting should start from, not reach as its final result. They were the stuff of experience' (Clark, 2018a, p. 16). The catalogue, citing Clark, speaks suggestively of Cézanne painstakingly building up his pictures with individual brushstrokes that are 'units of experience' (Elderfield, 2017, p. 29); might these be what he called his 'petites sensations', his 'little sensations'?

Bion famously recommended that the analyst should aim with each patient and each session at 'an exclusion of memory and desire' (Bion, 1967, p. 19), and this now seems now to be Cézanne's aim: to attend, as faithfully as he can, only to his moment-to-moment sense of things. The self-portraits of this period sometimes record a quizzical look, as if the painter were asking 'just what is this I see in the mirror? What is it made of?'. This can result in both a sense of the incontrovertible 'thereness' and 'nowness' of things and of himself, and of provisionality—as in some of his self-portraits of the early 1880s [illus. 1.4, a stunning drawing not in the exhibition].

There is a group of portraits of Madame Cézanne in a red dress from the late 1880s [illus. 1.5 and 1.6], which in the words of an exhibition wall panel 'ask us

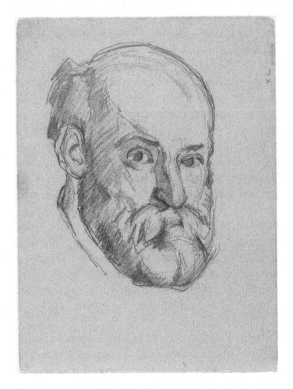

Illustration 1.4 Paul Cézanne, *Self-portrait*, c. 1880/2. Graphite on woven paper (sketchbook page), 22.1 × 12.5. National Gallery of Art, Washington DC. Collection of Mr and Mrs Paul Mellon, Accession No. 1985.64.85.a. Open Access—Public Domain

not to be too specific about interpreting them'. Their effect is 'embodied in the articulation of touch, drawing and colour over the entire surface', only now this surface, less decorative, also seems less bothered about pleasing.

The exhibition's Madame Cézannes 'could be mistaken for sisters', says the panel—they have a family resemblance and remind us that we do not always look the same, a phenomenon as observable in the consulting room as in the studio. Perhaps our ordinary senses of selfhood and individuality derive less from our unvarying consistency than from a vaguer feeling of family resemblance between our different states.[2] Individuality is not uniformity.[3]

2 I later read in Bronowski, in his commentary on Heisenberg's principle of uncertainty, that 'if an object (a familiar face, for example) had to be *exactly* the same before we recognised it, we would never recognise it from one day to the next' (Bronowski, 1973, p. 365).

3 The art historian Paul Smith has argued that Cézanne's own 'multiple selves'—'primitive', 'child', and his identifications with various fictional representations of artists—nevertheless retained a 'family identity' and constituted his 'artistic self' (Smith, 2007, p. 59).

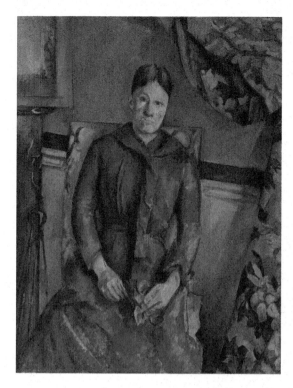

A Green
"work of the negative"

Illustration 1.5 Paul Cézanne, *Madame Cézanne in a Red Dress*, 1888–90. Oil on canvas, 116.5 × 89.5. Metropolitan Museum of Art, New York. Mr and Mrs Henry Ittleson, Jr, Purchase Fund, 1962 (acc. no 62.45). Bridgeman Images. Open Access—Public Domain

Cézanne's portraits of his wife nevertheless do suggest emotional states: she can seem sad, withdrawn (nothing we know about Cézanne suggests he would have been easy to live with). But the capacity of the portraits to evoke emotion and stimulate the viewer's reflections about her is not a product of the painter's interest in psychology. It seems to be precisely a suspension, an absence of judgement, that allows the portraits to speak for themselves, and the sitter to speak for herself.

Cézanne's task, to borrow a phrase of André Green's, was a 'work of the negative' (Green, 1999, p. 1): it was a question of making a mark that was *not* false, and then another, and another, with the risk of getting it wrong and having to start all over again. He seems to have been taking care not to falsify what felt alive through exaggeration or undisciplined zeal.

A strange self-portrait of c. 1885 [illus. 1.7], the only one done from a photograph, and from a photograph taken several years earlier, makes me think of a session that somehow doesn't come to life—that might, for example, be too much 'about psychoanalysis' itself, too caught up in theorising, especially about the past. The experience of an unfolding and unpredictable present encounter is lost.

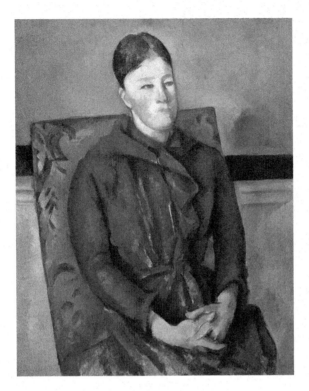

Illustration 1.6 Paul Cézanne, *Madame Cézanne in a Yellow Chair*, 1888–90. Oil on canvas, 81 × 65. Art Institute, Chicago. Wilson L. Mead Fund (1948.54). Bridgeman Images. CCO Public Domain Designation

It is as if in this rather dead painting, Cézanne was unable to look himself in the eye, having recourse to a mediated, already given account of himself.

Certain paintings of the 1890s could also seem to be casting a backward glance, for example, to the Romantics. *The Portrait of a Man with Crossed Arms* (c. 1899) [illus. 1.8] might be viewed as a rather rhetorical account of a brooding state of mind. But I think we can be confident that this is because the painting records a pose and a glance characteristically adopted by the sitter, not one pre-conceived and imposed by the painter. The sitter simply went about the world like this, or aspired to, and presented himself in this way to his portraitist. He *was* a bit of a Romantic.

At the same time, Cézanne was no less subject than other artists to a sort of art-historical unconscious or 'field'—something of a different order from his manifest love of, for example, Rubens, as evident in many early paintings and again later in his career. He thought Jacques-Louis David was simply a bad painter, cold and without soul (Gasquet, 1921 and 1926, p. 131). Is there nevertheless an echo in *The Man with Crossed Arms* of a painting from the school of David from

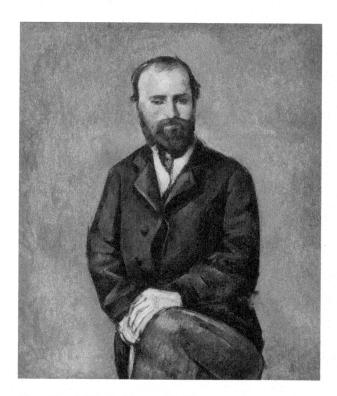

Illustration 1.7 Paul Cézanne, *Self-portrait*, c. 1885. Oil on canvas, 65.41 × 11.43. Carnegie Institute, Pittsburgh. Acquired through the generosity of the Sarah Mellon Scaife Family. Accession number: 68.11

the revolutionary period, *La Maraîchère* (*The Market Woman*, c.1795, Musée des Beaux-Arts, Lyon)? The exhibition draws attention to Cézanne's later paintings of peasants and tradespeople and suggests that portraying them did not challenge him as much as did painting someone from the educated bourgeoisie, such as his dealer Ambroise Vollard, or the statesman Georges Clémenceau, with whose portraits he struggled. Cézanne himself was a bourgeois, his father a hat-maker who became a well-off banker, and whose money enabled his son to continue to paint; Cézanne's political views were often, although not monolithically, conservative (he was, for example, an anti-Dreyfusard). Perhaps his liking for painting working people was a product of his need for a degree of unselfconsciousness and lack of 'educated' expectation the part of his sitters. They made few demands on him, freeing him to attend to his task. Their personalities were not as marinated in convention, so he did not have to paint that. With some patients (and for many possible reasons) it is so much harder to hold to an 'analytic' attitude of receptive neutrality than it is with others.

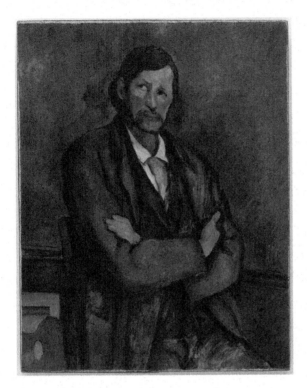

Illustration 1.8 Paul Cézanne, *Man with Crossed Arms*, c. 1899. Oil on canvas, 92 × 72.7. New York, Solomon R. Guggenheim Museum. © 2020. The Solomon R. Guggenheim Foundation/Art Resource, NY/ Scala, Florence

In the final period, during which Cézanne worked on his great series of bathers [illus. 3.5 and 3.6; the third is in the National Gallery, London], and on the finest of his paintings of the Montagne Sainte-Victoire [cover and illus. 1.9, and see 3.7], the work has a 'classical' solidity and incontrovertibility (the French word is *incontournable*); it is at the same time as open to possibility as an analytic session. There is nothing else like it in nineteenth-century painting. This is the context in which Cézanne's most often quoted pronouncements make the greatest sense, and can come to our aid: 'I wanted to make Impressionism into something solid and durable like the art of the museums' (Denis, 1907, p.170), and the converse, to bring Poussin to life from nature ('vivifier le Poussin devant la nature', Jourdain, 1950, p. 84). 'We must become classics again through nature', he told the painter Emile Bernard (Bernard, 1907a, p. 80), that is, find the 'incontournable' *in* nature. 'Imagine Poussin entirely redone from nature, that is classicism as I understand it' (Gasquet, 1921 and 1926, p. 150). It is in these last years, especially after 1900, in his sixties, that he develops what the critic Lawrence Gowing called 'an uncharacteristic longing for exegesis and explanation' (Gowing, 1977, p. 56), as if he were seeking to orient

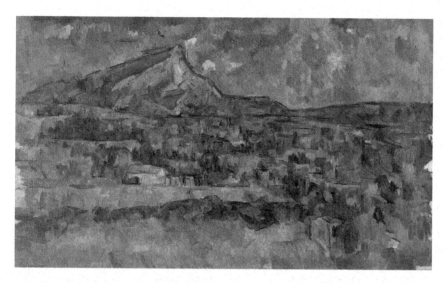

Illustration 1.9 Paul Cézanne, *Mont Sainte-Victoire*, c. 1902–6. Oil on canvas, 57.2 ×
97.2. Metropolitan Museum of Art, New York. The Walter H. and Leonore
Annenberg Collection, Gift of Walter H. and Leonore Annenberg, 1994,
Bequest of Walter H. Annenberg, 2002. Accession Number: 1994.420.
Bridgeman Images. Open Access–Public Domain

himself in uncharted territory in which objects and figures will 'increasingly merge
into the flux of colour', mimesis will give way to inherent meaning, and the subject
becomes the 'breadth and depth of nature' itself (ibid., pp. 55–6).

There can, from the mid-1890s, be a sense of the numinous. The *Woman with
a Cafetière* [illus. 1.10] is like an ancient goddess in ordinary clothes. She has the
presence of a Cycladic figure and the sculptural solidity of a Poussin. At the same
time, she is who she is, in the here and now, a housekeeper or cook perhaps, in a
functional blue dress whose dye may have faded somewhat, with a coffee pot in
a panelled interior. How everyday and mysterious it all is. Her numinousness, in
Coleridge's words (of 1816), emerges 'through and in the Temporal'. It 'partakes
of the Reality which it renders intelligible'; it is the 'Special in the Individual ...
the General in the Especial ... the Universal in the General' (Coleridge, 1894, p.
322). She is like a sort of promise of a symbol—is this something like what Bion
meant with his elusive concept of 'O'?

If, phenomenologically speaking, the painting is a sort of investigation into the
nature of the encounter between painter and subject—although it also seems to be
about more than this—the aesthetic form it has found for this feels both definitive
and awkward: lucid, satisfying and disquieting all at the same time.

Should we—following D. H. Lawrence's suggestion that Cézanne instructed
his models 'Be an apple!'—be content with the view that he painted the woman's
head in the same way as he painted an apple? (True, he instructed Vollard to sit

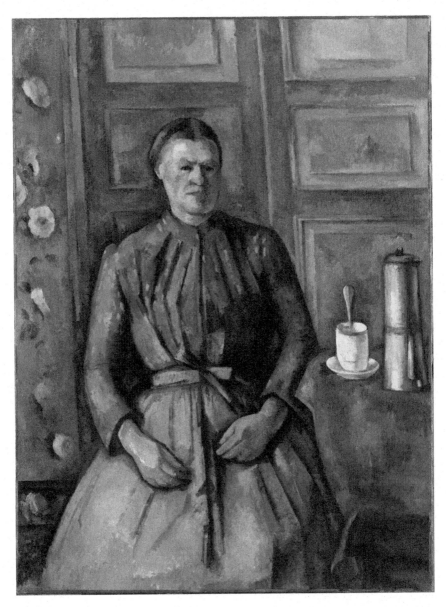

Illustration 1.10 Paul Cézanne, *Woman with a Cafetière*, c. 1895. Oil on canvas, 130.5
× 96.5. Musée d'Orsay, Paris. Gift of M and Mme Jean-Victor Pellerin,
1956. Photo © RMN-Grand Palais (Musée d'Orsay)/Hervé Lewandowski

as still as an apple. Vollard, 1914, p. 76.) In his figure paintings, wrote Lawrence, 'while he was painting the appleyness he was also deliberately painting out the so-called humanness, the personality, the "likeness", the physical cliché' (Lawrence, 1929, p. 212). In 1934 Samuel Beckett made a similar observation, that Cézanne painted the landscape as 'material of a strictly peculiar order, incommensurable with all human expressions whatsoever' (Beckett, 2009, p. 222; T. J. Clark refers to both writers in his review). But how does this fit with the sense of the woman's 'incontournable' human presence?

All the elements in the picture seem to belong together, but each too is treated as separate and independent. Each is articulated with very great respect indeed, from the line of the skirting board to the stiff folds in the dress. But what are the relations between them? They are linked, but how? *Woman with a Cafetière* is full of enigma. The spoon, cup, saucer, the dress, and its pleats, the woman's hands—all these features in the painting's field share presence and weight. There are internal echoes of other kinds across the field, for example, echoes of colour and geometric shape—the ellipse of the top of the coffee cup with the white flower motifs on the wallpaper—and of volume—the cylindrical form of the cafetière and the woman's sleeved forearm. There are relationships in space, the continuing unresolved tension between surface and depth, which the receding line of the table edge, which ought to clarify things, in fact only works to heighten.

Other relationships between the painting's elements are relations of use and function, obvious but not to be overlooked: cup, spoon, the eye and arm that will guide the hand to pick up the coffee jug that will pour the coffee into the cup that will be stirred by the spoon and drunk by ... whom? The woman herself? Perhaps, perhaps not. If she is a housekeeper in her kitchen, she is in the field in which she functions for a significant part of her life. Here she is, at her leisure or formally posing, in the flesh or in the painter's memory, it is hard to tell, with her tools at hand, with which she has developed a familiarity over time, so that in this sense she and they *do* seem almost of the same stuff. The mundane, functional possibilities noted above are undeniably present; but the separateness with which the elements are realised makes them and their possible inter-relations strange.

Perhaps when Cézanne spoke of his 'sensation' it was, by this stage of his career, not just a question of optics. The *Boy in a Red Waistcoat* [illus. 1.11], or the various *Card Players*, with their long arms, are perceived not just optically, geometrically, or perspectively, or even 'haptically', that is, through the sensations which are the painter's somatic response,[4] but through the total experience

4 The notion of the 'haptic' was developed in Vienna by the Austrian art historian Alois Riegl at the turn of the nineteenth and twentieth centuries. In contrast to the purely 'optic', the haptic emphasises the tactile, the role of the hand and touch in visual art. Riegl's interest in the relationship between viewer and work of art led him to a theory of attentiveness; his thinking helped inform Otto Rank's seminal *Art and Artist*, of 1932. Rank wrote, for example, 'Artistic productivity, not only in the individual, but probably in the whole development of culture, begins with one's own human body and ascends to the creation and artistic formation of a soul-endowed personality' (Rank, 1932, p. 355. See also Wikipedia entry, Riegl, viewed on 28 November 2019).

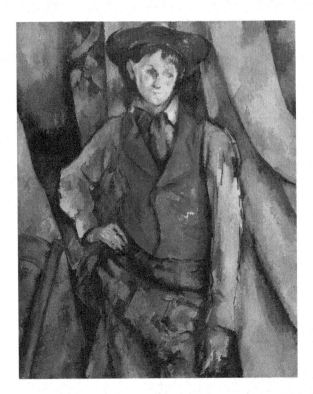

Illustration 1.11 Paul Cézanne, *Boy in a Red Waistcoat*, 1888–90. Oil on canvas, 89.5 ×
72.4. National Gallery of Art, Washington DC. Collection of Mr and Mrs
Paul Mellon, in Honour of the 50th Anniversary of the National Gallery
of Art. Accession No.1995.47.5. Open Access—Public Domain

of being with them, the *disturbance* of the meeting. This is certainly something
more than the merely retinal disturbance registered by the Impressionists in their
response to the way light gives the world colour. But if like the Impressionists
Cézanne had left behind the perspectival conventions of the Western Renaissance
tradition, his painting was still nourished by the Old Masters, Titian and the
sixteenth-century Venetian colourists in particular (look at the red of the boy's
waistcoat). Colour matters very much.

Where there is disturbance there is trauma. Christopher Bollas (1993) wrote of
the human face and form as both traumatising and 'evocative'—it 'calls' us, as the
philosopher Emmanuel Levinas said (Levinas, 1982) —but for this evocative qual-
ity to be realised the trauma of the encounter has first to be borne. 'Temperament'
is required. The painter would have 'known' this internally, unconsciously, and
felt it—and the transformation did not always seem to happen. But he'd know
when it had if the painting—whether of a person, an object or a landscape—
gave him back what we can legitimately call an 'aesthetic' experience, a sense of

tension-holding discovery, and of something brand-new coming to life. His conscious means for achieving this remained, in his maturity, the work of bringing patches, planes, and lines of colour into relation with each other (this last sentence seems to invite a 'merely'—as if this focus of Cézanne's effort were not also its central struggle).

In a breathtaking group of portraits, the gardener Vallier [illus. 1.12] is also seen in his element, outdoors—the first time Cézanne attempted such a thing with a living model. He is dappled with sunlight and seems to merge with his background, his world. He is a feature of his own field.

I also find myself thinking of a passage about mimicry and camouflage I once came across in a novel by Alfred Jarry, *Le Surmâle.* I must look it up. This unlikely pairing—Cézanne with his anarchic younger contemporary, creator of the monstrous Pa Ubu, inventor of 'pataphysics' (the science of imaginary solutions) —surprises me when it occurs to me. What to make of it?

Vallier's hands, his work tools, are central and it is as if his body grows and extends out of them. There is a sense of this in the *Woman with a Cafetière*, and something similar happens with the hands and bodies of other working people

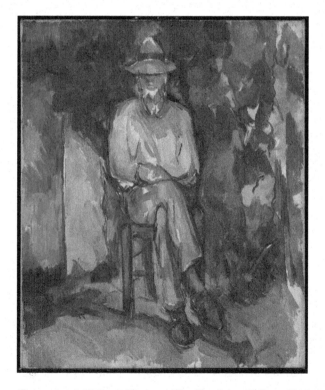

Illustration 1.12 Paul Cézanne, *The Gardener Vallier*, 1905–6. Oil on canvas, 65.5 × 55. Tate, London. Bequeathed by C. Frank Stoop, 1933. Image © Tate, London, 2020

painted by Cézanne during these last years. Turning to the catalogue, I find the art historian Elaine Scarry writing on Jean-François Millet's mid-nineteenth-century pictures of peasants; she notes 'the reach of sentience, and the unity of sentience with the things it reaches'. For Marx, writes Scarry,

'the activity of "making" comes to be the activity of "animating the world", either described as a willed projection of aliveness ... or a more passive occurrence arising from sheer proximity to real human tissue' (Scarry, 1985, pp. 246–8, cited in Elderfield, 2017, p. 36).

The portraits seem to place me in fundamental relation too. More than merely telling us about it, Cézanne is giving us an experience of 'sheer proximity', a sense of belonging within a shared bodily space, infused with human intentionality.

Perhaps sometimes the portraits can feel 'cold'. They do disappoint if one approaches them in search of expressions of human warmth and 'personality' (Cézanne's portraits struck Clark 'as putting the strange word "expression" to death'. Clark, 2018a, p. 13). But this is no reason to turn away. The catalogue points us towards a statement by the painter that might encourage us to take our time. 'One does not paint souls. One paints bodies; and when the bodies are well painted ... the soul, if they have one, the soul of every part shines and glows through' (Gasquet, 1921 and 1926, p. 131).

I am struck by the parallels with the therapist's task: not to start by trying to tease out or develop 'personality'—this will develop of its own accord—but rather to proceed through a conscientious description of things as they seem to be and to be coming into being, to be bodying forth. The patient/sitter is required only to appear, preferably in person, in whatever state. The analyst's challenge is to find ways of registering his/her 'sensations', and there may be times when the 'sensation' requires the painter/analyst to shift position or to intervene more actively to adjust the position of the sitter. But this would not be to invent but to assist at the emergence and birth of 'personality' or 'personhood'—in the language of psychoanalysis, of a 'true self' (Winnicott), or of 'desire' (Lacan). But in the end, both the painter's and the analyst's tasks are founded in respect for the inviolable otherness and mystery of the other. Who am I, each asks, to claim special knowledge of who, why, or how s/he is?

Later on, walking in an unfocussed sort of way up and down through the exhibition, I am taken by surprise to find myself among such human presences—all these primal, sometimes geometricised configurations of the face and upper body. They have a preternatural quality (I look this word up and find a lovely definition: 'suspended between the mundane and the miraculous', Douglas, 2007, p. 565, cited in Wikipedia). Is Cézanne giving us the pre-verbal infant's registration, among the earliest human perceptions, of the face and upper torso of the carer? Is it the moment of the first transformation of 'β' to 'α'—Bion's notation for the transformation of raw sensation to a world of feeling/thought? The earliest experience, at once traumatising and liberating, of the mother's unbearable beauty (Meltzer and Harris Williams, 1988, pp. 21–2), jolting us into life? Cézanne will not rush us into it. He seems already to have worked through some of the trauma for us. And if the figures in the paintings seem to breathe the same air, to share the

same substance as us, Cézanne can slow us down to the extent that we begin to feel we are of the same substance as the air itself. We are not just in an environment, we also are it.

Intrigued by the large 1902–6 indoor portrait of Vallier [illus. 1.13], I turn to Gasquet, who tells us, mythologically maybe, that the sitter was sometimes ill and did not turn up.

> Then Cézanne would pose himself. He put on the dirty old rags in front of a mirror. And thus, by a strange transference, a mystical substitution—which was perhaps unintentional— he mingled together in this profound painting the features of the old beggar with those of the old artist, both their lives at the confluence of the same void and the same immortality.
>
> (Gasquet, 1991, p.132).

Perhaps Gasquet is right when he claims to recognise a disillusioned Cézanne under the battered cap and 'the wretchedness of a great soul deceived by his dreams and his art'. Shifting his perspective, he also sees 'a softened heart, a trusting look from the poor man who sees fraternal alms coming to him from

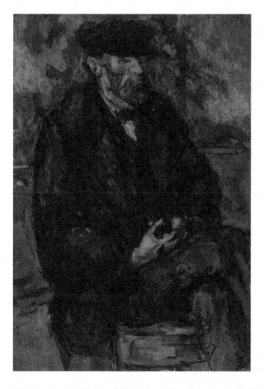

Illustration 1.13 Paul Cézanne, *The Gardener Vallier*, 1906. Oil on canvas, 107.4 × 74.5. National Gallery of Art, Washington DC. Gift of Eugene and Agnes E. Meyer, Accession No. 1959.2.1. Open Access—Public Domain

the kind, rich man who may even envy him'. The sentimental overlay of this observation does not lessen the force of Gasquet's next comment, that the portrait is a 'moral testament'. 'By infusing his soul with that body, with that face, he drew from them, like Shakespeare, a sort of unconscious king' (Gasquet, 1991, pp. 132–4).

Cézanne points towards the 'moral testament' that analysis can become: a mutual bearing witness to sorrow, in which the individual suffering of each protagonist is transcended, universalised, in the way that Shakespeare universalised Lear.

2 The field idea

Genesis and evolution

'The psychoanalytic cure, as innovative as it may be in the history of interhuman relations, can have neither sense nor results unless it encounters and enters into relation with something pre-existent and fundamental in human existence', said Jean Laplanche (1992, p. 171)

agree ?

There is, for example, the question of whether birds are ever free from the fetters of the skyways, a question as old as human time. Around 1800, Friedrich Hölderlin wrote, 'free as swallows the poets are', the point being, as Hölderlin's translator Michael Hamburger noted, that swallows, migratory birds, are precisely *not* free, but subject to forces both within them and quite beyond them, just as poets and the rest of us are (Hamburger, 2003, p. xiv; Snell, 2013, p. 106). Only unlike swallows (at least as far we currently know), we are subject not only to evolution and genetics but also to language, metaphor, and culture. This is one way of thinking about the wider 'field' we share; thus, all schools of psychoanalysis recommend paying close attention to language. And this cultural field is not only given to us as something static we are born into; since it is co-created by us, it is charged, dynamic, and in constant transformation as a result of our actions.

Analytic field theory post-Bion transcends a model of human interaction and sociality in which one monadic subjectivity engages with another across some neutral ether. But it is a measure of the success of the Cartesian revolution in the seventeenth century that this view still has a 'common sense' quality about it; it has become a key and insistent feature of our Western 'social unconscious'. Even 'relational' psychoanalysis, which sees itself as a 'field' theory, ultimately subscribes to it: its paradigm is still one of bounded individuals, albeit individuals-in-relation.[1] Post-Bionian field theory, respectful of the 'I' and 'thou', is able to point to our profound implication with each other and with something bigger than

1 Ferro and Civitarese also critique the relational school—IRP, interpersonal and relational analysis—on the grounds that it too readily falls back on the supposed 'reality' of what the patient reports (see for example Ferro and Civitarese, 2015, pp. 87–91).

both of us, a 'body larger than our own' (Morgan-Jones, 2010, p. 225), without dissolving the individual or the sense of 'self' in some mystical merger.

In the first half of the twentieth century, the pioneering sociologist Norbert Elias developed an exemplary way of thinking about this from a social and historical point of view. Elias recognised that we are on problematic ground from the outset when we frame our thinking in terms of 'individual' and 'society'—as if we were not dealing with two convenient, culturally and historically determined, abstractions. The very notion of the individual, for Elias, was susceptible to socio-historical analysis. In his book *The Civilising Process*, first published in German in 1939, he argued that individualisation is a process that is embedded in a society which, in turn, has its own particular and evolving history. Socialisation and individuation are simultaneous; we are formed both by sociogenesis and psychogenesis. The 'social unconscious'—we shall return to this idea shortly—originates from both, and is thus personal *and* relational. Humans, far from being isolated entities struggling into relation with each other, are connected in 'figurations', chains of interdependency, of which we are not necessarily or even ever predominantly conscious. It makes far greater sociological sense, wrote Elias, to think of 'open people', in the plural, 'homines aperti', than the singular, closed individual, 'homo clausus' (see Lavie, 2011, pp. 155–75).

Post-Bionian field theory extends this thinking. Its psychoanalytic foundations were laid down in the 1960s, in the work of Madeleine and Willy Baranger, a French couple with backgrounds in the classics and philosophy. The Barangers moved to Argentina in 1946 and became members of the new Argentine Psychoanalytic Association. Following Enrique Pichon-Rivière, a founder of the APA and Willy Baranger's analyst, they were convinced of the essential unity of the psychological and the social, with all the socio-political dimensions of both. For Pichon-Rivière, psychoanalytic enquiry was always unavoidably group-analytic, even when only two people were present; the object of research was the 'interaction field' (Tubert-Oklander, 2011, p. 61). The Barangers' basic tenet was that the analytic situation, involving two people who are inevitably bound up with and complementary to each other, is by definition a 'dynamic field' (Baranger and Baranger, 2008; Civitarese and Ferro, 2013, p. 190 and note 1).

If the idea of the analytic field ultimately has its roots in the physics of the electromagnetic field (Bazzi, 2018, pp. 2–3), its pre-history would also have to include the work of the philosopher of science Ernst Cassirer (1874–1975), who was among the first to disseminate the new scientific insights more widely. Since the phenomena observed in modern physics are better explained in terms of the relationships between objects than of their inherent individual natures, other disciplines too, Cassirer thought, might usefully go beyond such 'substance' thinking (Cassirer, 1923, and see Canguilhem, 1952).

In psychology, the Hungarian-born Marxist philosopher Georges (György) Politzer challenged Freud's view of the unconscious as the individual repository of a hidden and 'true' reality. A 'psychic fact', for Politzer, was something that needed two actors in order for it to come into existence since it always arose out of a shared interpretation of a given narrative. Politzer thus conceived of a living,

active, and 'dynamic' unconscious, with the potential to connect the dreamer with an 'unforeseen' subjectivity (Politzer, 1928).[2] In a loosely parallel, independent development, the French philosopher and ethnologist Lucien Lévy-Bruhl (1857–1939), who exerted a considerable influence on Jung, also formulated 'psychic reality', and being itself, as a matters of 'participation' (Lévy-Bruhl, 1949).

Between the wars, the Gestalt theorists had determined that mammals and humans respond not just to individual sensory elements in the perceptual field, but to the whole context and its structural organisation. Drawing on his interest in Gestalt theory, the social psychologist Kurt Lewin, who influenced Norbert Elias among many others, became the single most important pioneer of field theory in psychology; indeed, all versions of analytical field theory can ultimately be traced back to him (Bazzi, 2018, p. 1). Bion himself was a careful student of Lewin's work (Torres, 2013b). Lewin postulated a psychic, affective field as a fundamental process (Lewin, 1942, p. 54, and 1997). The field, for Lewin, was made up of dynamic properties that underlie all psychic processes; his 'force-field analysis' was a means of charting these otherwise non-representable forces as they help or hinder movement towards a goal in a social situation (ibid., 1934). Lewin had studied under Cassirer; he also insisted, in a way that was analogous to quantum physics' understanding of the effects of observation on that which is observed, that the experimenter is never outside the experimental field. Experimenter and subject change the situation merely through being brought together; the subject or 'test person' shapes the development of the experiment (ibid., 1918); every observation of a phenomenon interacts with the instruments for perceiving and measuring it. The individual's sense of the totality to which she or he belongs—what Lewin called his or her 'life space'—can never be a matter of objective perception (ibid., 1918; 1943).

In a certain psychoanalytic understanding, the 'mechanisms' underpinning the mutual involvement of analyst and analysand are projective and introjective identification, key concepts developed by Melanie Klein. These too are non-representable and largely unconscious; Betty Joseph's work on transference as a 'total situation' (Joseph, 1985) was also fundamental, as was the work of the Argentinians Heinrich Racker and his student León Grinberg on the interplay of transference, counter-transference, and (Grinberg) counter-projective identification. Their compatriot José Bleger, who was also analysed by Pichon-Rivière, went further and identified the two-person analytic session as an active field in which phenomena are forever in the process of becoming. Bleger's concept of 'syncretic sociability' refers to the earliest levels of symbiotic dependence and affiliation between infant and primary carer, a state in which subject and object are not yet differentiated; it is pictured in the situation of a mother and child in the same room, the mother perhaps sewing and the child playing, the two indirectly, invisibly but distinctly connected (Bleger, 1958; 1963, and see Neri, 1998, pp. 53–4 and 172. This paragraph and the two preceding it are indebted to Bazzi, 2018).

2 Politzer was working in Paris in the 1920s; he had met Freud through Ferenczi in Vienna.

Analytic field theory received further and decisive stimulus from the inter-subjective psychoanalytic theories being developed in Britain, notably by W. R. Bion and by D. W. Winnicott. For Bion, as for Pichon-Rivière, the analytic couple was by definition always already a group.[3] In *Experiences in Groups*, Bion had developed the idea of 'basic assumptions', unconscious fantasies within the group that both worked to bind the group together and to structure its feelings, thoughts, and behaviours (Bion, 1961, p.153). Each individual member had a particular 'valency' for establishing emotional bonds, a 'spontaneous and instinctive (unconscious, automatic, and inevitable) capacity' (Civitarese and Ferro, 2013, p. 192).

But perhaps the basic assumptions are only a limit case for a great variety of unconscious social or socialising processes of which we are unaware, except in so far as they show up, like the tips of icebergs, in language, metaphor, literature, art, and dream, all of which are both common property and things we appropriate for ourselves and can to a greater or lesser extent call our own.

For Bion, dream and reverie are indispensable foundations for life itself. In his model of the mother-infant relationship, Bion saw the mother as, optimally, capable of receiving the baby's primitive terror of overwhelm and annihilation in such a way that this terror might be transformed and returned in a more bearable form; she achieved this process of metabolisation and transformation through her reverie, born out of her spontaneous unconscious capacity for establishing an emotional bond. This is what Bion termed 'containment', and it was, for him, what enables psychic growth to happen. For Winnicott, in a parallel and independent theoretical development, it did not even make sense to claim there was such a thing as a baby. 'There is no such thing as an infant', he famously stated, only a mother-baby dyad, for outside the mother-baby relationship 'there would be no infant' (Winnicott, 1960, p. 39, note 1). Individuality and self-consciousness, the sense of an integral 'I', are for later. Both Bion and Winnicott extrapolated from this very earliest of relationships an understanding of what needs to take place in an adult analysis. Both baby and patient must literally be 'dreamed' into life.

Thanks to Bion in particular, the Barangers, in turn, broadened their conception of the field and its life. They invoked the Kleinian word 'phantasy', which in their understanding

> is not the sum or combination of the individual fantasies of the two members of the analytic couple, but an original set of fantasies *created by the field situation itself. It emerges in the process of the analytic situation* and has no

3　In 1960, for example, Bion wrote that he wanted to 'work out the theory that interpretation is an attempt to relate an individual's peculiar and particular characteristics to the social group, because the analyst who makes it is a member of a group and so associates the individual with himself, and because interpretation is into the language of the group'.

(Bion, 1994, p. 138)

existence outside the field situation, although it is rooted in the unconscious of the members.

<div align="right">(Baranger, 2005, p. 62f., cited in Civitarese and
Ferro, 2013, p. 192, note 4, my italics)</div>

The 'field', in other words, is by definition something we unconsciously co-create and continually affect, but that also has a life of its own. Moreover, as Bion hypothesised in *Experiences in Groups*, there is a common reservoir of primitive mentality into which, in the group, the contributions of each member flow, 'and in which the impulses and desires these contributions contain can be satisfied' (Neri, 1998, p. 61).

Two further features are worth noting in this brief historical survey of the post-Bionian analytic field landscape: 'bastions' and 'characters'. The concept of 'bastions' is an aspect of the Barangers' work that has particularly drawn Ferro's attention: they are blind spots in the session, 'areas of resistance formed by crossed projective identifications ... an unconscious collusion of sorts with the analyst ... I found it crucial that the ramparts were created by the analytic couple' (Ferro and Nicoli, 2017, p. 87). Ferro goes on to summarise the work of another pioneering Italian theorist of the analytic field, Francesco Corrao. If Corrao considered the field to be 'the sum of the patient's and the analyst's internal group dynamics', it was also 'an extended group situation' in its own right' (Ferro and Nicoli, 2017, p. 87). If analysis involved not two people but a group, this group consisted 'of the characters that emerge in the session, thanks to the joint creation by patient and analyst'. Corrao introduced the idea of the analytic space as an 'unsaturated field', in which 'narrative transformations' between characters took place (Ferro and Nicoli, 2017, p. 87, drawing from Corrao, 1986); narratology, a discipline forged primarily in Italy by Umberto Eco, has thus also played a significant part in the development of contemporary analytic field thinking (Ferro, 2005a, p. 61).

It is important not to underestimate just how much analytic field theory has derived its impetus from group analysis. Norbert Elias and the founder of group analysis, S. H. Foulkes, had been colleagues in Frankfurt in the 1930s, and Foulkes seems to have owed more to Elias than he himself acknowledged (Lavie, 2011). Foulkes's 'foundation matrix' is a powerful tool for understanding transpersonal, supra-individual processes, and out of this has emerged the notion—complementary to that of the field but, I would argue, less elastic—of a 'social unconscious', both personal and relational. The psychoanalyst and group analyst Earl Hopper defines it in terms of 'the existence and constraints of social, cultural and communicational "arrangements" of which people are "unaware"' (the scare quotes indicating the complexities of our arrangements and depths of our unawareness. Hopper and Weinberg, 2011, p. xxx); there are parallels with the Jungian personal, cultural, and collective unconscious (Fariss, 2011). Others, such as Hopper's colleague Haim Weinberg, who like some contemporary neurologists conceptualises the mind as a process, go so far as to speak of the flow of information and energy between a social group's members as 'the mind of the social system', something that exists—like the field for the field theorists—as 'a matter of substance' in a

co-created transitional space (ibid., pp. xliv–xlv). Common ground between the 'social unconscious' and the 'field' might perhaps also be sought—although this is not a search I can undertake here—in the work of Pichon-Rivière, with his over-riding concern, both as an individual and a group psychoanalyst, for 'the interaction field' (Tubert-Oklander, 2011, p. 61). His influence on the idea of a 'social unconscious' and on the development of analytic field theory within individual practice has been seminal.

In 1995, in his book *Gruppo* (published in English in 1998 as *Group*, and as rich and fresh now as it was then), the Italian psychoanalyst and group analyst Claudio Neri provided a comprehensive and subtle summary of the field concept, which underlines the centrality of Bion's contribution (Neri, 1998, pp. 59–68 and 155–6). Perhaps Ferro had one-to-one analysis particularly in mind when, following a conference on Bion in Boston in 2009 that included 'a great work by Jim Grotstein' (probably Bion's greatest posthumous commentator), he 'formally announced the engagement between Bion's theory and the field' (Ferro and Nicoli, 2017, p. 86). They had in fact been coupling and growing together for many years, and we are, as Ferro writes, at least in the fourth generation of the field concept; it is itself an expanding, evolving, and provisional theoretical universe (ibid., pp. 69 and 90–1).[4]

To sum up, the field idea involves several related levels of meaning. It has been thought of both as a 'transpersonal container' and as a shared mental state (Neri, 1998, p. 59); it is a system both of synchronicity, in which time is 'condensed into the here-and-now' (ibid., p. 66) and of interdependence (ibid., pp. 66–8). It is fundamentally dynamic. Each element in the field, which includes the analyst and analysand, is in continuous and direct relation with every other element, and the nature of this relationship is constantly changing; the shifting identity of each element in the field is a given of its belonging within it. These parts or elements have no independent existence outside the field that they constitute together. The field itself is more than the sum of its parts; its properties are not attributable to the properties of its elements. Everything that takes place within it changes its state overall. It follows from this that the focus of analysis will be on the field itself and the transformations that are taking place within it, and on the way it changes and develops (Civitarese and Ferro, 2013).

The field idea is not easy to get hold of for those of us trained in object relations or more classical thinking, any more than Cézanne, or the idea of an expanding/contracting universe, is easy to grasp; there are times when it can feel almost impossible not to fall back exclusively on two-body, Newtonian, or indeed Cartesian thinking (Jung even suggested, in response to a question from the young Bion at the Tavistock in 1935, that our psyche may simply be incapable of thinking otherwise. Gatti and Neri, 2006, p. 198). For Ferro, the field idea is both a weak and a strong theory: weak in that (like Cézanne) it 'preserves a large space for change … foresees

4 In 2017, Ferro posited a fifth advancement of the field concept, 'the group dream-game' (Ferro and Nicoli, 2017, pp. 87–8).

painting also exists in & creates 'a field'

its transience ... and has a strong fascination for the new and unknown ... opens up to what we do not know'; and strong in that (also as with Cézanne)

> once you're within it, you get to know it, and to spend time with it, it becomes quite difficult to think as if Bion had never been born, or as if wolves did not exist, and as if we were ever at the origin of the study of the psyche. We know very little, however we've made a few little steps and we deserve to enjoy their fruits.
>
> (Ferro and Nicoli, 2017, pp. 89–90)

Part of what I want to explore is that it is just this, the 'field', that became Cézanne's subject, as if he wanted to paint the 'chain of dependency' itself. He was seeking, as no painter had before, to get to grips with both the world and our ways of being in and apprehending the world, and how the two are inseparable. In painting the mountain, he was painting the 'field' that held both him and it.[5] It was also, as we shall see, an ambition fraught with difficulty and contradiction.

Perhaps we can also now start to make sense of something else in our experience of Cézanne. Where patient and analyst create bi-personal, unconscious 'field fantasies' or 'couple fantasies', not reducible to expressions of merely individual instinctual or internal life, the painting too is always more than the sum of the contributions of painter and *motif*. There is a surplus, generative in itself, emerging out of the act of painting. And it is a new experience that keeps repeating once the painting is finished, in its every encounter with a receptive viewer. Perhaps this is a key dimension of what we might understand by the 'aesthetic'. The viewer undergoes a subtle change, and so, on closer acquaintance does the picture; even 'Cézanne' does not remain a fixed entity.

Merleau-Ponty

The Barangers' intellectual background also included, crucially, the work of the philosopher Maurice Merleau-Ponty, and one does not have to search far in Merleau-Ponty's work to see its importance for subsequent theories of the field. 'I am a field, an experience', he wrote, a system of relationships (Merleau-Ponty, 1945a, p. 473; Civitarese and Ferro, 2013, p. 191). Merleau-Ponty was profoundly concerned with the interdependence of subject and context, and with how identity is determined intersubjectively, through the mutual and constant influence of self and other. He exerted a profound influence on the work of Derrida; his teachings can be applied to the most advanced notions in contemporary psychoanalysis (Ferro and Civitarese, 2015,

5 To approach this from a two-body position: the mountain has no 'subjectivity', but Cézanne revealed it to have a mysterious internal life and structure of its own, and an 'unconscious', a history, geology, culture, agriculture.

pp. 152–3, in a chapter reprinted from Civitarese, 2014b). His monumental *Phénoménologie de la Perception* appeared in 1945; as early as this, reflecting on ordinary experience and without psychotherapy particularly in mind, he had defined the analytic field in a way that could hardly be improved upon:

> In the experience of dialogue, there is constituted between the other person and myself a common ground, my thought and his are inter-woven into a single fabric, my words and those of my interlocutor are called forth by the state of the discussion, and they are inserted into a shared operation of which neither of us is the creator. We have here a dual being, where the other is for me no longer a mere bit of behaviour in my transcendental field, nor I in his; we are collaborators for each other in consummate reciprocity. Our perspectives merge into each other, and we co-exist through a common world.
>
> (Merleau-Ponty, 1945a, p. 413)

He was describing not a desirable situation to be aspired to, but a simple phenomenological given. And further on in the book: 'I am an intersubjective field, not despite my body and historical situation, but, on the contrary, by being this body and this situation' (ibid., p. 525, both passages above cited in Friedman, 1964, pp. 200 and 201).

Merleau-Ponty indeed brought to philosophy an extraordinarily modern emphasis on the importance of our embodiedness in space, and this is central to his philosophy of perception and being. Space, for Merleau-Ponty, is something we are never outside. We are ourselves, rather, 'the null point or degree zero of spatiality'. 'I live it from the inside; I am immersed in it. After all, the world is around me, not in front of me' (Merleau-Ponty, 1964, pp. 58–9). He was acutely and unfailingly aware of the dynamic continuity of consciousness and our experience as embodied beings together in space and time; distinctions between 'subject' and 'object' start to dissolve. His radical and comprehensive critique of the cognitivist, Cartesian paradigm (at least as he needed to make rhetorical use of it) was a re-writing of 'I think therefore I am' so that it becomes 'I think therefore we are' and 'we think therefore I am'.

He sought to expose the fallacy of Descartes's notion of space as 'a network of relations between objects such as a third party ... would see it; or by a geometer reconstructing and hovering over it' (ibid., pp. 58–9.) 'Something about space', he wrote, 'evades our attempts to survey it from above' (ibid., p. 51). For Merleau-Ponty, space and time are not merely the given, to be taken-for-granted media within and through which we move, but properties that come into being together with us, inseparably from us (Civitarese and Ferro, 2013, pp. 2 and 190). 'C'est donc ensemble qu'il faut chercher l'espace et le contenu', he wrote; 'it is together that space and contents must be sought' (Merleau-Ponty, 1964, p. 66). Or in the terms Bion was to elaborate: container and contained are inseparable.

And Merleau-Ponty is a direct link to Cézanne. He had leaned on visual art, and on Cézanne in particular, in order to bring his thinking into focus. His seminal essay 'Le Doute de Cézanne', 'Cézanne's Doubt' (1945b and 1945c),

is a philosophical wellspring of Cézanne interpretation. With reason, and it will serve here, alongside Merleau-Ponty's extended essay and last published work, *L'Œil et l'Esprit* (1964), and his unfinished, posthumously published *Le Visible et l'Invisible* (1964a), to take us deeper into our appreciation of the nature and requirements of the field. 'Cézanne paints perception itself through the chaos of sensation', he wrote (Merleau-Ponty, 1945c, p. 15). And Cézanne, it has justly been claimed, 'is the archetypal painter for Merleau-Ponty. It could even be said his work "illustrates" Merleau-Ponty's model of perception' (De Mille, 2013, p. 102). But this also sounds a note of caution: we must be careful not to 'Merleau-ise' Cézanne *too* enthusiastically.

Merleau-Ponty is, in addition, a bridge between modern art and psychoanalysis. Modern art's effort, he wrote in 1960, has been 'to multiply systems of equivalence' (Merleau-Ponty, 1964, p. 71, my translation). 'Cézanne's Doubt' is partly a meditation on psychoanalysis, on which he is astonishingly astute, even ahead of the (psychoanalytic) times. Psychoanalysis, he wrote, is 'a hermeneutic musing, which multiplies the communications between us and ourselves', and as such 'better suited than rigorous induction to the circular movement of our lives'. It respects our 'freedom ... as a creative repetition of ourselves, always, in retrospect, faithful to ourselves' (Merleau-Ponty, 1945c, p. 25). As a formulation of biographical method, this is superb—particularly so where an artist of Cézanne's single-mindedness is concerned.

The body of the visible

> A Cartesian [wrote Merleau-Ponty] does not see himself in the mirror; he sees a mannequin, an 'outside', and he has every reason to believe that other people see him in the same way. But what he sees is not a body in the flesh, any more for him than it is for others. His 'image' in the mirror is an effect of the mechanics of things. If he recognises himself in it, if he thinks it 'looks like him', it is his thought that weaves this connection. The mirror image is in no sense him.
>
> (Merleau-Ponty, 1964, pp. 38–9)

This is the fundamental misrecognition of which Lacan wrote, developing his thinking on 'The Mirror Stage' (Lacan, 1960). Reading this passage in Merleau-Ponty brings to mind the strange deadness of Cézanne's self-portrait of c.1885 made from an old photograph (Elderfield, 2017, p. 111) [illus. 1.7]. For we are not or not only images or pictures of one another, memories, and mental pictures, but bodies in the world sharing our embodiment with each other and with the world.

Crucially, for Merleau-Ponty, we are both seeing and seen: 'my body is at one and the same time seeing and visible', and in looking at ourselves we recognise the 'other side' of our power as see-ers ('notre puissance voyante') (Merleau-Ponty, 1964, p. 18), and this is constitutive of our very selfhood:

> one is a self ... through the inherence of he who sees with what he sees, of he who touches with what he touches, of the feeling with the felt—a self, then,

which is caught between things, which has a front and a back, a past and a future.

(Merleau-Ponty, 1964, p. 19)

'It is by lending his body to the world that the painter changes the world into painting', the body understood not just as 'a piece of space' or 'a bundle of functions' but 'an interlacing of vision and movement' (Merleau-Ponty, 1964, p. 16). Vision proceeds from movement, of the eyes, the body. For 'The visible world and the world of my motor intentions belong totally to the same Being' (Merleau-Ponty, 1964, p. 17).

He elaborates, in this challenging and pregnant passage from *L'Œil et l'Esprit*, which one of Cézanne's outdoor portraits of Vallier would 'illustrate' impeccably:

Visible and mobile, my body belongs among things, it is one of them, it is caught in the fabric of the world and its cohesion is that of a thing. But, since it itself sees and moves, it keeps things in a circle around it, they are an annex or prolongation of itself, they are encrusted in its flesh, they are part of its full definition and the world is made of the same stuff as the body.

(Merleau-Ponty, 1964, p. 19. Appendix 2)

Merleau-Ponty will not settle for a concept of vision as an unquestioned, common-sense abstraction and just a physiological faculty.

Vision is caught or comes to be in things—in that place where something visible undertakes to see (là où un visible se met à voir), becomes visible to itself and in the sight of all things in that place where there persists, like the mother-water still present within crystal, the undividedness of the sensing and the sensed … Since things and my body are made of the same stuff, it means its vision must be made in some way in them, or maybe that their manifest visibility creates a double and secret visibility in my body. 'nature is inside us', said Cézanne.

(Merleau-Ponty, 1964, pp. 19–22. Appendix 2)

Seer and seen—with only some parts of my own body visible to me—I am a thing among things, participating with them in a sense that is not mystical, but in a way that might enable me to say 'the mountain sees me', because, he who sees being inherent with what he sees, it is the mountain that calls my seeing into being, generates seeing in me. The sensing and the sensed are ultimately undivided. Thus Merleau-Ponty could write of an 'internal equivalent', a 'carnal formula' for the presence of things (Merleau-Ponty, 1964, p. 22, and Appendix 2).

On one level, psychoanalysts know very well how crucial such awareness of embodied perception is. Edgar Levenson, for example, writing of the effort to get in touch with the meaning of the patient's emotional experience, wrote 'We embody it' (Ferro and Civitarese, 2015, pp. 64 and 67). Counselled by Lacan (1960), we must also be wary of the lures of the imaginary that may be lurking in such identificatory embodiment. But Merleau-Ponty is talking about something

more basic and profound than merely hysterical identification. In *Le Visible et l'Invisible* (1964a), he further elaborated his thinking on shared corporeality, on the world's encrustation in our flesh. The idea of the 'chiasm', an expansion of the notion of 'flesh', was developed in a chapter entitled 'L'entrelacs [interlacing, network]—Le chiasme'. It enabled him more surely than ever to transcend a naïve subject-object distinction.

> We say therefore that our body is a two-fold entity, a thing among things on the one hand, and on the other that which sees and touches them; we say, because it is self-evident, that it unites these two properties in itself, and its double belonging to the order of 'object' and to the order of 'subject' reveals to us some very unexpected relations between the two orders.
>
> (Merleau-Ponty, 1964a, p. 178)

One of these 'unexpected relations' is the fact that there is always a gap—'un écart'—between seeing and seen, feeling and felt, which prevents them falling into undifferentiation, and preserves us from any hasty leap into the idea of mystical union. Instead, we have a mediating 'flesh', 'chiasm', a kinship through which communication—with all the surprises it may hold in store for us—is possible. As a commentator on Merleau-Ponty has put it:

> The generality of flesh embraces an intercorporality, an anonymous sensibility shared out among distinct bodies: just as my two hands communicate across the lateral synergy of my body, I can touch the sensibility of another: 'The handshake too is reversible' [Merleau-Ponty, 1964a, p.184; 1964b, p.142] … the sentient and sensible never strictly coincide but are always separated by a gap or divergence (écart) that defers their unity. Chiasm is therefore a crisscrossing or a bi-directional becoming or exchange between the body and things that justifies speaking of a 'flesh' of things, a kinship between the sensing body and sensed things that makes their communication possible.
>
> (Toadvine, 2016, no page number)

And now something that is so obvious in late Cézanne leaps into focus. There is throughout his mature work a sense in which all elements or characters in the field participate with another, not only through graphic interpenetration, but 'chiasmically'. Cézanne paints the 'chiasmic' space between his eye and the mountain; he called it the 'envelope'. Consider one of those late paintings of the Montagne Sainte-Victoire [cover, and illus. 1.9]: it is as if the air itself, while never taking on the full solidity of the rock or the trees, becomes through the skein of coloured brushstrokes the fleshly agent that palpably both divides and unites. He is the painter of the intermediate world and of intermediate space, to which, for Civitarese, psychoanalysis also belongs: transferential (Freud), transitional (Winnicott), 'something between' (Bion), 'intersubjective third' (Ogden), and field (Ferro) (Civitarese, 2019, p. 55).

There is a striking parallel too between Merleau-Ponty's 'chiasm' and Bion's idea of the 'caesura', to which we shall return: a similar gap, both separating and linking, that is created whenever two minds come together, and the investigation of which, for Bion, is fundamental and mandatory.

Subject and object, in Civitarese and Ferro's summary, are not distinguished from each other, but dialectically correlated.

> Rather than existing as positive entities, pure presences-in-themselves, except in an abstract sense, they mould each other in an incessant, fluid to-and-fro traffic of sensations regulated by the 'porosity of the flesh'. Subject and object co-originate in a primordial medium to which both belong. Touching something is, at the same time, being touched. Our sense of the world is not only an intellectual content, and cannot dispense with our experience of our bodies; it stems from our fleshly existence and is present even before a consciousness of self forms.
>
> (Civitarese and Ferro, 2013, p. 191)[6]

Such was the basis on which Merleau-Ponty could assert that he *was* a field, an experience (Merleau-Ponty, 1945a, p. 473.) Perceiving, mobile, and embodied, we are the field to which we belong, and this field, as Cézanne's painting teaches, is immeasurable in Cartesian terms. But if it is true that our sense of the world is not an 'intellectual content' that can dispense with our experience of our bodies, Merleau-Ponty's later work also highlights the fact that our intercorporality, that 'anonymous sensibility shared out among distinct bodies' (Toadvine, 2016), allows us to touch the sensibility of another. 'Sensible flesh—what Merleau-Ponty calls the "visible"—is not all there is to flesh, since flesh also "sublimates" itself into an "invisible" dimension: the "rarefied" or "glorified" flesh of ideas' (Toadvine, 2016). Thoughts, ideas, feelings, are also products of the interpersonal, intercorporeal field, and agents or, as Ferro and Civitarese will say, 'characters' within it.

6 'The patient-analyst relationship is inevitably dialectical', wrote Christopher Bollas, 'as each participant destroys the other's perception and rhetorical rendering of events, to create that third intermediate object, a synthesis, that is owned by neither participant and objectifies the loss of omnipotent wishes to possess truth just as it situates the participants in that collaborative place from which the only analytically usable truth can emerge'.(Bollas, 1993, pp. 112–13, and p. 99).

3 The painter and the field

Conversations with Cézanne

[handwritten note: × Like moving pointing around in Fr. Dahoe]

Bion with Cézanne

Bion's theorising, as Ferro and Civitarese (2015) remind us, was very close to Merleau-Ponty's (although he did not directly draw upon it). But Bion's relationship to Descartes significantly diverged from Merleau-Ponty's. Descartes had come to the conclusion that there is no reliable clue to distinguish waking from sleep:

> considering that all the same thoughts which we have while awake can come to us while asleep without any one of them being true, I resolved to pretend that everything that had ever entered my head was no more true than the illusions of my dreams.
>
> (Descartes, 1637, p. 28)

There is constant overlap between waking and dream in Bion's thinking; Descartes's methodical doubt was a crucial part of Bion's intellectual background (Civitarese, 2008, pp. 1126 and 1127).[1]

Where Merleau-Ponty has probably been Cézanne's most influential twentieth-century commentator, between Bion and Cézanne there are close personal parallels.

Both Cézanne and Bion insisted on an absolute refusal of intellectual preconceptions and on a form of submission, and this they share with the phenomenologist Merleau-Ponty. The painter, said Cézanne, can never be too 'scrupuleux … sincère … soumis'. He must 'adapt his means of expression to his *motif*. Not bend it to his will, but bow himself to it. Let it be born, germinate in you' (Gasquet, 1921 and 1926, pp. 119–20). 'Scrupulousness with regard to ideas, sincerity toward oneself, submission before the object … absolute submission to the object … To work without believing in anyone, to become strong. Everything else is

1 Revisionist readings of Descartes, for example Baker and Morris (1996), have questioned entrenched readings of 'Cartesian dualism' that have made it hard to discern other patterns of thought in his work. Civitarese (2008), and phenomenologists from Heidegger to Levinas, have sought to reinstate the importance of embodied sensation in Descartes's philosophy; for a critique of the phenomenological account, see Mehl (2018).

[handwritten annotations in top margin: "tremendous emphasis — on avoiding the I know or expected)"; left margin: "th bih"]

hogwash' (Gasquet, 1921 and 1926, p. 151. Appendix 3). 'Paul Cézanne placed himself before nature with a commitment to *forget everything*' ['avec le parti pris de *tout oublier*'], and it was at this point that his discoveries began, discoveries … that amounted to a revolution' (Bernard, 1904, p. 33).

Bion shared Cézanne's 'restlessness, his wild exploratory tendencies, his unwillingness to adopt the received ideas of his day', as Dore Ashton wrote of the painter (Ashton, 1980, p. 31). Bion, for example, famously demanded that the analyst should 'aim at a steady exclusion of memory and desire' rather than concern herself with 'generalized theories imperfectly "remembered"' (Bion, 1967, p. 16).[2]

Each was profoundly sceptical about routinised, schooled, merely technical and theory-based approaches: 'skill abstracts, it ends up desiccating, its rhetoric worn out and stultifying', Gasquet reports Cézanne as saying (Gasquet, 1921 and 1926, p. 114). 'He knows that it is only within life that the soul dwells, and theory and abstraction slowly dry the artist out, as surely as do manual skill or the uninspired execution of craft' (Bernard, 1907, p. 50). '[I]f the *laws* of art are fertile, studio *recipes* are deathly, and it is only through contact with nature and constant observation that the artist is a creator' (Bernard, 1907a, p. 80). Bion wrote of 'Respectable, shoddy, worn-out psycho-analytic mental, "reach-me-down" mental clichés for the dead-from-the-neck-up!' (Bion, 1991, p. 66).

Each used a language that could be challenging and opaque. Cézanne 'expressed himself in the elliptical and sometimes obscure language of the solitary' (Rivière and Schnerb, 1907, p. 86). In later life especially, both Cézanne and Bion had reputations for difficulty, intransigence, and eccentricity. Cézanne described himself at the end of his life as 'l'entêté macrobite', which could translate as 'stubborn old man hanging on beyond his time' (Letter to Bernard, 21 September 1906, cited in Doran, 1978, p. 48), and smart, artistic circles in Paris around 1906 considered him 'absolutely intractable', no dealing with him (Osthaus, 1920–21, p. 100). Even supporters could be damning. 'Cézanne has no knowledge of the human body', wrote Emile Bernard. His forms 'are illogical because ignorant and without foundation' (Bernard, 1907a, p. 63).

Bion, if we are to judge by some reactions to *A Memoir of the Future*, was also lost in his own world to the point of derangement: 'mixing and blurring categories of discourse, embracing contradictions, and sliding between ideas rather than linking them... his late thinking becomes less boundaried … the texts too open, too pro- and e-vocative, and weakened by riddling meanings' (O'Shaughnessy, 2005, pp. 1523 and 1524).

(Bion's text, wrote Giuseppe Civitarese, 'is constructed in such a way as to generate, in the reader, the experience described in it'. Language is 'pressed into performative use' [Civitarese, 2008, p. 1132]. What an excellent starting point from which to approach Cézanne.)

2 Cézanne: 'To give the image of what we see, forgetting everything that appeared before'.
 [Gasquet]: Is it possible?
 Cézanne: I've tried … Who knows? Everything is so simple and so complicated' (Gasquet, 1921 and 1926, p. 113).

At the core of Bion's revolution is the idea of transformation not through insight, arrived at by means of interpretation, but through developing channels of communication within the patient and between patient and analyst. 'At the core of the Cézannian revolution', wrote the painter's biographer Alex Danchev, 'is a decisive shift in the emphasis of observation, from the description of the thing apprehended to the process of apprehension itself' (Danchev, 2012, p. 338).

Cézanne and Bion each rejected the idea of himself as a master. 'Ne m'appelez pas maître', snapped the painter to Gasquet (Gasquet, 1921 and 1926, p. 127). Cézanne turned his back on the Parisian art world, where, in theory, he might have founded a 'Cézanne school', preferring the independence and relative seclusion of Aix. Bion, rather than 'sink without trace under the weight of decorations' (Bion, 1970, p. 78), abandoned London for Los Angeles.

In their attitudes to theory, each sought universality and certainty, while aware that both these things would always be out of reach. One might instance Bion's 'Grid'—his attempt at an algebraic tabulation of all the possibilities of the analytic encounter—and his later attitudes to it. 'As soon as I had got the Grid out of my system, I could see how inadequate it is ... only a waste of time because it doesn't really correspond with the facts I am likely to meet' (Bion, 1980, p. 56).

Bion's grid and Cézanne's wish 'to make Impressionism into something solid and durable like the art of the museums' (Denis, 1907, p. 170) were ambitions of a similar order. Cézanne described certitude as his

> principal hope ... Every time I attack a canvas, I am sure, I believe it will be there ... But then all of a sudden I remember I have failed every other time ... I never know where I'm going or where I'd like to go with this blasted métier. It brings all your theories to grief.
>
> (Gasquet, 1921 and 1926, p. 147)

Both painter and psychoanalyst died while still working. 'I want to die painting ... to die painting', Cézanne is said to have declared (Gasquet, 1921 and 1926, p. 161). Cézanne is routinely hailed as no less than the Father of Modern Art. Both he and Bion came to be seen, not long after their deaths, as founding fathers, primitives, to paraphrase Cézanne, of the new. With Bion, wrote Ferro, 'nothing is as it was before' (Ferro, 2019a, p. 56).

Both, finally, put a premium on truth. 'He did not have the idea of beauty in him, only that of truth', the painter Emile Bernard said of Cézanne (Bernard, 1907a, p. 58). 'I wish to be true ... like Flaubert ... wrest the truth from everything' (Gasquet, 1921 and 1926, p. 154). For James Grotstein, a 'truth drive' underlay 'the hidden order that runs through the whole of Bion's work' (Grotstein, 2007, p. 52).

In one of his most quoted sayings, Cézanne told Bernard: 'I owe you the truth in painting, and I shall tell it to you' ['Je vous dois la vérité en peinture, et je vous la dirai'] (Cézanne, Letter to Bernard, 23 October 1905, cited in Doran, 1978, p. 46). But there is paradox and ambiguity about this. Jacques Derrida anatomised it in the introduction to his book *La Vérité en peinture* (Derrida, 1978, pp. 6–8).

Did Cézanne feel he owed Bernard a verbal account of the truth of painting ('I shall tell it to you')? Or was he putting himself under an obligation to tell the truth in and by means of painting itself? Or was it some truth inherent in the very activity of painting that he was promising to reveal, not the truth it could tell about the world it depicted, but the truth of its own being and function as part of the world? These problems have a profound bearing on our discussions, on a 'hidden order' within what the activity of psychoanalysing generates, and a truth that cannot be assumed, post Bion, to reside solely in what is said or shown.

Both insisted on fidelity to their experience and perceptions. In his later life, Cézanne would refer to his 'petite sensation' as his most valued possession (and once accused Gauguin of trying to steal it. [Denis, 1907, p. 180]). 'To paint', said Cézanne, 'is to record your coloured sensations' (ibid., p. 178). But what exactly was he talking about? Merely the impact of colour on the eye and brain? Or was the 'little coloured sensation' a feeling or sense in the psyche-soma, in the fingertips, perhaps, or the scalp or the forearms? Might it, as Cézanne himself sometimes hinted, also have been a question of synesthetic experience, in which, for example, the colour purple might be like a bell ringing, and/or of associative links, in which purple might evoke the ringing of a particular *church* bell? Was he pointing towards an 'expressionist' theory of colour, according to which it elicits in the viewer an emotion or state of mind shared by the painter? Was he perhaps referring to the totality of his experience in front of the sitter or motif? Was the 'petite sensation' something like a dream or reverie, giving access to an arena of primitive experience before or beyond words?

Bion and Cézanne, the sublime and Bergson

There are two further noteworthy areas of common ground between Bion and Cézanne. Firstly, the links of both with the aesthetic category of the sublime. In an important article of 2014, Civitarese explores in depth and detail how a number of Bion's most important concepts—'O', negative capability, nameless dread, the infinite, the 'Language of Achievement' (more on this later), unison—can be traced back to this aesthetic paradigm; it is a 'secret model', a matrix that reveals these concepts to be dynamically interrelated and works to make them more intelligible. Civitarese notes too that historically, especially around the turn of the eighteenth and nineteenth centuries, the late Enlightenment and Romantic era, the feeling of the sublime was provoked not only by the spectacle of nature at its most dangerous, 'snowy peaks, active volcanoes, impenetrable forests, deserts, fearful precipices, grand ruins, abysses, stormy oceans', but also by everyday objects,

as when bottles and items of china are arranged on a table to project their shadow onto the background of a painting, or in those examples of still life in which the fruit is painted at its highest point of maturity,

(perhaps some of the fruit in illus. 3.1, for example). In his early scenes of rape and murder, Cézanne had certainly plunged into some of the more dramatic

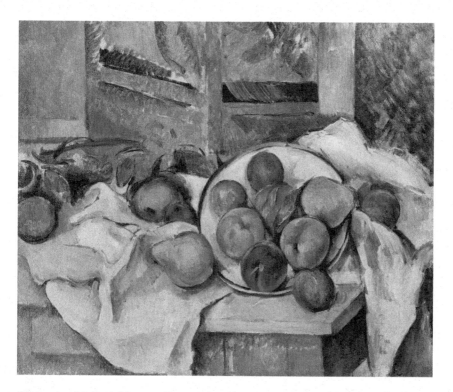

Illustration 3.1 Paul Cézanne, *Un coin de table*, c. 1895. Oil on canvas, 47 × 56.5. Barnes Foundation, Philadelphia. BF711. Public Domain

manifestations of the sublime, 'the darkness, fog, night, the unconscious, madness' that Civitarese also notes as among its aspects (Civitarese, 2014a, p. 1062), before turning his attention to still lifes arranged on a table.

Civitarese's understanding of the subject matter of the sublime is that it is 'a conflict between the sensible and the super-sensible, between the natural and moral existence of man' which if faced successfully—as, arguably, Cézanne faced it in his transition from violent sensuality to still life—helps us make ourselves

> independent of the object to which we are irresistibly attracted. The experience of the sublime in art is therefore a victory over the subjugating power of the object. The emotion of the sublime—the terrible beauty, the horror rendered thinkable by art—consists after all in the subject placing ... himself at a safe distance from a real that is experienced as threatening.
>
> (Civitarese, 2014a, p. 1085)[3]

3 It thus becomes possible to establish 'a meaningful space for vision that reflects the relationships with the primary objects and becomes in addition a set of preconceptions for successive experiences' (Civitarese, 2014, p. 1085).

For Philip Shaw, an art theorist and historian writing in 2013, the sublime in Cézanne is closely linked to Nietzsche. A 'realisation of the otherness of nature', Cézanne's is a version of the sublime 'freed from the fiction of self-realisation' (Shaw, 2013, no pagination). This too is ground that we shall be revisiting.

The second area of shared background between Cézanne and Bion is the philosophy of Bergson, and the painter's and the analyst's exposure to it. Born in 1859, Henri Bergson was one of the most famous French philosophers of the later nineteenth and first half of the twentieth centuries, influencing Merleau-Ponty as well as thinkers from Levinas and Sartre to Deleuze and Foucault. Central to Bergson's philosophy was the idea of 'durée', duration, first taken up in 1889 in his doctoral thesis *Time and Free Will: An Essay on the Immediate Data of Consciousness*. For Bergson, while the data of consciousness are multiple, our experience is continuous; it is merely for practical expediency that we rationally break down perception and experience into discreet units; for intellect 'congeals into distinct and independent things the fluidity of a continuous undivided process' (Bergson, 1896, p. 123). Intellect does not give us an account of lived reality but works to obscure it, and can stand in the way of us 'living' our experience.

Cézanne's interlocutor Joachim Gasquet would, like many of his generation, been steeped in Bergsonism, but we shall see how Bergson's ideas on 'durée' may have informed Cézanne's work more directly. These ideas feed into two important features of Bion's thinking, to which we shall also return: 'O', his notation for ultimate, unknowable reality, and the mentally and existentially freeing potential of transcending the caesura between all kinds of expediency-driven conceptual dualities (from back-front to body-soul).

Bergson directly addressed one such duality himself, matter/mind, developing a form of panpsychism, the notion that matter has all the ingredients of mind embedded in it: 'living matter, even as a simple mass of protoplasm, is already irritable and contractile, that it is open to the influence of external stimulation, and answers to it', he wrote in *Matter and Memory* (Bergson, 1896, p. 17); what we ordinarily call *mind* and *consciousness* are

> nothing else than differentiated, complex and specialised forms of movement and memory … universally present in reality as a whole … Bergson considered matter as the lowest degree of mind: hence matter and mind were not different substances, they had the same basic properties.
>
> (Torres, 2013a, p. 63)

Primed by Merleau-Ponty's insistence on our constitutive embodiment,[4] and with Bergson's further prompting, we are arriving at something of central importance. Something 'mysterious … entangled in the very roots of being, in the impalpable source of all sensation' (Gasquet, 1921 and 1926, p. 111), as Gasquet put it.

4 Merleau-Ponty's philosophy was itself in many ways a long engagement with Bergson. See Olkowski (2002).

Grotstein's idea
about ag... incl.
The proto-mental *curiosity*

Bion's biggest contribution to the development of analytic field theory was precisely in the area he called the 'proto-mental system' or 'proto-mental matrix'. Bergson was very much part of the background to this. Bergson proposed the existence of mentality and adaptability in a mass of protoplasm that is able to respond to the physical environment; it is a small step from this to Bion's idea of proto-mental phenomena that are responsive to the social environment (Torres, 2013a, p. 63). More immediately, Bion developed his concept of a proto-mental matrix from his work in groups; he used it to evoke the primitive mentality, the common reservoir, which determines the basic assumptions. The proto-mental system was where currently inactive basic assumptions are accommodated, and in it,

> physical and psychological or mental are undifferentiated. It is a matrix from which spring the phenomena which at first appear—on a psychological level and in the light of psychological investigation—to be discrete feelings only loosely associated with one another. It is from this matrix that emotions proper to the basic assumption flow to reinforce, pervade, and, on occasion, to dominate the mental life of the group. Since it is a level in which physical and mental are undifferentiated, it stands to reason that, when distress from this source manifests itself, it can manifest itself just as well in physical forms as in psychological.
>
> (Bion, 1961, p. 102, cited in Civitarese
> and Ferro, 2013, p. 193)

The proto-mental is what links group members in a common psychological situation. Claudio Neri has used the metaphor of a mushroom field, in which all the individual mushrooms are linked by a system of tendrils below the ground.

> Observing a mushroom-bed one sees the individual fungi separated from each other and scattered over a large area of ground but an infra-red photograph would show not the fungi, but the network joining them. The 'network' of the proto-mental system is not directly visible but if it is damaged, the damage appears in the suffering or ailing of one or more of the elements (the fungi scattered over the ground).
>
> (Neri, 1999, p. 86, and see Gatti and Neri, 2006)

Recent discoveries in the study of belowground ecology lend the metaphor even greater power. There exists in forests a subterranean network of tree-fungus mutualism—nicknamed the 'wood wide web'—within which trees are able to share and move resources between them, thanks to the interfacing action of certain common (mycorrhizal) fungi (Macfarlane, 2019, pp. 89–91). Other researchers now insist that a fundamental shift in our scientific outlook is needed, towards a view of humans as part of the physical and cultural ecosystem. We may need a new language for this, one not shaped to our values, a language, perhaps, of

spores (ibid., pp. 110–11). The self as a closed system is a delusion; our atoms ultimately come from the fusion of hydrogen and helium in the Big Bang, many from the outer reaches of the universe (Oliver, 2020; Kerridge, 2020). Or as Gasquet reported Cézanne putting it: 'We are all, beings and things, just a little solar heat that has been stored up and organized, a memory of the sun, a little phosphorus burning in the tissues of the brain' (Gasquet, 1921 and 1926, pp. 111–12).

Civitarese and Ferro summarise.

> It will be seen that, already for Bion—who was here absolutely in unison with Merleau-Ponty—the subject cannot be thought of except on the basis of the intrinsic intersubjective dimension of the proto-mental system, of the area of 'initial biopsychic emergence' [Fornaro 1990, p.20, translated]. ... Mental life extends beyond the physical boundaries of the individual; it is 'transindividual'.
>
> (Civitarese and Ferro, 2013, p.193)[5]

What is more, the ultimate inseparability of the physical and the mental may have a correlation in our interlinkedness as human beings: 'the (relative) absence of a distinction between mind and soma in the individual is in some way correlated with the background of a substantial (relative) absence of distinction between individuals' (Civitarese and Ferro, 2013, p. 193).

Bion's intuition, first elaborated during the period of *Experiences in Groups*, was that human mental capacities emerge from the continuous inter-action of biological nervous system activity with group dynamics (Torres, 2010, p. 54).[6] The individual's proto-mental system cannot be studied in iso-lation from the proto-mental matrix of the group. The Freudian unconscious,

5 Civitarese has often found himself drawn to Heidegger, because 'in his existential analysis there can be found a radical and definitive critique of the limitations of thinking about the subject as iso-lated' (Civitarese, 2008, p. 1076, note 10). But from a radical Heideggerian perspective, the very notion of 'intersubjectivity' is questionable. Our '*Mit-sein*, our being-in-the-world-with-others, is not one "world" or "dimension" of being human. It is what being human *is*'. *Mitwelt* is *not*, Heidegger insisted in the second Zollikon seminar with Martin Buber on 3 February 1960, 'the "intersubjectivity" that existential therapists confusedly talk about. Heidegger's lifelong quest was to describe the human being as *Da-sein*: not as a "subject". There can be "intersubjectiv-ity" only where there are "subjects". That is a degenerate way of being-with' (Stadlen, 2020). A thoroughly Heideggerian confrontation with post-Bionian field theory would be an invaluable undertaking. Such a confrontation might also be extended to encompass the post-Heideggerian, post-structuralist 'death of the subject', as variously elaborated in the works of Barthes, Foucault, Derrida, Althusser, Butler, and many others (Heartfield, 2006).

6 Proto-mental phenomena 'are a function of the group' (Bion, 1961, p. 103) and part of its func-tioning. This must be true of Cézanne's 'petite sensation' too. For how otherwise would his work have spoken as it did to his younger contemporaries—to painters like Bernard and Denis, not to mention Picasso, Braque, Matisse, Bonnard—and have continued to resonate as powerfully as it has?

in contrast, only locates such forces in the individual unconscious; the revo-
lutionary implications of what Bion had to say thus include a revised devel-
opmental story:

> The subject is formed on the basis of a substrate of anonymous, prereflective,
> and prepersonal intersensoriality/intercorporeality even before any actual
> self-reflective capacity exists. An albeit still obscure precategorial back-
> ground which, however, does not lack meaning, paves the way for the entry
> of the transcendental ego on to the world stage … Our sense of the world …
> stems from our fleshly existence and is present even before a consciousness
> of self forms.
>
> (Civitarese and Ferro, 2013, pp. 190–91)

It is a background in which 'the social, the biological, and the emotional are indis-
tinguishable, all mixed up, and unable as yet to produce a thought-object' (Gold,
2018, no pagination).

In a parallel formulation, the philosopher and psychoanalyst Julia Kristeva has
borrowed the word 'chora' from Plato's *Timaeus* to denote this primal, preconcep-
tual space. It is an equivalent to Winnicott's 'maternal environment', the universe
of the mother's body, a world of multiple and relatively undifferentiated sensa-
tion that is plethoric, alarming, wondrous, in constant flux. Kristeva imagined the
baby's intra- and post-uterine experience of the mother's inchoate sounds, heart-
beats, rhythms, gurglings, rumblings, and she termed this the 'semiotic' (a source
perhaps of Ferro and Civitarese's occasional use of the term), the raw material out
of which language and speech would eventually form, the background noise of the
symbolic (Kristeva, 1976 and 1980, p. 133; Grosz, 1986).[7]

7 From Milton, *Paradise Lost*, Book II:

> the hoarie deep, a dark
> Illimitable Ocean without bound,
> Without dimension, where length, breadth, and highth,
> And time and place are lost; where eldest Night
> And CHAOS, Ancestors of Nature, hold
> Eternal ANARCHIE, amidst the noise
> Of endless warrs and by confusion stand.
> For hot, cold, moist, and dry, four Champions fierce
> Strive here for Maistrie, and to Battel bring
> Thir embryon Atoms; they around the flag
> Of each his faction, in thir several Clanns,
> Light-arm'd or heavy, sharp, smooth, swift or slow,
> Swarm populous, unnumber'd as the Sands
> Of BARCA or CYRENE'S torrid soil,
> Levied to side with warring Winds, and poise
> Thir lighter wings. To whom these most adhere,
> Hee rules a moment; CHAOS Umpire sits,
> And by decision more imbroiles the fray

The findings of neuroscience and cognitive psychology point along similar lines. Antonio Imbasciati, for example, understands perception as far from a merely passive, receptive process, but something complex and active, involving the coding and decoding of a stream of 'afferent nervous impulses', a continuous stream of raw biological data, somatic information coming from all parts of the body and from the outside world, with no psychic meaning in itself (Torres, 2010, pp. 63–4).

From the semiotic to the semantic, in Bion's abstract notation, we are dealing with 'β-elements', primitive sensations, 'thoughts waiting for a thinker', 'preconceptions' that need a human home, that is, a transformative place in the mind of a mother capable of reverie, so that they can become 'α-elements', thought-objects, feelings linked to thoughts.

In analytic practice, as Thomas Ogden has said, when a patient goes into analysis, he, so to speak, *loses his own mind*. He reconnects with the re-established proto-mental area (Ogden, 2008, paraphrased in Civitarese and Ferro, 2013, p. 193). For growing from babyhood to child- and adulthood, moving from the 'semiotic' to the 'semantic', involves a 'loss' of the body:

> The body that is lost in rising to the concept is the body as a source of obscure and vague sensations. In this sense, to subjectify oneself does not mean to lose but to *take on* the body in the sense of adopting ... the 'sensible concepts' necessary to life.
>
> (Civitarese, 2019, pp. 3–4)

Ogden has added particular depth and richness to thinking about this pre-symbolic realm. It is where 'sensory-based units of experience [are] being organised ... preparatory for the creation of symbols'; Ogden's use of the phrase 'units of experience' is resonant. The process is mediated, he says, by the experience of Winnicottian transitional phenomena (Ogden, 1989, p. 49), and he developed this

> By which he Reigns: next him high Arbiter
> CHANCE governs all. Into this wilde Abyss,
> The Womb of nature and perhaps her Grave,
> Of neither Sea, nor Shore, nor Air, nor Fire,
> But all these in thir pregnant causes mixt
> Confus'dly ...
>
> (Milton, 1667, p. 40, lines 891–914)

And on how the artist might draw on this 'semiotic' chaos, there is this, among other passages from a wonderful 1927 study of Coleridge by John Livingston Lowes. In the 'bizarre pages' of Coleridge's Note Book, writes Lowes, we catch

> glimpses of the strange and fantastic shapes which haunted the hinterland of Coleridge's brain ... 'The Rime of the Ancient Mariner', 'Christabel', 'Kubla Khan', 'The Wanderings of Cain', are what they are because they are all subdued to the hue of that heaving and phosphorescent sea below the verge of consciousness from which they have emerged. No single fragment of concrete reality in the array before us is in itself of such far-reaching import as is the sense of that hovering cloud of shadowy presences. For what the teeming chaos of the Note Book gives us is the charged and electrical atmospheric background of a poet's mind.
>
> (Lowes, 1927, pp. 30–1).

thinking into the notion of what he termed the 'Autistic-Contiguous Position'. This is a form of psychic organisation associated with a

> specific mode of attributing meaning to experience in which raw sensory data are ordered by means of forming presymbolic connections between sensory impressions that come to constitute bounded surfaces.
>
> (ibid., pp. 49–50)

Here lies the origin of consciousness and the sense of self: Ogden is following Freud, for whom the ego (the 'I') is 'first and foremost a bodily ego'. In a footnote, Freud added that 'the ego is ultimately derived from bodily sensations, chiefly from those springing from the surface of the body' (Freud, 1926, p. 26).

By 'autistic', Ogden means to refer not to pathology but to the most primitive mode of psychological organisation; the word 'contiguous' catches 'the experience of surfaces touching one another ... a principle medium through which connections are made and organisation achieved' (Ogden, 1989, pp. 52–3). He is referring above all to skin; early sensation-dominated experience is also one of rhythmicity and, if all goes well, of increasing predictability and continuity, enabling a sense of the 'shape' and edges both of things and of experiences.

When there is some rupture in the functioning of the carer-/mother-infant dyad, there may be, in adulthood, the threat of a foggy 'annihilating shapelessness' linked to an insufficient 'feeling of sensory groundedness ... ordinarily provided by the interpersonal "touch" of our shared interpersonal experience of the world', with its crucial contribution to our feeling sane (ibid., p. 69). Like 'chiasm', Ogden's 'autistic contiguous' is 'the barely perceptible background of sensory boundedness of all subsequent subjective states', and of the possibility of a sense of connectedness with each other even across a distance. It is, crucially, not just a developmental stage but also a 'position' (ibid., p. 50). If this were not so, then the psychotherapeutic relationship could have no hope of becoming a 'healing sensory experience' (ibid., p. 52), and nor could art: for example, the way a landscape by Cézanne, with its rhythmicity, can introduce us to the clear atmosphere of Provence and lend restorative shape to our experience.

In a fine paper, the art historian Paul Smith has explored key terms such as 'sensation', 'temperament', and 'primitive' as Cézanne used them to evoke a sense of himself and of what he did. Another such term was 'child'. The painter's own understanding of the childlike rests in large part on Jean-Jacques Rousseau who, in *Emile; ou, De l'éducation* (1762), had suggested that a child's 'sensations' are imbued with pleasure or pain and therefore carry meaning. Indeed, for Rousseau, they go on to shape behaviour until, losing their grounding in sensuous experience, and increasingly emptied of meaning, they become mere habits and prejudices, susceptible as these also are to modification through our adult capacity for reason. A return to our 'primitive dispositions', the 'nature within us', can restore us to meaningful experience and a healthy life.

Smith's own thinking is guided by Wittgenstein, who restated Rousseau when he argued that our given or 'primitive forms of life' (Wittgenstein, 2009, pp. 11e, 16e)

are what make the more complicated forms of adult experience meaningful, even possible. Thus taking on the position of a child, writes Smith,

> makes it possible to return to a way of life that is not grounded in reasons (and hence the false beliefs that reasons are prone to contain) but in the instinctual dispositions and behaviours that we (to a great extent) all share as humans … Being a 'child' in this sense … can be a way to re-establish contact with ourselves that can then grow into new 'complicated forms of life'.
>
> (Smith, 2007, p. 52)

All this, Smith convincingly argues, is consistent with what we know of Cézanne's (self-) understanding (ibid.). As a devoted reader of Baudelaire, Cézanne would certainly have resonated too with the poet's famous dictum that 'genius is childhood recaptured at will' (Baudelaire, 1975–6: II, p. 684).

Merleau-Ponty's thinking about painting also centred on our bodily 'instinctual predispositions'. 'Quality, light, colour, depth, which are there before us, are there only because they awaken an echo in our bodies and because the body welcomes them', he wrote (Merleau-Ponty, 1964, p. 22). This was fundamental. Merleau-Ponty, who was also a writer on the psychology of children, goes on to use the bodily metaphor of rhythmical inhalation and exhalation to say this about the primal mix-up between subject and object, seamlessly connecting his thoughts to Cézanne:

> What we call 'inspiration' should be taken literally: there really is inspiration and expiration of Being, respiration within Being, action and passion so lightly discernible that it is impossible to tell who sees and who is seen, who paints and who is painted. We say that a human being is born the moment when something which, in the depths of the mother's body, was only potentially visible, simultaneously becomes visible for us and for itself. The painter's [and we might hope the analyst's] vision is a continual birth.
>
> (Merleau-Ponty, 1964, pp. 31–2)

As far back as 1945, he had noted how

> distinctions between touch and sight are unknown in primordial perception … The lived object is not rediscovered or constructed on the basis of the contributions of the senses; rather, it presents itself to us from the start as the centre from which these contributions radiate. We see the depth, the smoothness, the softness, the hardness of objects; Cézanne even claimed that we see their odour. If the painter is to express the world, the arrangement of his colours must carry with it this indivisible whole, or else his picture will only hint at things and will not give them in the imperious unity, the presence, the unsurpassable plenitude that is for us the definition of the real. That is why each brushstroke must satisfy an infinite number of conditions.
>
> (Merleau-Ponty 1945c, p. 15)

Thus

> Cézanne did not think he had to choose between feeling and thought, between order and chaos. He did not want to separate the stable things which we see and the shifting way in which they appear; he wanted to depict matter as it takes on form, the birth of order through spontaneous organisation.
>
> (Merleau-Ponty, 1945c, p. 13)

For Cézanne after 1890, wrote Merleau-Ponty, there was similarly no distinction between touch and sight (1964, p. 15). We touch instead on a 'primordial perception', a primitive, preconceptual, pre-visual body-sense, and it is I think what the German philosopher of aesthetics Alois Riegl had in mind when he formulated the idea of 'the haptic', a kind of seeing-through-touch that is more profoundly engaging than the merely optical. The elongated arms of the *Boy in the Red Waistcoat*, in Cézanne's portrait of 1888–90, may, I have suggested, be one striking manifestation of this [illus. 1.11].

> Other minds [wrote Merleau-Ponty] are given to us only as incarnate, as belonging to faces and gestures. Countering with the distinctions of soul and body, thought and vision is of no use here, for *Cézanne returns to just that primordial experience from which these notions are derived and in which they are inseparable.* The painter who conceptualizes and seeks the expression first misses the mystery—renewed every time we look at someone—of a person's appearing in nature.
>
> (Merleau-Ponty, 1945c, p. 16, my italics)

In essence, all visual art seeks this return to primordial experience. '[P]ainting's interrogation aims ... at this secret and feverish genesis of things in our body', said Merleau-Ponty (Merleau-Ponty, 1964, p. 30); this is why 'Cézanne could not convince by his arguments and preferred to paint instead' (Merleau-Ponty, 1945c, p. 13). Paintings, writes T. J. Clark, are not propositions, but 'an ordering of things more open and centrifugal—more non-committal—than grammar can almost ever countenance' (Clark, 2018b, p. 135). For Cézanne, of all painters, the door to this realm of the proto-mental and preconceptual was the act of painting itself, the silent conversation between hand, eye, canvas, and motif, and it was the pull towards it that made painting in the way he came to paint both possible and necessary, imperative. If he was organising 'sensory-based units of experience', there could hardly be a better description of his working process and its results than Ogden's: 'raw sensory data are ordered by means of forming presymbolic connections between sensory impressions that come to constitute bounded surfaces' (Ogden, 1989, pp. 49–50).

Out of the primordial, pre-social, pre-verbal matrix of preconception and proto-mentality, out of what Merleau-Ponty called 'a prespatial hinter-world' (Merleau-Ponty, 1964, p. 73), the figure, the apple and the bowl 'se forment d'elles-mêmes',

form themselves out of themselves. As Merleau-Ponty insists, Cézanne's late painting retains a sense of its history in the very roots of being.

But if generation is its potential, this primal, preconceptual realm can also threaten to overwhelm; there can be 'turbulence ... whirlwinds and sometimes ... tsunamis of β-elements', raw sensation (Ferro and Basile, 2009, p. 11). Once again, different analytic metaphors exist for this. Christopher Bollas has drawn attention to just how much the newborn and the child have to bear internally.

> To be a child is to endure a prolonged situation in which the human mind is more complex than the self can ordinarily bear. However puzzling the circumstances in our world, however disturbing our parents and others may be, our minds—in themselves—produce contents that will be overwhelming. To be successfully normal, then, we rather have to dumb ourselves down.
>
> (Bollas, 2016, p. 4)

Jean Laplanche made the idea of 'enigmatic signifiers' or 'enigmatic messages' central to his theorising: messages from the unconscious of the caregiver overwhelm the newborn's capacity to 'translate' them (Laplanche, 1987, p. 126). In the language of the cognitive psychoanalyst Antonio Imbasciati, it is the stream of 'raw afferent stimuli' (cited in Torres, 2010, p. 64). For Laplanche, such messages, untranslatable by the infant because they are sexual in nature, are partly repressed, and thus form the basis of the (essentially Freudian) unconscious. Otherwise, the accumulation of energy must be violently expelled, and perhaps this is what we witness in the violence of some of Cézanne's early paintings. In his late work, overwhelm of sensation is transformed and transcended, although he was also prone to great outbursts of rage. In his wish to connect with what felt to him most real and life giving, he was still 'willing to enter into states similar to psychosis, of turbulent infantile disablement' (Rhode, 1990, p. 6). It is a state of nameless dread, fear of death and dissolution, and not least of the death involved in being born into something new. 'The analyst himself, understandably, hesitates in venturing into these border territories. Death is frightening, and, even more, death leads to anguish regarding aspects that have never been "born"' (Ambrosiano and Gaburri, 2009, p. 128). It remains, however, 'an astounding truth that psychoanalysis can sometimes reach back ... to the primordial aspects in adults and perhaps restart development' (McCaig, 2019, p. 148).[8]

From sensation to transformation: the Bionian and post-Bionian model

We might now revisit and go a little further into the thinking that Bion brought to psychoanalysis and see how it leads into 'field' thinking. It is a revolution in

8 Paintings too can reconnect us to these revivifying primordial aspects, in so far as the painter's vision is 'a continual birth' (Merleau-Ponty, 1964, p. 32).

our understanding of what being human might mean. The summary that follows structures the next sections of the book.

The origins of Bion's thought lie in the experience of sensory and emotional overload, that is, of trauma, and it was no doubt stimulated by the traumata of his own earlier experience, above all as a young tank commander who lived through the full horror of the western front in World War I. But trauma is also ubiquitous, as analytic thinkers from Bollas to Laplanche have argued; it effects a closure of the mind; we have to 'dumb ourselves down' in response to a bombardment of sensation. This is the moment of Freudian 'primary repression' (Laplanche); in Bion's terms this closure is an 'attack on linking' (Bion, 1959), and there seems to be some evidence from neuroscience that a closure of this kind involves actual synaptical rupture, potentially leading to failure to develop, or real deterioration, a 'neurologically certain decay of mental faculty', as Bion put it (Bion, 1967, p. 16).

Psychoanalytic technique would, therefore, necessarily and primarily, seek to repair the channels of communication and connection themselves—'multiplying systems of equivalence', in Merleau-Ponty's phrase (Merleau-Ponty, 1964, pp. 71–2); such attempts should lead, in Bion's terms, to 'an increase in the number and variety of moods, ideas and attitudes seen in any given session' (Bion, 1967, p. 16). This can only be safely and successfully done in the presence of another who is capable of bearing the anxiety generated by the fear of a new tsunami of raw sensation, of reactivated trauma, like the mother who through her capacity for reverie metabolises the baby's terror so that it can be returned in a more bearable form. The listening other must be able to maintain her own internal and external connectedness, or be able to bear its temporary absence and trust in its return when the pressure is not so great as to put it in abeyance. And rather than seeking to expel or discharge it, she must be able to 'dream' it and find an appropriate (metaphorical, 'coloured') voice for it, and thus, in Bion's expression, 'contain' and transform what threatens to overwhelm.

This is why, for psychic growth to happen, baby and patient must literally be dreamed into life. The capacity to dream remains fundamental to development and life. Bion's great commentator James Grotstein encapsulated this in a sentence: 'The dreamer who dreams the dream is the ineffable subject of being'. To dream is to contribute to the growth of an internal container ('the dreamer who understands the dream'), just as the mother's reverie originally transformed the infant's torment into meaning (Grotstein, 2000, p. 46). Thus internalised, the container becomes an 'inner thinker unknown' (Amrosiano and Gaburri, 2009, p. 124).

The container and the process of containment generate new connectivity. In Ferro and Civitarese's conceptualisation, it is the 'field' itself that becomes the container. Thus, in post-Bionian theory and practice, the emphasis is on the construction and development of the interpersonal field itself, on facilitating the means for this rather than just listening out for symbols and meanings. Symbol, meaning, and content can take care of themselves—as they do in Cézanne's mature work. They are the patient's and the viewer's concern. Perhaps this is what Laplanche had in mind when he admonished analysts: 'Hands off! Hands off the patient's theories!' (Laplanche, 1992, p. 70).

Where symbol and meaning seem to insist, and threaten new closure and anti-gen-erativity, where they become, in classical analytic language, used as defences either by patient or by analyst or by both (and group becomes anti-group), Bion's instruction to the analyst was 'investigate the caesura' (Bion, 1977): since meaning and symbol, as we have learned from Saussurian linguistics, rest on binary distinctions, keep a question mark over the binaries and attend to the permeability of the dividing-and-uniting line itself between them. Such distinctions might include 'reality-dream', 'analyst-patient', and even analytic shibboleths like 'transference-countertransference'. This is absolutely required in order to nurture and keep the field open, the space that belongs to neither protagonist and to both, in which things might remain fluid, indeterminate, and mutative: a potential space, an atelier containing 'as much creative mess as we are able to tolerate' (Ferro and Civitarese, 2015, p. xvi).

Civitarese sums up the theoretical position:

> every event in the relationship does not belong to one or other of the two actors on the stage, but is merely, albeit to different degrees, a point of condensation of the forces pervading the field. In this way, Bion is referring to a symbiotic-fusional level of the setting, which is first and foremost characteristic of intra-uterine life, but which nevertheless continues to exist as a psychic dimension of transindividual functioning and participation in a formless and undifferentiated *basal* background of experience. This is the area which we describe, with different nuances of meaning, as the intersubjective matrix, the transitional space, the protomental area, the bipersonal field, or the group mentality.
>
> (Civitarese, 2008, p. 1132)

Negative capability

What else is needed to keep access to the generative 'field' open, and, at the same time, to help analyst/painter work with potentially overwhelming storms of sensation?

On the one hand, a wilful act of suspension, everything, in the language of psychoanalysis, that goes under the rubric of 'the analytic attitude', including perhaps its most radical and succinct statement, Bion's insistence on excluding conscious memory and desire (Bion, 1967, p.17 et seq.) because they are obstacles to deeper unconscious-to-unconscious connectedness. Bion supported this insistence with a powerful metaphor, that of a searchlight beam of darkness.

> Instead of trying to bring a brilliant, intelligent, knowledgeable light to bear on obscure problems, I suggest we bring to bear a diminution of the 'light'— a penetrating beam of darkness: a reciprocal of the searchlight. The peculiarity of this penetrating ray is that it could be directed towards the object of our curiosity, and this object would absorb whatever light already existed, leaving the area of examination exhausted of any light that it possessed. The darkness would be so absolute that it would achieve a luminous, absolute

X *Obscuring the* ← *The painter and the field* 47

vacuum. So that, if any object existed, however faint, it would show up very clearly. Thus, a very faint light would become visible in maximum conditions of darkness. *inside illuminates the*

inside "

(Bion, 1990, pp. 20–1)

Freud had used a similar metaphor in a letter to Lou Andreas-Salomé in 1916, commenting that when he was writing, he had to blind himself in order to focus on one dark spot (Freud, 1966, p. 45). This was part of a (sublime, Bergsonian) struggle against the distractions of the senses, a struggle that Bion would continue in earnest. It was 'a victory over the subjugating power of the object', a way of establishing a safe distance from the object's attracting/threatening power (Civitarese, 2014a, p. 1085). It speaks to a fundamental obligation to which the analyst must try to hold so that the consulting room can be the setting for an expansion of the interpersonal field rather than for merely social enactments.

Lovers of films, Ferro and Civitarese combine Bion's and Freud's metaphors:

> blindness to all external reality allows us to see scenes in the consulting room that the glare of external reality would obliterate … There are no external scenes if we make it all dark around us: the dramatization of the analytic scene takes on density, life and body … an infinity of affective storylines … in a cinema, you need to keep the emergency lights turned on, but it has to be dark.

> (Ferro, 2019a, pp. 34–5)

Only in darkness, Civitarese reminds us, 'only by obscuring phenomenal reality and the perceptions that construct it', is 'the capacity of the unconscious to dream the real, projecting its films onto it', most effectively deployed (Civitarese, 2018, p. 15).[9]

At the same time, just as the analyst insists on the protocols of the setting (a 'cinema': boundaries of time, consistency of place, etc.), the painter deliberately limits the field of vision. Cézanne keeps still, and requires his sitters to do the same; he returns again and again to the same *motif*, writing to his son in 1906:

> Here on the bank of the river the motifs multiply, the same object seen from a different angle offers subject for study of the most powerful interest and so varied that I think I could occupy myself for months without changing place.
> (Letter of 8 September 1906, Cézanne, 2013, pp. 370–1)

He carefully arranges his still lifes, so that he can surrender himself to them in relative security, and so that the thus delimited world of sensations to which he

9 The painter Sargy Mann became almost totally blind later in his life, and continued to make pictures.

submits himself may, potentially, be manageable, workable with.[10] And he must still be able to bear the strain and anxiety, the potential loss of bearings, to which this attention and effort of abstention can expose him. Ferro describes it as being able to stand in the paranoid-schizoid position without there being any persecution (Ferro and Nicoli, 2017, p. 130). Bion borrowed the phrase 'negative capability' from Keats to characterise what is needed.

> *Negative Capability*, that is when man is capable of being in uncertainties, Mysteries, doubts, without any irritable reaching after fact and reason.
>
> (Keats, 1958, volume I, p. 193)

Keats had been pondering just what it is that makes a 'Man of Achievement'—he was thinking about Shakespeare in particular. Perhaps Keats's formulation also brought him some relief: it absolved him of having to make any particular claims to knowledge. He disapproved of poets, like Wordsworth, who lectured: 'We hate poetry that has a palpable design upon us—and if we do not agree, seems to put its hand in its breeches pocket' (Keats, 1958, I, p. 223). Cézanne also turned to a sartorial metaphor. 'You mustn't pull people by the sleeves', he told Gasquet. 'Il ne faut pas tirer les gens par la manche' (Gasquet, 1921 and 1926, p. 158). He too put no premium on specialist 'knowledge' as a starting point. To lead with one's supposed knowledge was to learn nothing, and teach little.

'Don't bend [the motif] to yourself but bow before it', he told Gasquet. 'Let it be born and germinate you … You can't imagine the discoveries that then await you', Gasquet reports him saying (Gasquet, 1921 and 1926, p. 120). Allow the patient to germinate in you; risk the unknown.

And here is some supervision:

Cézanne: … if one day I interpret more than I should, if today I am carried away by a theory which opposes that of the day before, if I think as I paint, if I intervene … bang! All's lost! [patatras! Tout fout le camp!]
Gasquet: What do you mean, intervene?
Cézanne: The artist is only a receiver of sensations, a brain, a registering apparatus [un réceptacle de sensations, un cerveau, un appareil enregistreur] …

10 At Devil's Dyke near Brighton in 1824, Constable felt he was

> over-looking perhaps the most grand and affecting natural landscape in the world – and consequently a scene the most unfit for a picture … It is the business of a painter not to contend with nature and put this scene [a valley filled with imagery 50 miles long] on a canvas of a few inches, but to make something out of nothing, in attempting which he must almost of necessity become poetical.
>
> (Constable, letter to John Fisher, cited in Honour, 1979, p. 68)

If the view of the Montagne Sainte-Victoire from Aix is also expansive, it was Cézanne's native terrain, and deeply familiar to him, invested with personal meaning. Constable was away from home and seeing the view for the first time, in the company of trippers who thronged Devil's Dyke even in 1824.

A good apparatus of course, fragile and complex, especially in relation to others ... But if he intervenes, if, paltry as he is, he dares deliberately to interfere with what he must translate, then his own mediocrity filters through. The work produced is inferior.

(Gasquet, 1921 and 1926, p. 109)

Cézanne's 'registering apparatus' for his sensations is Freud's 'telephone receiver' (Freud, 1912, pp.114–15), receptive to messages from the unconscious.[11] Cézanne's 'sensations' are Freud's 'text', the units of the patient's speech. Lacan admonished his students to 'give more attention to the text than the psychology of the author'. 'Start from the text ... for the author, the scribe [the patient, the sitter], is only a pen-pusher and he comes second' (Lacan, 1988, p.153)—second, that is, to what is unknown and unconscious. If for Freud this unknown resided in the psyche of the other, for Cézanne it makes much more sense to think, with Ferro, Civitarese, Neri, and other dwellers in the post-Bionian universe, that it is a property of the field itself.

Here, incidentally, is an implicit message to the viewer: if you ascribe psychologising intent to Cézanne, you are likely to miss what is most important and profound. Cézanne never lectures. He never tells us what to think or feel. He puts us back in the world with all our primitive puzzlement and wonder. Like an analyst who makes an 'unsaturated' rather than a full, explanatory 'mutative' interpretation, of the kind Strachey (1934) recommended, he allows us responsibility, and this can jolt and challenge us. If it wasn't for the sheer enjoyment of the coloured, textured surfaces of his paintings, we might only be left to gripe 'why doesn't he help more'?

For some, perhaps already more Keatsian in temperament, a revelation and liberation might be in store. 'What a relief', wrote Samuel Beckett to his friend the poet Tom McGreevy on 8 September 1934, 'the Mont Ste. Victoire after all the anthropomorphised landscape—van Goyen, Avercamp, Ruysdael' (the painting in question, on loan to the National Gallery in 1934, later entered the Courtauld collection).

Cézanne seems to have been the first to see landscape & state it as material of a strictly peculiar order, incommensurable with all human expressions whatsoever. Atomistic landscape with no human velleities of vitalism, landscape with personality à la rigueur, but personality in its own terms ... *landscapability.* Ruysdael's *Entrance to the Forest*—there is no entrance any more nor any commerce with the forest, its dimensions are its secret & it has no communications to make. Cézanne leaves landscape [sic] maison d'aliénés & a better understanding of the term 'natural' for idiot.

(Beckett, 2009, p. 222)

11 Psychoanalysis, writes Civitarese, is 'an extremely sophisticated practice of listening to the unconscious and the systematic exercise of doubt' (Civitarese, 2019, p. 46).

Here, wrote J. M. Coetzee, was the first authentic note of Beckett's mature, post-humanist phase (cited in Danchev, 2012, p. 319). Beckett's dialogue with Cézanne was foundational, helping him free himself from the compulsion to project feeling onto the human and phenomenological world in such a way as to take the edge of its sheer *otherness* (his 'landscapability' invites comparison with Lawrence's 'appleyness' of seven years earlier).

Another link might also detain us. Earlier in 1934, the twenty-seven-year-old Beckett, not yet properly a writer, had begun psychotherapy with Bion, thirty-seven, not yet a psychoanalyst, at the Tavistock Clinic. In the paragraph before the one cited above, Beckett tells McGreevy that he has just returned to his therapy with 'covey', as he called Bion, after the summer holiday. 'The covey seemed nice after the rest from him & we got going again' (Beckett, 2009, p. 222). Perhaps it was the covey's refusal to sentimentalise over Beckett, to 'anthropomorphise' him, his challenging insistence on respecting his patient's otherness, which contributed to the sort of epiphany Beckett seems to have experienced in front of Cézanne.

The approach recommended by Bion, and Freud, creating darkness and self-blinding, also has a discriminating function, a setting aside or suspension of the apparent importance of certain phenomena or ways of looking and notating so that others, as yet unknown, might make themselves known.

This involves a suspension not just of what we think we know and can take for granted, but also of habitual ways of thinking that are, in fact, relative, culturally determined, not universal at all but contingent. Abstention from 'irritable reaching after fact and reason' helps us distance ourselves from our post-Cartesian compulsion to ascribe more or less linear cause and effect to everything, to put it all into a ready-made perspective. It involves accepting the great and inevitable limitations of our knowledge.

In October 1907, the painter Mathilde Vollmoeller and her friend, the poet Rainer Maria Rilke—perhaps Cézanne's greatest early commentator—are looking at paintings by Cézanne at the posthumous retrospective of his work at the Salon d'Automne. Vollmoeller remarks:

> 'He sat there in front of it [the motif] like a dog, just looking, without any nervousness, without any ulterior motive ... Here', she said, pointing to one spot, 'this he knew, and now he's saying it (a part of an apple); right next to it there's an empty space, because that was something he didn't know yet. He only made what he knew, nothing else'.
>
> (Rilke, 2002, p. 42)

An echo of Winnicott makes itself heard: 'I interpret mainly to let the patient know the limit of my understanding' (Winnicott, 1971, pp. 85–6). Fundamentally, what is involved is a recognition of the vastness of the field of the unknown and other.

On what basis, for example, might the psychotherapist assume that the patient must be feeling a certain way because someone in his situation would

feel that way, or respond in this way? Always, and everywhere? 'Not knowing' and having 'no memory or desire' are far from empty mantras. Through the vigilance involved in refusing our own fictions and those of our culture—and we can never of course fully succeed in this—we may help the patient to dissolve some of the fictions by which s/he has lived, and connect with the unknown and undreamed of.

Cézanne's was in important respects a phenomenological discovery—so of course, he spoke powerfully to Merleau-Ponty—and if he answers to Freud, and to Bion, perhaps he also answers to his younger contemporary the philosopher Edmond Husserl (1859–1938), modern phenomenology's founding father. Husserl, like Cézanne, was a 'radical beginner' (Moran, 2000, p. 2). Cézanne would not have known about Husserl's project, his systematic effort to put scientific knowledge on firmer footings; but he was working in parallel, seeking to reestablish painting on firmer foundations (to 'redo Poussin from Nature'), through a similarly radical attempt at reconnection with what is most essential. The key, in the language of Husserl and phenomenology, is the discipline of 'bracketing off', or *epoché*, exclusion of all that we know or think we know about the phenomena in front of us, and their (e.g., psychological) relations in time and space, so that we may see them as if for the first time.

But perhaps all painters since Cézanne are phenomenologists at heart and understand each other as such. The British painter Sargy Mann (1937–2015) wrote this about Cézanne:

> More than for any other painter it was the very quality of visual experience as such that he wanted to get to the heart of. In his search for absolute truth to his visual experience he left behind more and more of the received truths of perception and how to represent them on a flat surface. Any system such as perspective or tonal ordering, anything however basic, which was known to be true, which was believed to hold for all experience, would get between him and the absolute uniqueness of the particular experience he was giving himself up to in his attempt to paint it... he had to discover afresh each time he took up his brushes, what it was to see the world. What is it to see? What do we know of this world when we look at it? ... If the painting had an easily readable perspectival drawing then the viewer would latch on to this and jump to a hasty and misconstrued conclusion of what the experience was that the painting represented. The same would be true if there was a recognisable system of ordered tones such as had formed the basic language of figurative painting, both good and bad, for centuries. There had to be nothing in the painting which would enable the mind to get ahead of itself.
>
> (Mann, 2016, no pagination)

'[M]y own (method)', Cézanne told Gasquet, 'I have no other, is hatred of the imaginative. I want to be as stupid as a cabbage [bête comme chou]' (Gasquet, 1921 and 1926, p. 126, cited in Mann, 1981, no pagination).

In a fascinating paragraph on *astonishment* as an effect of the sublime (as discussed by Edmund Burke in the mid-eighteenth century), Civitarese notes how it is 'a feeling of wonder and surprise so intense that it almost wipes out the ability to speak and act'. It is akin to stupor (Civitarese, 2014a, p. 1076). 'The nearer the analyst comes to suppressing desire, memory and understanding', wrote Bion, 'the more likely he is to slip into a sleep akin to stupor' (Bion, 1970, p. 47, cited in Civitarese, 2014, p. 1076). In this way, the analyst may be able to intuit the patient's 'hallucinations'; Bion's 'stupor' favours 'the emergence of images, sensations, thoughts', which might indicate 'important aspects of [the patient's] psychic reality, or of the unconscious emotional reality of the therapeutic relationship'—or, we might say, turning back to Cézanne, the nature of the encounter with the motif. 'Bête comme chou' ('stupide' is the closest French synonym of 'bête'), the painter established the only conditions for the appearance of the 'sensation'. It was a loss of ego, a voluntary powerlessness, out of which might come 'a psychological revival; from ecstatic ravishment creative resources are revealed; from the abyss of the senseless come the ravishments of daydream and the epiphanies first of hallucinosis and then of dream' (Civitarese, 2014a, p. 1077).

Time, training, culture, experience, a home

'These things cannot be measured by time ... *patience* is all!' wrote Rilke in 1903 (Rilke, 2012, p. 14). Awareness of the need for time, for slowing down and not getting ahead of ourselves, is a hedge against an anxious sense of urgency. As psychoanalysis teaches, psychic and emotional growth, the passage from proto-mentality to mentality, requires not automatic motor discharge, following the reflex to rid the organism of too much stimulus, but delay (see Torres, 2010, pp. 70–1). The too-muchness may be the persecuting sensation of absence and lack; the decisive factor, if a conception—a new thought/feeling/experience—is to be born and not killed at birth, is tolerance of frustration, 'a function of the time whereby the absence of the object is measured' (Civitarese, 2008, p. 1134). As Bion put it, 'Inability to tolerate empty space limits the amount of space available' (Bion, 1994, p. 304), and compromises the 'evolution' of the work (Bion, 1967) and of the field.

This tolerance communicates itself to the patient, as it does to the patient viewer of Cézanne. Frustration and suffering are experienced as bearable. Through the work of containment undertaken by the analyst (and painter), tolerance becomes internalised as a capacity in the patient (and viewer); there is an increase in the patient's own internal space and capacity for containment, and a consequent sense of emotional expansion. This will make itself known in the greater richness and diversity of the field itself.

From the analyst's point of view, 'What the patient tells us must pervade us and soak us through' (Ferro, 2009, p. 172); 'we have to wait out the time needed for things to take a definition, a shape' (Ferro and Nicoli, 2017, p. 130).

Cézanne, according to numerous contemporaries, made exactly this point. 'I cannot render my sensation at the first attempt [je ne peux pas rendre ma sensation du premier coup]' (Denis, 1907, p. 176).

'Reading the model, and its *realisation*, is sometimes very slow in coming for the artist [La lecture du modèle, et sa réalisation, est quelquefois très lent à venir pour l'artiste]' (Letter to Charles Camoin, 9 December 1904. Cézanne, 2013, p. 346).

Cézanne followed the 'secret deepening of his analysis [l'approfondissement occulte de son analyse] ... His method of study really was a meditation brush in hand' (Bernard, 1904, pp. 33 and 58).

'Slowly the canvas saturated itself with equilibrium [La toile lentement se saturait d'équilibre]' (Gasquet, 1921 and 1926, p. 108).

A crucial factor in this process of 'secret deepening' is the internal capacity of painter and analyst for connectedness across a broad cultural field, which might offer resources to inform the analyst's own dreaming and thinking, and help her manage the bombardment of primitive sensation to which she exposes herself. It is, to adapt a favourite metaphor of the Italians, a sort of slow cooking.

As Gasquet recalled, Cézanne turned to photography as a metaphor.

> I said just now that the free brain of the artist when he is working must be like a sensitive plate, a simple recording apparatus. But it is immersion in knowledge that has brought the sensitive plate to this pitch so that it can be ready for impregnation with the careful image of things. Prolonged work, meditation, study, sufferings and joys, life have prepared it. Constant meditation on the methods of the masters. And then, the milieu we habitually move in ... The physical history, the psychology of the earth, [a great] bath of knowledge ... in which the sensitised plate has to soak.
>
> (Gasquet, 1921 and 1926, pp. 111 and 112)

Or to state it another way, Cézanne 'wanted to put intelligence, ideas, sciences, perspective, and tradition back in touch with the world of nature which they must comprehend' (Merleau-Ponty, 1964, p. 14).

'The Louvre is the book where we learn to read' (Cézanne, letter to Bernard, 1905, cited in Doran, 1978, p. 45). Merleau-Ponty reminds us that Cézanne

> went to the Louvre every day when he was in Paris. He believed that one must learn how to paint and that the geometric study of planes and forms is a necessary part of this learning process. He inquired about the geological structure of his landscapes, convinced that these abstract relationships, expressed, however, in terms of the visible world, should affect the act of painting. The rules of anatomy and design are present in each stroke of his brush just as the rules of the game underlie each stroke of a tennis match.
>
> (Merleau-Ponty, 1945c, p. 17)

Cézanne loved literature, and it was he rather than his friend Emile Zola who won school prizes for Latin translation and verse composition (Danchev, 2012, p. 28). As Dore Ashton put it, Cézanne 'sought confirmation of his temperament in a wide spectrum of reading', from the poetry of Victor Hugo and Alfred de Musset, whom he, Zola, and their friends read enthusiastically on their boyhood rambles

in the countryside around Aix, to Lucretius and Virgil, whom he was re-reading in 1896 (Ashton, 1980, pp. 31–2). He returned to Baudelaire's poetry and essays throughout his life, writing to his son in the last year of his life that he was re-reading Baudelaire's *L'Art Romantique*. 'One who is strong is Baudelaire ... he is never mistaken about the artists he likes' (Cézanne, 2013, p. 372).[12]

Cézanne's wide culture and learning—its extent often underestimated—indeed informed the manner of his participation in the field and deepened his capacity for dreaming and thought. We must make allowances for Gasquet's poeticism here, but there can be no doubt the physical and emotional field of Aix—the *genius loci*—played an important part:

> if I close my eyes and call up those hills of Saint-Marc, my favourite place in the world ... the smell of scabious comes to me, my favourite smell. The whole woody smell of the countryside, I can hear it for myself in Weber. Deep in Racine's verses I sense a local colour, à la Poussin, and beneath some of Rubens's purples an ode unfolds, a whisper, a rhythm à la Ronsard.
>
> (Gasquet, 1921 and 1926, p. 111)

Cézanne keeps us in touch with the everyday and the domestic in a way that can be very moving. A photograph of April 1906 [illus. 3.2], taken by Gertrude Osthaus when she and her husband, the collector Karl Ernst Osthaus, visited Cézanne, shows the painter lifting a straw-bottomed chair down the steps of his studio into the garden.[13] Another visitor, the archaeologist Jules Borély, had also noted the chair, reporting Cézanne carrying it in as dusk was falling, 'because the humidity of the night would spoil the straw' (Borély, 1902, p. 20): an old man's simple care for objects.[14] This sense of care and tangibility, and a poignant tension between durability and transience, follow you around if you are a modern visitor to Aix-en-Provence in search of Cézanne. There are the coats and canvas bags in his atelier, and the stick with the metal point that also appears, propped against the doorframe, in the photograph. A particularly resonant encounter might be with the zinc-topped tables in the Café Les Deux Garçons in the Cours Mirabeau—zinc sheets neatly tacked onto the wooden table frames. The painter's hands may have rested on this surface. He met old friends here, no doubt

12 According to Emile Bernard, Cézanne came back from the Château Noir one day singing Baudelaire's praises and reciting 'Une Charogne' by heart 'without mistake' (Bernard, 1907a, p. 71). Cézanne's other favourites, according to Larguier, and as enumerated by Cézanne himself on the final page of his copy of *Les Fleurs du mal*, were 'Les Phares', 'Don Juan aux Enfers', 'L'Idéal', 'Sed non satiata', 'Les Chats', 'Le Mort joyeux', and 'Le Goût du néant' (Larguier, 1925, pp. 13–14). 'A good unflinching selection', commented T. J. Clark (Clark, 1995, p. 115).

13 At the end of our visit to the studio, the master carried chairs onto the terrace in front of the house ... Cézanne was amiability itself and in excellent humour ... With a smile he gave my wife permission to take a photograph to immortalise our meeting. (Osthaus, 1920–1, p. 99)

14 I later read that Cézanne's maternal grandfather had been a chair turner (Danchev, 2012, p. 47).

Illustration 3.2 Gertrude Osthaus, *Cézanne outside his studio at Les Lauves, 13 April 1906*. Photograph. Marburg, Bildarchiv Foto Marburg

Gasquet's father among them, talked and played cards. We know he was there in the last month of his life.

Similarly, the milieu in which the analyst lives and works, her broader education and experience, including perhaps her contact with an artist such as Cézanne, as well as her training and continuing study, contribute to her receptivity. All these conditions help her be available for 'impregnation with the careful image of things. Long labour, meditation, study, suffering and joy, life' (Gasquet, 1921 and 1926, p. 111). Cézanne's form-finding activity as a painter grew out of a practice and a craft so deeply internalised over time that it can feel to the viewer as if the forms have grown spontaneously out of the landscape itself. '[E]verything should happen as if it happens by chance, without intention', writes Civitarese (Civitarese, 2019, p. 56)—the interpretation as a continuation of the dream.

Depth, space, volume

Cézanne's challenge—that which has faced painters since time immemorial—was to find how things from three dimensions might be persuaded to co-exist in two (Bell, 2019). It was necessarily a problem of the edges of things.

Cézanne, said the sculptor Alberto Giacometti, was in search of depth his whole life (cited in Merleau-Ponty, 1964, p. 64). He needed to filter out the seductive and insistent call of post-Renaissance, perspectival 'realism', so that he might rediscover depth and space as if for the first time. As Merleau-Ponty wrote in *L'Œil et l'Esprit*, the painters of the Renaissance themselves knew from experience that none of their techniques of perspective was definitive or 'natural'. There was no one projection of the existing world that could do justice to all its aspects and dimensions. 'The perspective of the Renaissance is ... only one particular case, a date, a moment in a poetic report about the world, and the world continues after it' (Merleau-Ponty, 1964, pp. 50–1). The single-viewpoint linear perspective of much post-Renaissance Western art, up to and including nineteenth-century Realism and academicism, simultaneously shaken and given new validation by photography, implied Descartes's invisible, omniscient narrator, standing outside the scene. In the process of freeing painting from the enthralment of the single, detached viewpoint, Cézanne re-opened, for the first time in painting since the Renaissance, the whole problematic.[15]

> All the inquiries we believed closed open up again. What is depth, what is light, τί το ὄν? What are they—not for the mind that detaches itself from the body but for the mind Descartes says is spread throughout the body? And finally, not only for the mind but also for themselves, since they pass through us and envelope us? But this philosophy, which is yet to be elaborated, is what animates the painter—not when he expresses opinions about the world but in that instant when his vision becomes gesture, when, in Cézanne's words, he 'thinks in painting' [Dorival, 1948, p. 103].
>
> (Merleau-Ponty, 1964, p. 60)

Furthermore, Cézanne made for himself the

> gripping discovery, already familiar to the painters, that there are no lines visible in themselves, that neither the contour of the apple nor the border between field and meadow is in this place or that, that they are always on the near or the far side of the point we look at. They are always between or behind whatever we fix our eyes upon; they are indicated, implicated, and even very imperiously demanded by things, but they themselves are not things.
>
> (Merleau-Ponty, 1964, p. 73)

15 In this sense, Cézanne might be said to parallel Baudelaire, for the poet similarly freed himself from the burden of authorial omniscience, in what the critic Leo Bersani called an 'excitingly playful, if risky, adventure in self-scattering and self-displacement' (Bersani, 1977, p. 151). If 'playful ... adventure' is hardly how Cézanne would have characterized his own work, self-displacement, in the sense of a radical suspension of ego, came to be at its heart.

Merleau-Ponty had been thinking since 1945 about the difficulty the artist tl faced.

> Not to indicate any shape would be to deprive the objects of their identity. To trace just a single outline sacrifices depth—that is, the dimension in which the thing is presented not as spread out before us but as an inexhaustible reality full of reserves.
>
> (Merleau-Ponty, 1945c, p. 20)

So how is the painter/analyst to proceed? In the act of painting/analysing, one attends to what, through negative capability, and in a phenomenological spirit, strikes one the most. When Cézanne famously said 'I aim ... to render the cylindrical side of objects' (Rivière and Schnerb, 1907, p. 88), the salient part, that nearest the eye, he was relying not on what he 'knew' through preconception or could measure, but on what his visual sensation reported to him. In reporting 'cylinders' it confirmed a sense of how the things of the world, including ourselves, hang together in multiple, indeterminate, shifting relationships in space: when we move the world can seem to rotate around us and to peel away on both sides of our peripheral vision as if on scrolls that are being wound.

At the same time, more is involved than a simple or naïve acceptance, 'without memory or desire', of what is. Cézanne was never—could never have been—unaware both of the artifice of what he was undertaking and of the fact that in painting he was also, always already, generalising out of the particular so that it might be communicable. In a famous letter to Emile Bernard in 1904, he pointed to this necessary dimension of his task, and it was a path Bion himself was to follow half a century later.

> Allow me to repeat what I told you here: to treat nature in terms of the cylinder, the sphere and the cone, everything put in perspective, so that each side of an object, of a plane, leads to a central point. Lines parallel to the horizon give breadth, be it a section of nature or, if you prefer, the spectacle that Pater Omnipotens Aeterna Deus spreads before our eyes. Lines perpendicular to this horizon give depth. Now, we men experience nature more in terms of depth than surface, whence the need to introduce into our vibrations of light, represented by reds and yellows, a sufficient quantity of blue tones, to give a sense of atmosphere.
>
> (Letter to Bernard, 15 April 1904 cited in Cézanne, 2013, p. 334).

Bion was to write of 'the axiomatic geometric deductive space that I wish to introduce as a step towards formulations that are precise, communicable without distortion, and more nearly adequate to cover all situations that are basically the same' (Bion, 1965, p. 125).

Yet this did not mean that Cézanne, any more than Bion, was not also committed to bowing before the motif (patient, analytic process) in its particularity,

rather than bending it to his will—to allowing it to 'germinate' in him (Gasquet, 1921 and 1926, p. 120). At best, he found no contradiction; the resolution was, as it were, phenomenological. He wrote to Bernard a couple of months later,

> In order to make progress in realisation, there is only nature, and an eye educated in contact with it. It becomes concentric by dint of looking and working. I mean that in an apple, a ball, a head, there is a culminating point, and this point is always the closest to our eye, the edges of objects recede towards a centre placed at eye level. With only a little temperament one can be a lot of painter. All you need is an artistic sensibility.
>
> (Letter of 25 July 1904 to Bernard. Cézanne, 2013, p. 342)

In the analytic session, the therapist similarly learns, educated through contact with the patient, to attend to what is salient in the world of her 'sensations', to what strikes her, a culminating point, a convexity, what Bion called a 'selected fact' (Bion, 1962, p. 67, citing Cézanne's compatriot and contemporary, the mathematician Henri Poincaré[16]). '[I]f you listen long enough, after a time, something evolves. Something pushes out towards you', said Bion (2018, pp. 10–11). The analyst makes herself a concave receptacle for the patient's convexities and projections, 'a concave and welcoming space for the other', in an 'ethics of hospitality' (Civitarese, 2019, p. 53), just as Cézanne, 'concave', was able to discover the convexity of things he painted. And more, he revealed the interplay between concavity and convexity in the visible world which for Ferro is also a basic emotional grammar: 'the alternation between receptive and penetrative … you accept me/you reject me/I accept you/I reject you' (Ferro, 2019a, p. 59).

Interpretation itself becomes a matter of concavity rather than convexity (Ferro and Nicoli, 2017, p. 130). Rather than an attempt to impress something (or just to impress), it is an invitation to the patient to do the filling in. Or as John Berger put it, writing on late Cézanne, the white patches of canvas left by the painter 'are not mute … they represent the emptiness, the hollow openness, from which the substantial emerges' (Berger, 2015, p. 253).

Against the background of an infinite and ungraspable plentitude of phenomena, there are certain phenomena of the session that stand out in higher or lower relief. Among them might be, for example, the patient's sister's irresponsible behaviour, his persecuting neighbours and the worry they cause, a sudden cramp in my toe, an unbidden memory of feeding a horse with my mother, the patient's intense feelings of personal responsibility, a loud motorbike in the street outside. The analyst attends to one or the other, in thought or in speech, perhaps making the simplest observational comment in response to what is

16 Henri Poincaré (1854–1912), mathematician, theoretical physicist, engineer, and philosopher of science, was an important contributor to mathematical field theory, and a key influence on Bion. See, for example, Massicotte (2013, pp. 155–8).

happening (for example, 'what a noise!'), with no thought as yet of trying to make a synthesis, of bringing things together in the form of a more elaborate and consciously constructed interpretation. It is what Ferro and his colleagues would call 'unsaturated' interpretation. To attempt any more than this might be to ruin that which is unfolding—'patatras! tout fout le camp!'—when it is not yet clear what is foreground and what is background, how these elements might or might not relate to each other and, what is more, how their inter-relations might go on to multiply. All the while, new phenomenological events, 'sensations', are occurring.

'Motivating all the movements from which a picture gradually emerges', wrote Merleau-Ponty, 'there can be only one thing: the landscape in its totality and in its absolute fullness, precisely what Cézanne called a "motif"' (Merleau-Ponty, 1945c, p. 17). But there is a problem and a paradox. Not only must three and two dimensions somehow be reconciled, there is also the fact (the problem the author faces in constructing this essay) that we can only proceed sequentially, step by step, while at the same time under the requirement to register a sense of the totality of the field and the simultaneous existences of its elements.

Faced with this task, we might follow Cézanne's lead and find ourselves on the path the Italian field analysts have, independently, been following. The word 'motif' might be translated as 'that which moves one', in other words, a 'sensation', or an intuition. Both Cézanne and Bion stressed the cardinal importance of the painter/analyst's commitment to the truth of the 'sensation' and intuition, as the most reliable guide.

Perhaps too the earlier comparison between Bion and Cézanne may now seem more than a mere *jeu d'esprit*; for some of the points of comparison between the two men make sense as products or requirements for the protection of the 'petite sensation', for creating the optimal conditions for glimpsing the pinprick of light that is a point of access to the pre-spatial hinterland of the preconceptual, the realm of primal generativity out of which a world might authentically be born.

Colour

For Cézanne, the 'petite sensation' was intimately related to colour. In the margin of the letter of 25 July 1904 to Bernard, near the words 'a little temperament', Cézanne added 'sensations colorantes' (Cézanne, 2013, p. 342): sensations or perceptions that yield colour. Colour may be among the earliest qualities of the visual field that the baby experiences (see Skelton, 2018); it remains the most sensuous and the most able to engage us in feeling. Colour, said Cézanne, is 'where our brain and universe meet' (a sentence enthusiastically cited by Paul Klee. Cited in Merleau-Ponty, 1964, p. 67). 'Colour, if I may say so, is biological. Colour is alive and colour alone makes things come alive' (Gasquet, 1921 and 1926, p. 119).

Here is Sargy Mann again.

He abandoned everything except his belief in the expressive potential of ordered colour as a response to coloured sensations. Coloured sensations

being the product of distance, inclination, illumination, and local colour, were utterly unique and could not be predicted or predetermined. Drawing and everything else that went into making a figurative painting, had to be rediscovered in every painting … Cézanne became convinced that the only way to approach what he saw without prejudging it was through colour, the coloured sensations given off by the forms of nature at their various distances as they reflected the illuminating daylight. If he could find pigment colours and positions for them on his canvas that would be an equivalent for these coloured sensations coming from different distances in his subject then he would discover the true and unique nature of his subject without interposing any pre-knowledge either of the real world or of the ways of art (Mann, 1996, no page number).

It was for this reason, in order for his picture to be 'built up solely from these ordered sensations of colour', that

he had to make sure that none of the other systems of generating a believable representation of reality came into play in such a way as to jump the gun so to speak … nothing to distract it from the patient attention to colour which would, in time build an experience of uniquely particular coloured forms in light and space, an experience *utterly real and utterly unknown.*

(Mann, 1996; my italics).

'To paint', said Cézanne, 'is to record one's coloured sensations [ses sensations colorées]' (Denis, 1907, pp. 177 and 178). Mathilde Vollmoeller made the following keen observation to Rilke in 1907. In the earlier paintings Cézanne made in 'artistic' Paris,

colour was something in and for itself; later he somehow makes use of it, personally, as no one has ever used colour before, simply for making the object. The colour is totally expended in its realisation; there's no residue. And Miss V. said very significantly: 'It's as if they were placed on a scale: here the thing, there the colour; never more, never less than is needed for perfect balance. It might be a lot or a little, that depends, but it's always the exact equivalent of the object'.

(Rilke, 2002, pp. 42–3)

Merleau-Ponty, charting Cézanne's development, would not have disagreed with Vollmoeller's conclusion. The painter, he wrote, knew the external form of things was secondary and derivative. It is not what causes a thing to 'take form'. As he put it, this 'shell of space', the fruit bowl, for example, must be broken. But what to put in its place? Must there (as to some extent for the early, so-called 'analytic' Cubists a few years later) be cylinders, spheres, and cones, as the painter told Bernard? Should there be pure forms, definitive of a law of construction? In Merleau-Ponty's account of Cézanne, this was not a problem the painter could

ignore, for to deal in such 'pure forms' would be to emphasise 'the solidity and immutability of things at the expense of their variety' (Merleau-Ponty, 1964, pp. 65–6).

Merleau-Ponty noted that Cézanne had tried an experiment of this kind in his middle period, going straight for the solidity of objects in space. This, however, led him to the key discovery: this space was 'a box or container too large' for the things it contained. They started to move, colour against colour—to 'modulate in instability'. It was thus together, concluded Merleau-Ponty, 'that space and contents must be sought. The problem becomes more general, it is no longer the problem of distance and line and form, it is also that of colour' (Merleau-Ponty, 1964, pp.65–6).

Cézanne told Emile Bernard: 'There is no such thing as line ... no such thing as modelling, there are only contrasts. When colour finds its richness, form finds its fullness [Quand la couleur a ses richesses, la forme a sa plénitude]' (Bernard cited in Denis, 1907, p. 176). In the late work, for instance in paintings and water-colours of the Montagne Sainte-Victoire [cover and illus. 1.9], line and even a vestigial perspective are, in fact, rarely abandoned completely. But it is mainly colour, arranged in planes, that gives depth and recession: surface and depth are articulated together. Merleau-Ponty had noted in 1945 how at times Cézanne also 'follows the swelling of the object in modulated colours and indicates several outlines in blue ... Rebounding among these, one's glance captures a shape that emerges from among them all, just as it does in perception' (Merleau-Ponty, 1945c, p. 15) [see, for example, illus. 3.1]. In these ways, apple and meadow '"form themselves" from themselves, and come into the visible as if from a pre-spatial world behind the scenes [d'un arrière-monde préspatial]' (Merleau-Ponty, 1964, p. 73).

In conversation with Maurice Denis, Cézanne spoke of '*modulating* rather than *modelling*' (Denis, 1907, p. 178). By 'modelling', might we understand a wilful effort on the analyst's part to bring some aspect of the analysis, the analyst-patient relationship ('transference interpretation') perhaps, or the patient's character, into sharper relief? (How easily the language of the studio or the art critic lends itself.) The alternative, espoused by the post-Bionians, is to follow Cézanne's example and seek to register what is there by means of a coloured 'touch', an 'unsaturated interpretation', or perhaps an exploratory number of such interventions. By this means, surface—the patient's narration—and depth—its dream dimension—might be registered together, and a 'shape' start to emerge. The vibration of colour also equals the feeling, the emotional complexion of the analyst's intervention, the freshness and modulation of her metaphors. 'Colour' would be the emotional complexion of the interchange, its hue, tone, timbre, and degree of saturation.

In Merleau-Ponty's and Cézanne's 'pure' Platonic forms perhaps we find equivalents to psychoanalytic metapsychology, the attempt, through for example exclusive recourse to Oedipus, or the primal scene, or primal envy, to rely on 'definitive laws of construction', which, however, while not lacking possible validity, might also seriously compromise or falsify the 'variety' of the session,

the patient, and the field. Bion himself abandoned his grid; in his final writings he leaves behind the gnomic, laconic style of a scientist's report for (in the *Memoir of the Future*) dramatic multilogue, and rather than on a search for the 'ideal forms' of metapsychology, or the perfect notation or interpretation, or the highest acuity of investigation, the emphasis now would be on allowing what is there to emerge of its own accord from its 'arrière-monde préspatial'. 'Too many times analysts devote themselves to trifling details ... we should always look for the "global response with colour" of how a situation works', says Ferro (Ferro and Nicoli, 2017, p. 106).

And in this commentary by Rilke, we might hear the clearest possible statement of the field analyst's approach.

> There's something else I want to say about Cézanne: that no one before him had ever demonstrated so clearly the extent to which painting is something that takes place among the colours, and how one has to leave them completely alone, so that they can come to terms among themselves. Their mutual intercourse: this is the whole of painting. Whoever meddles, whoever arranges, whoever injects his human deliberation, his wit, his advocacy, his intellectual agility in any way, is already disturbing and clouding their activity. Ideally a painter (and, generally, an artist) should not become conscious of his insights: without taking the detour through his conscious reflection, his progressive steps, mysterious even to himself, should enter so swiftly into the work that he is unable to recognise them in the moment of transition. Alas, the artist who waits in ambush there, watching, detaining them, will find them transformed like the beautiful gold in the fairy tale which cannot remain gold.
>
> (Rilke, 2002, p. 66)[17]

Analysis 'is something that takes place among the colours': between the quality and vivacity of the analyst's interventions and of the interchanges between analyst and patient.

17 'Everything, as I already wrote, has become an affair that is settled between the colours themselves; a colour will come into its own in response to another, or assert itself, or recollect itself' (Rilke, 2002, p. 72). It was an affair that moved Rilke to some vivid word-painting. 'Its inward carmine bulging out into brightness provokes the wall behind it to a kind of thunderstorm blue' (ibid., p. 78); 'a landscape of airy blue, blue sea, red roofs, talking to each other in green and very moved in this inner conversation, and full of mutual understanding' (ibid., pp. 83–4). Picasso offered a contrasting view of the nature of Cézanne's attention:

> If Cézanne is Cézanne, it's precisely because ... when he is before a tree he looks attentively at what he has before his eyes; he looks at it fixedly, like a hunter lining up the animal he wants to kill. If he has a leaf he doesn't let it go. Having the leaf, he has the branch. And the tree won't escape him.
>
> (cited in Ashton, 1980, p. 38)

Bion, in a further borrowing from Keats, developed the concept of a 'Language of Achievement': 'language that is both a prelude to action and itself a kind of action; the meeting of psycho-analyst and analysand is itself an example of this language' (Bion, 1970, p. 125). An analyst who is also a Man of Achievement is, for Civitarese, one 'capable of speaking the Language of Achievement—that is, of being with the patient in a way that is authentic, passionate, creative, sincere, and without regard for decorum' (Civitarese, 2014a, p. 1075).[18]

For Cézanne too, to realise his coloured 'sensation' was to be 'authentic, passionate, creative, sincere, and without regard for decorum'. It was also to embrace the human encounter: he searched, for example, for the 'justice de ton' to catch Gasquet *père*'s emotional tenor, his 'assiette morale', when he was working on his portrait (Gasquet, 1921 and 1926, p. 147) [illus. 3.3]. The painter makes a

Illustration 3.3 Paul Cézanne, *Portrait of Henri Gasquet*, c. 1896–7. Oil on canvas, 56.2 × 47. McNay Museum of Art, San Antonio. 1950.22. Bequest of Marion Koogler McNay

18 Keatsian 'Achievement' would, in Alexander Jasnow's terms, equate to a vision of psychotherapy as an opening to creativity, through which we might become artists in life by adopting 'an aesthetic frame of reference in regard to ourselves and others', in order to foster 'the experience of an ever-open and expanding horizon, within as without' (Jasnow, 1993, pp. 188–9).

mark, and this alters the whole canvas and the inter-relationships of its elements in a series of microtransformations: there is a cumulative, transformative effect, and a gradual deepening. 'One touch then another, one touch then another', commentated Cézanne as he worked on the portrait—on one of his eyes, specifically. 'I carry on with barely perceptible touches all around. The eye is looking better [Une touche après une autre, une touche après une autre ... Je continue, par touches insensibles, tout autour. L'œil regarde mieux]' Gasquet, 1921 and 1926, pp. 153 and 152; see Ferro, 2009, p. 178).

The analyst makes an 'unsaturated' interpretation, sufficient to indicate the limits of her understanding, to which the patient offers feedback, as does the canvas to the painter. It is feedback about the current state of things. Cézanne's canvas prompts him as to what kind of mark is needed next, and where; the patient, or, as Ferro or Civitarese might say, the canvas of the field itself provides similar supervision, and the analyst at work hardly requires any other guide.

The untouched patches of canvas might be equivalent to pregnant silences. But there is evidence too, contrary to the received idea that Cézanne typically allowed long minutes to elapse before he made the next tentative brushstroke, that he could also paint rapidly (Danchev, 2012, p. 361); the analyst's response is certainly not always the result of long deliberation. It is not enough for an interpretation merely to express an idea, it must also bring something to life, *be* an experience, and it is the analyst's attention to the effect of her interventions, heard in the patient's response or sensed in the atmosphere, that is critical. Her intervention, the fate of which she cannot know at the moment she intevenes (will she make some contact with the patient, facilitate some movement in the patient's psyche-soma?), is always a potential expansion of the field.

For it has the potential to reflect and communicate 'not only with the most differentiated aspects of the mind but also with the most primitive ones', and it is able 'to influence the vestiges of foetal life and the inaccessible unconscious'. The Language of Achievement, writes Civitarese, 'has the characteristic of being open ... to the preverbal sensory levels of discourse' (Civitarese, 2014a, p. 107).

A transformation takes place through 'colour' when it is treated in this way; a parallel reality starts to manifest itself in the session as on the screen of the canvas, something both utterly real and utterly unknown. It is a transformation and transfiguration of the concrete, of the kind Rilke discerned when, in 1907, he was standing in front of *Madame Cézanne in a Red Armchair* [illus. 1.3]. The chair seemed 'so perfectly translated into its painterly equivalents that, while it is fully achieved and given as an object, its bourgeois reality at the same time relinquishes all its heaviness to a final and definitive picture-existence' (Rilke, 2002, pp. 71–2).

'Sensation', intuition, reverie

Trust the 'sensation' and the colours will take care of themselves. Such is Cézanne's lesson, and it seems he may have treated 'sensation' as a reliable guide in every sphere. He also used the word simply to mean instinct or judgement. 'I have the greatest confidence in your *sensations*, which give your mind the

direction it needs in looking after our interests, in other words I have the utmost confidence in your management of our affairs', he wrote (optimistically) to his son Paul on 8 September 1906 (Cézanne, 2013, p. 371).

The word 'sensation' had a particular weight and resonance in the latter half of the nineteenth century in France, thanks above all to the writings of Hyppolite Taine (1828–93), a philosopher whose work moulded the outlook of the genera-tion—Cézanne's—that was reaching maturity around 1870. Taine was a theo-rist of the interdependence of the physical and the psychological in determining human development (Reid, 1976, p. 606), of a 'physiologie psychique' or 'psy-chophysiologie': he was the 'philosopher of Naturalism' whose work profoundly informed the novels of Zola. He was also an important part of Merleau-Ponty's intellectual background. Reading him today catapults us straight into the world of Ferro and Civitarese. In *De l'intelligence* (Taine, 1870), the book that contains the sum of his thinking, he writes of perception as having three components: a mental image or 'hallucination'; an antecedent 'sensation' or activation of the nervous system; and a still more remote antecedent, an external object corresponding to the hallucinated image. But this object itself need not materially exist. 'Painting is something inside', said Cézanne (Jourdain, 1950, p.84): 'sensation' and the result-ant hallucination could be generated from within. Innermost sensations generate images that lead to the production of ideas. For Taine, the unsettling fact was that all consciousness was hallucinatory. 'Our external perception is an internal dream which is found in harmony with external things; and instead of saying that halluci-nation is a false external perception, it is necessary to say that external perception is a *true hallucination*' (Taine, 1870, vol. 2, p. 411, cited in Schiff, 1984, p. 45, to which this summary is indebted). '[I]n a state of waking we are always dreaming a dream of which we are unaware', writes Civitarese (2019, pp. 48–9).

So it is for the post-Bionian analyst, for whom 'reverie' would seem to be equivalent to the painter's 'sensation'; through reverie, as for Cézanne through 'sensation', the most telling and affecting unsaturated coloured verbal 'touches' are made.

Underpinning Bion's emphasis on reverie is that other widely influential phi-losopher of the second half of the nineteenth century in France, Bergson, and in particular Bergson's concept of 'intuition'. Intuition is the means of contact with 'durée', with the 'dynamic rhythmical continuous process of change and growth' (Torres, 2013a, p. 23), and, in the language of Bion, with psychic reality itself. For intuitive knowledge 'installs itself in that which is moving and adopts the very life of things' (Bergson, 1903, p. 53).

For Bergson as later for Bion, intuition is something beyond intellect—'the symbolic knowledge by pre-existing concepts, which proceeds from the fixed to the moving' (ibid.)—and fundamentally different from it. We must never, wrote Bergson, in a passage marked by Bion in his copy of *Matter and Memory*, for-get 'the utilitarian character of our mental functions, which are essentially turned towards action'. What is more, 'the habits formed by action find their way up to the sphere of speculation, where they create fictitious problems ... and metaphys-ics must begin by dispersing this artificial obscurity' (Bergson, 1896, p. xvii).

For Bion too, reason and intellect, which are directed towards useful action upon the world, and emotion, are two different forms of enquiry and paths of knowledge: on the one hand, 'a kind of simian capacity for acquiring technical skills … and a capacity for full emotional and intellectual development on the other' (Bion, 1948, p. 84, the quotations above cited in Torres, 2013a, p. 23). Note how Bion in fact brackets emotional and intellectual development here, implying that intellect requires emotion for its development.[19]

Bergson, crucially, proposed that there exists a kind of mental functioning that is contemplative, intuitive, and metaphysical, and not directed at external reality as received by the senses. Hence Bion's assertion that

> there are no sense-data directly related to psychic quality, as there are sense-data directly related to concrete objects. [For] it is hard to believe that sense data, as ordinarily understood, could bring much material of value when the object of the senses is an emotional experience of a personality.
>
> (Bion, 1962, p. 53)

And (as we have seen) the psychoanalyst 'is not concerned with sense impressions or objects of sense'; for 'awareness of the sensuous accompaniments of emotional experience are a hindrance to the psychoanalyst's intuition of the reality with which he must be one' (Bion, 1967, p. 15).[20]

19 Readers of Iain McGilchrist's *The Master and his Emissary* (2009) will not fail to note the parallels with his research into left and right brain hemisphere functioning and the relationship between the two. 'Reason is emotion's slave and exists to rationalize emotional experience', wrote Bion in the opening lines of *Attention and Interpretation* (Bion, 1970, p. 1).

20 In *The Interpretation of Dreams*, Freud pointed to how hindering these sensual accompaniments could be, writing of Romantic accounts of dream as

> a liberation of the mind from the power of external nature, a release of the soul from the fetters of sensuality, and similar judgements by the younger Fichte and others, which all represent the dream as an ascent of the inner life to a higher level.
>
> (Freud, 1900, p. 54)

'From my early reading', wrote Coleridge in 1797, corroborating Freud and anticipating McGilchrist, 'my mind had been habituated *to the Vast*—& I never regarded *my senses* as in any way the criteria of my belief. I regulated all my creeds by my conceptions not by my *sight*—even at that age'. Those who rely for a sense of the whole

> on the constant testimony of their senses … contemplate nothing but *parts*—and all *parts* are necessarily little—and the Universe to them is but a mass of *little things*. // I have known some who have been *rationally* educated … They were marked by a microscopic acuteness; but when they looked at great things, all became a blank and they saw nothing.
>
> (From a letter to Thomas Poole of 16 October 1797, Coleridge, 1956, p. 354,
> cited in Nicolson, 2019, pp. 226–7).

The senses could never supplant the evocative power of the imagination. They could, however, limit its effectiveness. And for that reason it is well worth renouncing them *a priori*.

> (Civitarese, 2018, p.15)

This may seem to take us away from the sensuous world of the painter; but perhaps what it also underlines is a non-sensuous dimension of the 'petite sensation': that 'sensation' does not exclusively refer to sense data, at least 'as ordinarily understood' (Bion, 1962, p.53), and that the painter's mental positioning in front of the motif and the canvas is an attempt to 'adopt the very life of things' (Bergson, 1903, p.53).

Bion's Bergsonism helps us further appreciate the radical nature of his thinking and the extent of his departure from Freud. For Freud's view of mental functioning, that it must ultimately adapt to the reality principle, is essentially utilitarian. Just as Cézanne put a question mark over depth and space (turning at one point to the non-sensuous geometry of cylinder, sphere, cone), intuition challenges the Freudian distinction between secondary process, sensuous reality, the reality principle, and primary process, the pleasure principle, dream (Torres, 2013a, p. 27). In Bergson's terms, this aspect of the Freudian edifice is a fine example of the 'bias and inadequacy of intellectual thinking based on the utilitarian spatial sensuous perception of concrete objects' (Torres, 2013a, p. 23), and of how habits of thinking formed in action find their way up to the sphere of speculation (Bergson, 1896, p. xvii). What is obscured, and that to which Bion gave central place in his approach to psychoanalysis, is another kind of mental functioning, which comes to life through the practice of intuition and connects us to psychic, non-sensuous reality.

Intuition is the main tool in analytic work and must be trained.

> For Bion intuition is … a capacity and a skill that must be trained and exercised, which is what was proposed by Bergson: a laborious and painful effort to reverse the usual utilitarian work of the intellect in order to place oneself directly, by a mental expansion, within the object studied.
>
> (Torres, 2013a, p. 27)

Negative capability, Ferro reiterates, is one of Bion's most important concepts and the essential condition for the transformation of the analytic space, through colour and the mutual intercourse of colours, into a 'picture-existence'. It is what is necessary to help us begin dispersing the artificial obscurity brought about by the utilitarian character of our mental functioning. There must be no jumping the gun, no leaping to conclusions, even through reconstructive and symbolic interpretation, if things are to take on their proper density, life and body and become embodied in the session, as on the canvas. Ferro re-asserts Bion's insistence on the centrality of dream in this process, and he adds a 'field' dimension. 'Negative capability is linked to the capacity of the analyst—but I would say of the field itself—to be able to dream in session, and by doing so to be able to perform those operations of deconstruction of a symptom that allow us to transform it.' (Ferro and Nicoli, 2017, p. 130)

If the analytic pair can let the field dream through them, the symptom might be transformed—just as Cézanne, in his engagement with the 'negative capability'

of the field generated by himself, Hortense Fiquet, and his materials, was able to transform the all-too-concrete 'bourgeois' armchair.

The reverie of the analyst is nevertheless crucial to this process and is itself a contribution to the field. It is her 'capacity ... to reconstruct the patient's communications as a dream', and this 'in turn becomes the capacity of the bipersonal field and finally that of the patient' (Ferro, 2019a, p. 245). Something beyond free-floating attention is needed for this; for free-floating attention, as a tool for accessing the repressed individual unconscious, belongs for Ferro to the old Freudian paradigm. Instead, if we approach the session as a 'dream field',

> the analyst's mental functioning has to be more dreaming ... able to combine the *dreaming ensemble* in the sense of dreaming together, with the *dreaming ensemble* in the sense of putting to work inside the field all the various modes of dream that we have ... so our mental functioning has to be ... that of attention ... but such as to allow a certain softness, a receptivity of listening.
>
> (Ferro and Nicoli, 2017, p. 121)[21]

T. J. Clark has taken up the dream-like quality of some of Cézanne's paintings, writing in an essay of 1995 about the 'dream-work' embodied in a painting such as the *Bathers at rest* (c. 1876–7) in the Barnes Foundation [illus. 3.4]. It is a painting that, for all its discontinuities, is also notable for 'a certain softness'; and 'dream-work' is a term Clark insists he did not choose casually.

> Never, for a start, has a picture declared itself so openly—so awkwardly— made out of separate, overdetermined parts co-existing only on sufferance ... The picture is paratactic. One can almost hear the dream-narration of it beginning. We were in a meadow by a stream ... there was a mountain in the background ... An individual of some sort was lying on the grass with no clothes on ... I couldn't see if it was a man or a woman ... One arm was thrown over its head, making a kind of pillow ... One knee was bent double, hiding its genitals.
>
> (Clark, 1995, pp. 95–6)

Clark also notes actual dreaming figures, for example, in the Barnes Foundation *Grandes baigneuses* 1904–6 [illus. 3.5]: a figure leaning against a tree on the far right, a little apart from the main group, whose expression and pose, and

21 For dreams, like Cathy's in *Wuthering Heights*, can change one's outlook: 'dreams ... have ... gone through and through me, like wine through water, and altered the colour of my mind' (Brontë, 1847, p. 57). Coleridge, a generation earlier, had characterized dreaming as 'the shifting current in the shoreless chaos of the fancy in which the *streaming* continuum of passive association is broken into *zig-zag* by sensations from without or from without' (cited in Lowes, 1927, p. 409). To be able to apprehend these sensations was, for Coleridge as it was to be for Cézanne, the very motor of creation. 'The stuff of dreams', said John Livingston Lowes, writing of 'The Ancient Mariner', 'has become the organ of the shaping spirit' (ibid., p. 412).

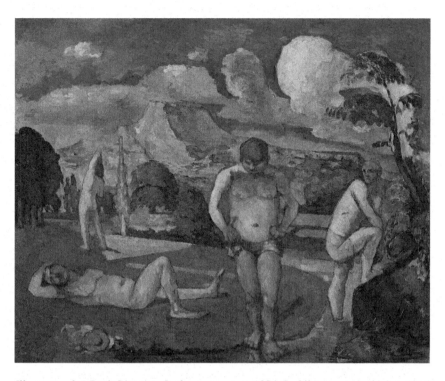

Illustration 3.4 Paul Cézanne, *Bathers at rest*, c. 1876–7. Oil on canvas, 82.2 × 101.2. Barnes Foundation, Philadelphia. BF906. Public Domain

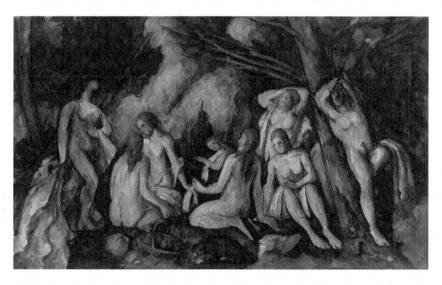

Illustration 3.5 Paul Cézanne, *The Large Bathers*, 1895–1906. Oil on canvas, 132.4 × 219.1. Barnes Foundation, Philadelphia. BF34. Public Domain

the deep shadow across whose face, seem to 'signal some sort of reverie or inward-turning' (Clark, 1995, p.100). Fearing that perhaps he is being tendentious, Clark nevertheless says 'I shall call it the dreaming figure', and he links it to the figure stretched out on the grass in the 1875–7 Bathers, which is similar in pose and expression, and whose face is also shadowed and disconsolate (Clark, 1995, p. 100).

Dream, if we follow Clark, is indeed both content and method in late Cézanne. At times, as we have seen, Cézanne seemed to feel that painting was an almost entirely inward activity: 'la peinture … c'est là-dedans!' (Jourdain, 1950, p. 84). In paying attention to his 'petite sensation', the painter/analyst allows the landscape/sitter/patient and the field between them to dream itself/herself in him: a form of reverie that gives the truest colour. The 'petite sensation' is a glimpse, an apprehension of the not-yet or just-about-to-be realised or formed: it is the equivalent in Cézanne of Bion's pinprick of light. It is a point of access to everything that has gone under the heading of 'unconscious': not merely the 'repressed' unconscious of classical, Freudian analysis but also the 'chora', the 'proto-mental', and 'pre-conceptual', indeed the whole 'mushroom field', the in-between and all-around, that is, the inter-psychic field. Reverie is a product and expansion of the 'petite sensation'/'pinprick of light'; or, one might say, the 'petite sensation'/'pinprick of light' are reverie's primary intimations, its ur-manifestations.

If the consulting room is thus an atelier filled with creative mess (Ferro and Civitarese, 2015, p. xvi), this does not mean anything goes and that we can 'dispense with discipline and thought'. The analyst's coloured 'living metaphors' are live only in so far as they are genuine products of unconscious reverie, unforced, not preconceived. They are

> forms of intuition … successful dreams, fragments of poetry, psychic productions that restore body to mind and mind to body. They are already the most profound form of thought of which we are capable … They emanate from the unconscious … the psychoanalytic function of the personality that is constantly working to find, or rediscover, a basic psychosomatic integration.
>
> (Ferro and Civitarese, 2015, p. 94)

The 'most profound form of thought of which we are capable', they are contributions to a dynamic and transformative process, indeed absolute requirements for it.

Reverie, writes Ferro, arises out of 'that continual activity of receptive/transformative work done without our being aware of it' (Ferro, 2019a, p. 58), deriving his thought from Bion's model of 'containment'. For the analyst in the analytic setting, reverie can 'take a variety of forms: a flash when it is instantaneous, a feature film when it arises out of a connection between different moments of reverie' (ibid.). What is more, its products, being unconscious, are not only unbidden but can be most unwelcome. Cézanne gives us an instance of this.

Flaubert, the painter reminded Gasquet, said that he saw the colour purple when he was writing his novel *Salammbô*. When Cézanne himself was painting the portrait known as *An Old Woman with a Rosary* [illus. 3.6], he said he saw

> un ton Flaubert ... something indefinable, a bluish, russet colour that, it seems to me, comes off *Madame Bovary*. It was no good reading Apuleius, which I did to try to get rid of this obsession, because for a time I thought it was dangerous, too literary. Nothing would do it. That great blue russet colour had got a hold on me, sang in my soul. My whole being was bathed in it [J'y baignais tout entier].
>
> (Gasquet, 1921 and 1926, p. 111)

Because the concept of reverie is at risk of meaning anything and everything, Ferro has come to favour a restrictive view of it, in which it is unwelcome by definition. In the mind of the therapist at work in the consulting room, something presents itself 'insistently and annoyingly', and these are reverie's two important features: it is 'insistent and grating' (Ferro and Nicolo, 2017, p.73). It imposes

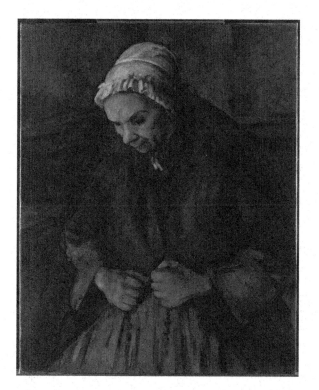

Illustration 3.6 Paul Cézanne, *An Old Woman with a Rosary*, 1895–96. Oil on canvas, 80.6 × 65.5. National Gallery, London. NG6195 © The National Gallery, London

itself and seems to interfere with the receptive, listening state of mind the analyst is trying to maintain—just as Cézanne felt the literary 'ton Flaubert' should be eschewed because it compromised his attention to his purely visual experience. And it usually has a bearing on the present state of the analytic relationship and situation and can lead to its deepening and expansion—just as Cézanne's reverie had a critical bearing on his portrait of the old woman, and contributes to its greater emotional resonance.

> [A] continual activity ... it is only a reverie in strict sense when, during a session, while I'm building without knowing a series of pictograms ... at one point one of these pictograms, instead of remaining hidden from myself, becomes something with which I get into contact.
>
> (Ferro and Nicoli, 2017, p. 75)

Civitarese conceptualises this in terms of hallucinosis, a dream-like painting of emotions, part of the ordinary 'psychosis of everyday life'—for 'in a state of waking we are always dreaming a dream of which we are unaware'. Hallucinosis is 'an analyst's tool to maximize receptivity, a kind of self-induced illness for therapeutic purposes', although 'it cannot be produced at will; we can only lay the groundwork for it to appear' (Civitarese, 2019, pp. 48–9).

Ferro gives the example of the image of a 'ship in a bottle' that appeared to him in a session. Once he was able to welcome it, he could abstract or decode it as speaking to a shared experience of stuckness and entrapment, illuminating the real impasse he and his patient were in. It was something that 'bathed' the whole being of the analysis and permeated the whole field, like Cézanne's 'blue-russet colour'. Only once the reverie had been welcomed might a shift be possible (Ferro and Nicoli, 2017, pp. 73–4); only then might the analyst, as Lacan put it, find 'in the very impasse of a situation the vital force of an intervention' (Lacan, 1947, p. 25).

The unbidden mental image of a 'ship in a bottle' is transformed into metaphor. Something in the field, the analyst may finally be able to think, is like a ship in a bottle, and he may now make use of this, in its raw or in a modified form—Ferro would say 'uncooked' and 'cooked'—as a communication to the patient. The reverie guarantees the metaphor its living emotional 'colour'; but reverie itself, which is unconscious, is not to be confused or conflated with metaphor, which is conscious. Perhaps the reverie-image is generally a product and communication of something that so permeates the whole field that it is hard or impossible to discern by any other, conscious, means—like the air the analytic couple is breathing, or something one must bathe in.

And perhaps, as Cézanne's experience might encourage us to think, reverie does not always take the form of a discreet image. It may be a synesthetic experience; or, an example from my own practice, a sort of word-picture. I 'saw' an aeroplane, an old Dakota, and the words 'Berlin airlift' popped into my head. In this instance, the message was not so very hard to welcome, random as it at first seemed: it was a reminder of the pressing importance for my patient—who as a child had endured a state of emotional siege and shutdown, a matter of psychic survival—that I should try to keep the channels of communication open at all costs.

The analyst's role, by remaining a receptive listener on every possible level, is to develop the channels of unconscious communication, to keep the skyways open, and thus to supply the field itself, and, indirectly and inevitably, develop the patient's unconscious 'dreaming' capacities. As itself a product of and communication from the field, reverie is, what is more, co-created, generated 'in the field': it is only twenty years later that it occurs to me that the Douglas Dakota was powered by two engines.

What might it have been like to be one of Cézanne's sitters? We know, from Vollard's account (Vollard, 1914), what a difficult experience it could be for the sitter as for painter when a sitting was going badly, and other testimonies are few—just as there is a paucity of accounts of analysis from the analysand's point of view. I don't think it is too fanciful to imagine, as Elderfield does (2017, p. 34), that for some of Cézanne's later, working-class sitters, with whom he felt in sympathy, the experience was mysteriously enriching, the experience of a shared sense of community. We do, however, have this observation made from the painter's point of view. Working on the portrait of Gasquet's father Henri [illus. 3.3], Cézanne noted (if Gasquet *fils* is to be believed) that 'there is a mysterious exchange that passes from his soul—which he knows nothing about—to my eye which recreates it and where he will recognise himself … if I am painter' (Gasquet, 1921 and 1926, p. 152). A successful portrait, like a working analysis, involves an exchange that is personal and particular. Through it, the sitter/patient may simultaneously be transformed and recognise himself, in a new way and perhaps for the first time.

The recognition might, furthermore, be of his always already contingent being, not fixed but in permanent transformation. It is this reality, we shall see, that Cézanne sought to register. The 'unconscious', in this way of thinking, is not so much a reservoir as a generative *process*, a 'mysterious exchange'. It brings about an expansion of the particular inter-psychic field of analyst and patient and since this field also has its roots in a common proto-mental field, a strengthening of the 'underground mushroom tendrils' themselves, their further branching out in new directions. It emerges and develops itself in the heart of the work itself, of thinking, feeling, and speaking in the session, and through the live nexus of interactions across it.

α, β

In their theoretical writings Ferro and Civitarese's own most insistent metaphors are drawn from theatre, film, and hologram; painting, nevertheless, has a special place in their thinking and is absolutely central to one of their most important publications, *The Analytic Field and its Transformations* (2015).[22]

22 The most moving art forms, write Ferro and Civitarese, are music and dance, 'but not … painting itself, which appeals to the most intellectual of the senses, sight' (Ferro and Civitarese, 2015, p. 61). Perhaps, in spite of their appreciation of the 'absolute importance' of form, they are here thinking of painting primarily as a vehicle for the conveying of content, in the service of reproducing the objects of our perception, often in order to tell a story, impart a message, or generate an emotion. But if a fresco by Giotto or a mythological scene by Titian moves us, it is also because of the way its content is given a visual form that speaks to us on the most primitive, pre-conceptual level.

'We all have an "inner painter" who transforms primitive sensoriality into images or pictograms and then ties them up into oneiric thoughts, dreaming and thinking in order to give a personal meaning to experience' (Ferro and Civitarese, 2015, p. xvii).

And again:

> If we were artists, it would be easier. Artists are not limited to abstract verbal communication. But we are artists, Bion suggests, or, at least, we should have the courage to use our skills as artists—after all, don't we all dream at night and during the day? Don't we all compose the poetry of the mind that Freud (1891) talks about in his book *On Aphasia?* Don't we all constantly transform 'sensoriality' into images, sounds, colours, all possible kinds of pictograms, audiograms, etc. olfactograms, and then assemble these fragments into narratives, paintings, olfactory melodies, musical odours, and so on. Then our 'atelier' must be in creative disorder to the maximum degree that we are able to bear, certain that the shadows and shapes will then come to life. If we discovered that we are just not capable of it, then that would be sad. We should infer from this—Bion explains with his typical calm, peremptory tone, which leaves us convinced and baffled—that we are in the wrong job.
>
> (Ferro and Civitarese, 2015, pp. 30–1)

Ferro elaborates, invoking Bion's concept of 'waking dream thought' and providing a working introduction to what he meant by 'α-function' and 'α-elements':

> α-function, that is, the matrix of the diurnal dream, continuously produces images. Such images build our waking dream thought, which will in turn build the Lego bricks of our thought and of our dream as well, and reverie is the phenomenon by which I can get in touch with one of these bricks that were shaped by the α-function from the senses and that the mind of each of us keeps building ... So I behold the opening of a widow on my psychic life, which gives me a key to understanding what's happening at that moment inside the story that I'm living with the patient... A window where the dream thought is taking shape, and through the opening seeing a frame of the movie that is being made.
>
> (Ferro and Nicoli, 2017, p. 75)

For Bion as for Ferro and Civitarese and their colleagues, the therapeutic act is the transformation of 'beta' elements, 'that is of senses, of clouds of senses, of fragments of the proto-mental, in[to] alpha elements, that is, towards the image', into pictograms, proto-thoughts and feelings and material for dreaming. It is in this sense that the idea of transformation can be said to run right through Bion's thought: transformation as a constant and core human process, where the classical model would see it in narrower terms, as the result of the analyst making the patient aware of hidden, unconscious messages. Post Bion, analytic work becomes about 'the transformation of these proto-emotional, proto-significant, "proto-everything" states, in[to] images, then in narremes, in unions of narremes,

that is in narratives'. The analyst assists in these processes, which lead to 'the construction of thought, to the construction of emotion, and basically also to the construction of the unconscious' themselves (Ferro and Nicoli, 2017, pp. 79–80).

I think with Cézanne too that we internalise not conscious 'insight' but something more like a 'method', or 'tools that allow us to mentally function in a better way', to feel better when we suffer a 'bombardment of proto-emotional states' (Ferro and Nicoli, 2017, p. 81). It is an experience or re-experience of 'the happy alternation of non-integration <-> integration on a pre-symbolic and pre-reflective level': a sense of internal cohesion and perhaps even composure, as against the unease that can accompany a feeling that things are chaotic. And it is, undoubtedly, 'the root of the sense of wellbeing experienced at the end of an[y] exciting visit to the theatre or an exhibition of fine art' (Ferro and Civitarese, 2015, p. 61). In front of a late painting by Cézanne, the viewer can experience alternating feelings of non-integration <-> integration of great intensity.

To attempt a summary, the process through which β-elements are filtered and transformed into α-elements is what gives rise to the 'petites sensations' Cézanne so prized. But they are not only privileged windows into the potentially life-giving preconceptual, raw materials waiting for transformation. They are also threats. And it is this polarity that gives the session/the canvas its 'electricity' (Civitarese, 2019).

The process could be expressed as a diagram, with the double vertical lines denoting the caesura, or filtering membrane, a permeable contact barrier.

```
              >  <------ || ------->  'petite sensation' / 'pinprick of light'
β ----------->           ||
              >  ----- >  ||-------> reverie --------> α
    proto-mental area    ||
```

Some raw β-elements from the proto-mental world, pressing for expression, find their way through the filter. Thanks to the transforming action of α-function and receptive reverie, which must too have some attractive, pulling power, they enter conscious experience in the form of pictograms and images, 'α-elements', available to be translated into feeling and thought.

Bergson's and Bion's strictures on such diagrammatic explanations must be respected, however. 'Images can never be anything but things, and thought a movement' (Bergson, 1896, pp. 124–5). 'Freud's model of mind, based on a diagram, is based on a realization of sensual space … it has facilitated understanding and discovery; but these models are inadequate' (Bion, 1967, p. 135).[23] It is hoped the

23 Cézanne:

> As for drawing, it is all an abstraction. So you must never separate it from colour. It is as if you wanted to think without words, with pure figures, pure symbols. It is an algebra, a writing. As soon as life happens to it, as soon as it signifies sensations, it takes on colour [il se colore].
> (Gasquet, 1921 and 1926, p. 123)

diagram above may nevertheless be of some help in facilitating an understanding of Ferro and Civitarese's 'transformations in dreaming'—in which the analyst and the patient too are able to bear and then enjoy thought's dynamism and motility, and remain open to the dream's casual disrespect for familiar sensual space. It is also I think implicit in the diagram, in which 'patient' and 'analyst' do not feature as vectors, that the contributions of each to this transformative dreaming activity can never be clear-cut. For it takes place within the field between and around them and furthers its evolution; they might indeed have a sense of the field dreaming them.[24]

It is a transformation

> in which the analyst ... precedes every communication by the patient with a kind of 'magic filter' comprising the words 'I had a dream in which...'; this represents the highest possible level of positive functioning of the field – namely when the field itself dreams. Sense date are transformed by the α-function into thought.
>
> (Ferro, 2009, p. 214)

Analysis is a motor of generativity, a process of turning reality into dream, and connecting with the non-sensuous field. Since 'verbal statements ... were developed from a background of sensual experience' (Bion, 1970, p. 1), existing language is, by definition, inadequate for this. So Civitarese has coined a new Italian verb: 'inconsciare', to 'unconsciate'

> (Civitarese, 2016, p. 90).

Caesura

How else is this metaphor of the caesura to be thought about and made use of? Existing metaphors are already a great help, for example, the linguistic metaphor used by the British Independent analyst Patrick Casement as an aid to listening. The patient speaks, and what she says—if the listener can play around with the grammatical structure and parse the speech differently, ignoring its 'commonsense' meaning—is that someone or something is in some relation of some as yet unknown kind to someone or something else. What is subject, verb, object, qualifier? It is a question to be always kept open (Casement, 1985).

Binaries such as 'conscious/unconscious' and 'thinking/feeling', populate any analyst's lexicon, and no therapist would deny that the ability to feel is fundamental—as it was for Cézanne.

24 The dream, or the 'dream-field', dreams us. The 'primitive' status of this idea is deftly registered in Werner Herzog's film *The Enigma of Kaspar Hauser*. The grown-up *enfant sauvage* Kaspar reports one morning that it has been dreamed to him/he has been dreamed. His kindly educator, a thorough-going representative of Enlightenment, corrects Kasper's grammar, for he must re-instate the subject as active author of the dream (Herzog [Producer and Director] 1974).

You understand, it is enough to feel ... your feeling never gets lost ... emotion is the principle, the beginning and the end ... if I'm cold, if I draw, if I paint as they do in the art schools, I'll no longer see anything. A mouth, a nose, done to formula, always the same, without soul, without mystery, without passion.

(Gasquet, 1921 and 1926, p. 152)

But what is also required is what Bion called 'binocular vision' (Bion, 1961): critically, thought plus feeling. The importance of feeling does not mean that cognition and intellectual deliberation have no part to play; there are points at which decisive intervention is called for. Cézanne was clear about this too. 'One has to ... get past feeling, have the audacity to give it objective shape and be willing to put down squarely what one sees by sacrificing what one feels' (Gasquet, 1921 and 1926, pp. 152–3).

I may *feel* tremendous sympathy and respect for my patient, for the accomplished grown-up that he is; but I *see* him having a small tantrum when I make a clumsy intervention, and much as I don't want to have this experience of him—as a cross child—or the feeling of irritation this brings up in me, the analytic task requires me to have the audacity squarely to put down what I see, at least in my own thoughts, and in this way to extend and deepen my picture of him, and thus not get in the way of him assuming his own fuller shape and active potential in the field.

In the painter there are two things, the eye and the brain; each should help the other. Both must be developed, but in the fashion of a painter; the eye by the vision of nature, the brain by the logic of organised sensations, which provide the means of expression ... The eye should concentrate, devour; the brain formulate. We identify ourselves with objects, we are carried away by them.

(Gasquet, 1921 and 1926, p. 159)

'You need to reflect ... the eye isn't enough, you need reflection' (Rivière and Schnerb, 1907, p. 89), said Cézanne.

And one, of course, might inform the other: 'sensation' might inform viewpoint; conscious reflection or shift of perspective might elicit new sensation. 'Eye and brain', 'feeling', and 'thought' exist in dialectical tensions with each other. One is immersed in the world of the patient and the co-created world of the session, identified, carried away; but the task of organising what Jeff Eaton has called the 'the data of experience' (Eaton, 2011, p. 134) remains.[25]

'Reflective, progressive analysis [l'analyse réfléchie et progressive]' (Bernard, 1904, p. 34): there is continual oscillation between eye and brain, feeling and thought, certainty and doubt, being moved and being numbed, clear and confused.

25 '[L]istening to myself listening to the patient becomes a necessary and essential way of gathering, monitoring, exploring, and elaborating the data of experience' (Eaton, 2011, p. 134).

Certainly, the analyst's silences, like the pauses between Cézanne's brushstrokes that Gasquet recalled (Gasquet, 1991, pp. 210–14), are spaces for allowing the next mark/observation to form itself, for the mysterious process of 'transcending the caesura', in response to the other person. The results of reflexiveness of this kind are only ever partly derived consciously.

'There is no such thing as line ... no such thing as modelling, there are only contrasts. When colour finds its richness, form finds its fullness', said Cézanne (according to Bernard, cited in Denis, 1907, p. 176). If he was never satisfied with the idea of line as outline, he did not, as we have seen, totally abolish line in his mature painting, making colour and plane do all the work at all times. Cézanne's line comes to function not merely as a means of defining the limits of objects but as a marker of the simultaneous separateness and unity of things, and more.

Cézanne's use of the drawn line was explored in detail in a book of 2008 by Matthew Simms, in relation to his watercolours, where line-colour relations can most easily be studied. From his early gestural deployment of both pencil and brush (1860s), Cézanne goes on to reverse usual watercolour practice and bring pencil back on top of colour; such freedom of approach will characterise his entire oeuvre. Under the influence of Pissarro and the Impressionists in the 1870s, gesture becomes less important, and he divides the tasks of registering mass and volume, and light and atmosphere: line becomes more incisive and colour lighter and more transparent. In the 1880s and 1890s, the patterns and rhythms of his attention itself become his major preoccupation, and his works mnemonic records of the process of representation itself; pencil and paintbrush begin to follow divergent paths across the surfaces, with wide variation between the amounts of drawing and colour in watercolours of the same motif. Graphic discontinuities, as for example in stunning views of the Montagne Sainte-Victoire of the late 1880s, register perpetual transformation. And this is why, in his late work especially, series is so important.[26]

In his late work, pencil and brush tend to greater collaboration, as in the outdoor portraits of the gardener Vallier, with their concern with rendering the 'envelope', the intervening, shaping space and atmosphere between eye and motif. Line joins colour, along with untouched areas on the supporting surface, to calibrate optical and physical sensations, and there is a return to gesture: in watercolours related to the late Bathers, and in the figures themselves, both drawn and painted lines are used to catch a sense of the body in movement (Simms, 2008; Snell, 2008).

And here Cézanne gives a living demonstration of his Bergsonism. The role of Bergsonian 'durée' in his work was noted by critics at the time. Cézanne's challenge was to 'give an idea of the whole and of duration with an instantaneous image', wrote Gustave Geffroy in 1901 (Geoffroy, 1901, p.64). Simms, paying close attention to views of the Montagne Sainte-Victoire made from the second half of the 1880s, notes a 'mnemonic layering' in the different ways Cézanne

26 See the catalogue of the great Museum of Modern Art, New York, exhibition of 1977, *Cézanne. The Late Work* (Rubin, 1977).

related pencil outline and hatching to watercolour from one work to the next, leading to a sense of temporal 'accretion' (Simms, 2008, p. 119) like that evoked by Bergson:

> My mental state, as it advances on the road of time, is continually swelling with the duration which it accumulates: it goes on increasing—rolling upon itself, as a snowball on the snow ... [For] the vision I have of [the object] now differs from that which I have just had, even if only because the one is an instant older than the other.
>
> (Bergson, 1907, pp. 1–2, cited in Simms, 2008, p. 120)

Cézanne gives us 'a sensory palimpsest of tactile and optical information' (Simms, 2008, p. 119) that registers 'the shifts and changes in his unfolding perceptual experience as they emerge in the process of rendering the motif', the temporal ebb and flow of his sensations. These shifts and that flow are literally retained in the watercolours. For the viewer notes the interval of time between the painter's putting down the pencil and picking up the paintbrush [illus. 3.7], together with variations, from work to work, in his use of pencil and brush and the relationship between them, in response to 'different sensory priorities and attentive itineraries' (Simms, 2008, p. 123). What is more, the accumulation of time is embodied in both Cézanne's watercolours and his oil paintings through, as the art historian George

Illustration 3.7 Paul Cézanne, *Mont Sainte-Victoire*, c. 1895 (recto). Watercolour over graphite on wove paper, 21.1 × 27.4. National Gallery of Art, Washington DC. The Armand Hammer Collection, Accession No. 1991.217.27.a. Open Access—Public Domain

Heard Hamilton was the first to note in the 1950s, the inclusion of multiple perspectives across closely successive depictions, slightly different views of the same motif, most notably the Mont Sainte-Victoire (Simms, p. 120): shifting vertices.

Bion addressed his version of the 'line' problem in a short but seminal late paper, 'Caesura' (Bion, 1977), in which he advocated the 'transcendence of the caesura', that is, a radical suspension of judgement regarding familiar and less familiar binaries. Inside–outside, past–present, self–other, knowing–not-knowing, psychotic–non-psychotic, reality–dream, history–dream, content–form, contained–container, syntagm (linear, horizontal, narrative)–paradigm (vertical, associative, inter-relational) (Civitarese, 2008, p. 1135, note 6): these and myriad other binaries must be 'deconstructed', as Civitarese, referencing Derrida, has put it (ibid., p. 1131 et seq.). Where one thing ends and another begins is put under a question mark, subjected to doubt. This for Bion is essential if stasis is not to ensue, and growth and life are going to be possible.

In the light of Bion's account of the interaction between mother and child and the idea of the interpersonal unconscious, Civitarese insists on the absolute centrality of 'transcending the caesura'. The caesura, he writes, is a boundary 'understood as an area of functional articulation' rather than as an impenetrable frontier (Civitarese, 2016, pp. 85 and 93). It is an 'écart', marking the 'chiasmic' (Merleau-Ponty, 1964a, pp. 177–8). Thus instead of the binary opposites 'conscious–unconscious', Civitarese proposes the notation 'un/conscious', which gives the pair back their dialectical nature. 'The slash that separates the two terms can be conceptualized as a caesura that has the dual function of separating and uniting' (ibid., p. 88; Sandler, 2005).

The contact barrier or caesura is thus not a rigid barrier against an overwhelm of β-elements but a constant negotiation with it. It is 'the *semi-permeable* membrane that separates the conscious and unconscious and regulates the functioning of the apparatus for dreaming and thinking' (Civitarese, 2016, p. 96). And more than this, it is constantly under construction: β-derived α-elements, 'material suitable for dream thoughts' (Bion, 1994, p. 233), enclose micro-experiences of meaning that participate in actually *forming* the contact barrier and thus broaden the unconscious, that is, the individual's capacity to do psychic work on inside and outside stimuli (Civitarese, 2016, pp. 95–6).

Each element contributes to constructing the caesura, and so towards making the further distinctions upon which the elaboration of concepts relies. This is also what gives rise to the awareness of the passing of time, of 'durée'. Civitarese, in his commentary on Bion's paper, emphatically puts it thus:

> the caesura of birth is the model of the birth of every new thought. Just as the caesura of birth makes one insensitive to the persistence of more primitive forms of knowledge and levels of the mind, so *every new idea establishes a new caesura, a barrier, an obstacle to other ideas, which are thrust back into a cone of shadow, if not positively 'killed'*: 'A foetal idea can kill itself or be killed, and that is not a metaphor *only*' (Bion, 1977, p. 417).
>
> (Civitarese, 2008, pp. 1130–1)

But how is this transcendence to be achieved? The invitation extended by Bion is to adopt a variety of viewpoints; and only then, as Civitarese puts it, 'does the shifting play of caesuras become equivalent to the respiration of the mind' (ibid., p. 1131). The idea of 'transcending the caesura' is itself double-edged, for all discrimination of one thing from another depends on a caesura: this–that. Bion's paper is prefaced by no less than ten quotations, the first being from Freud: 'There is much more continuity between intra-uterine life and earliest infancy than the impressive caesura of birth allows us to believe' (Freud, 1926, p. 138). It is never a question merely of substituting one term for another, for that would simply replicate the binary system, but of tolerating insecurity, ambiguity, 'the paradox of more than one truth and the aporias of reason' (Civitarese, 2008, p. 1131). The invitation is to allow interplay between viewpoints, a process of deconstruction fertilised by free association and what Civitarese calls 'the dissemination of sense' (ibid.). 'Investigate the caesura', Bion instructed, 'not the analyst; not the analysand; not the unconscious; not the conscious; not sanity; not insanity. But the caesura, the link, the synapse, the (counter-trans)ference, the transitive-intransitive mood' (Bion, 1977, p. 56). Not the electrical poles themselves, but the field generated between them.

Civitarese, referring to the ten quotations heading Bion's paper, suggests their presence invites us to put ourselves

> in the position of adopting a number of vertices which converge on a point to produce a consensual experience, each quotation as it were being a split that can be maintained but nevertheless recomposed—recomposed 'transitively', that is, in a way that overcomes barriers.
>
> (Civitarese, 2008, p. 1132)

He might be describing Cézanne's procedure, his adoption of multiple viewpoints in successive depictions of the Mont Sainte-Victoire, and his refusal to provide objects and figures with artificial outlines, allowing them instead to find their own shapes through his coloured interventions. What can be seen critically depends on the viewpoints from which it is seen, and this was of tremendous importance to Cézanne:

> the motifs multiply, the same object seen from a different angle offers subject for study of the most powerful interest and so varied that I think I could occupy myself for months without changing place, by turning now more to the right, now more to the left.
>
> (Letter of 8 September 1906.
> Cézanne, 2013, pp. 370–1)

The slightest shift could make a world of difference. Bion attempted to tabulate his theory of shifting 'vertices' in his grid, showing the multiplicity of different positions from which analyst and patient might be speaking at any given moment in a session.

In the end, the task as both Bion and Cézanne conceived it was to find a position whereby things might come together—a commitment, however, that rested uneasily, painfully, alongside a recognition that such a position could rarely if ever be found, let alone maintained.

To Gasquet, Cézanne offered this demonstration, a statement of his ambition:

> All right, look at this ... (He repeated his gesture, holding his hands apart, fingers spread wide, bringing them slowly, very slowly together, then squeezing and contracting them until they were interlocked.) That's what one needs to achieve. If one hand is too high, or too low, the whole thing is ruined. There mustn't be a single slack link, a single gap through which the emotion, the light, the truth can escape. I advance all of my canvas at the same time ... And in the same movement, with the same conviction. I approach all the scattered pieces ... Everything we look at disperses and vanishes doesn't it? Nature is always the same, and yet nothing of what appears to us remains. It is our art's job to convey the thrill of nature's permanence [le frisson de sa durée] along with the elements and the appearance of all its changes. We must taste her as eternal. What is behind her? Maybe nothing. Perhaps everything. Everything, do you understand? So I join together her straying hands ... I take from right and left, here, there, everywhere, tones, colours, shades, I set them down, I bring them together ... They make lines. They become objects, rocks, trees, without me thinking about it ... They take on volume. They have a value. If these volumes, these values correspond in my sensibility and on my canvas to the planes, the marks that I have there and are in front of our eyes, well, my canvas joins hands. It doesn't waver. It goes neither too high nor too low. It is true, it has density, it is full.
>
> (Gasquet, 1921 and 1926, pp. 108–9; and see
> Gasquet, 1991, p. 148)

The seriousness of the challenge this presents is not to be underestimated. As Civitarese points out, what Bion does in his thinking on the caesura is to dynamise a situation of static splitting. Splitting is a kind of normal hallucinosis required for the ordinary structuring of experience, as well as something recruitable as a defence against mental pain so intolerable that it might threaten psychic integration. Indeed, it is 'intolerance of frustration [that] ... establishes the cut, the breach, the pause, and ... renders a viewpoint absolute and conceals continuity' (Civitarese, 2008, p.1132). Turning to the world of our visual experience, Civitarese illustrates this by referring us to the optical illusion of the duck and the hare. We cannot see both simultaneously; a part of the figure simply disappears, and we see either one or the other (Civitarese, 2008, p. 1132) in a shifting reversal of perspective. Can it all be held together, as Gasquet's Cézanne would suggest? Perhaps the reality was close to what Bion does; that is, writes Civitarese,

> Bion *re-reverses the perspective, but without eliminating the ambiguity resulting from the consciousness that more than one viewpoint exists, that these viewpoints cannot be reduced to one another, and that what we call reality is what our states of normal hallucinosis cause us to see.* It thus

becomes clear that the concepts of negative capability, binocular vision, the vertex and dynamic splitting are all corollaries of transcending the caesura … models of *reversibility*.(ibid.)

'The work of the analyst is to restore dynamic to a static situation and so make development possible' wrote Bion (1963, p. 60). Civitarese proposes a new sign, ± RP, 'to denote the twofold functionality of reversible perspective, preceding it by a plus sign (+) or a minus sign (−) according to whether it serves the purpose of dynamic or of static discrimination' (Civitarese, 2008, p. 1133).

In the end, for the Italian field analysts, 'dynamic discrimination' is best served not by systematic thinking (the kind of thinking that Civitarese so impressively brings to theoretical questions), but through living metaphors. 'As ideas interwoven with emotion, they enable us to see reality from a number of different angles, investing it with a "poetic" ambiguity' (Ferro and Civitarese, 2015, p. 94).

Such metaphors, Ferro joins Civitarese in insisting (the context is an argument with the American Relationalist Donnel Stern), are true symbolisations, not to be confused with symbolic equations, in which one thing is simply equivalent to another, as in psychosis: 'Bion would describe this situation as transformation in hallucinosis' (Ferro and Civitarese, 2015, p.94). Metaphor and reverie are, on the contrary, products of the unconscious and of dream, that 'psychoanalytic function of the personality' which constantly seeks 'a basic psychosomatic integration' (Ferro and Civitarese, 2015, p.94).

Working on the caesura 'dreaming/waking', Ferro and Civitarese continue:

> The dream proper is defined by the equation 'dreaming + awakening'. Only then does the dream reward us with the intuition of living in a number of possible worlds, and of having a completely virtual inner reality even if that reality is, in its way, just as actual as material reality … We give precedence to the logic of a dream … over abstract reason, because we are convinced that, in the telling formulation of Ogden (2005), the unconscious speaks with a quality of truthfulness that conscious experience lacks.
>
> (Ferro and Civitarese, 2015, pp. 94–5)

Dream and metaphor, our most profound forms of thought, are key agents for caesura-transcending transformation. But bearing with ambiguity, and discovering the number of possible worlds we might inhabit, can also feel like the gravest of insults to logic and conscious experience.

'Emotional turbulence, pain, and states of psychological crisis are … inherent in psychic growth', and for Cézanne as for the analyst, 'every "true" interpretation is mediated by the … experience of persecution, fear and depression' (Civitarese, 2008, p. 1134). For the process of transformation is interminable, and marked by undecidability. The mind is continually called upon to transform β- into α-elements, proto-emotions into visual images, and to allow 'preconception … to be mated with a realisation to produce a conception' (Bion, 1963, p. 40). On every crystallisation of sense, 'the β-elements reopen the process of assignment of

meaning'. Symbolisation can thus be seen only as being in 'a state of continuous tension with its own undoing' (Civitarese, 2008, p. 1133–4).

Perhaps this gives a measure of the extent of Cézanne's turbulence and doubt, in the face of his self-imposed task to find a viewpoint from which the caesurae on which representation had depended might be transcended, and continuity, with a sense of 'rightness', truth, and fullness, might be restored. This man of the nineteenth century wished to come to grips with the material world and find harmony and stability in it, and seeing in the resultant work merely the record of a struggle caused him great pain.

But no wonder Picasso found Cézanne's anxiety so compelling, and no wonder Merleau-Ponty was fascinated by his doubt; and no wonder his work received the reception it did from most of his contemporaries. New thoughts calling for 'an unaccustomed permeability of conscious to unconscious thought'—precisely the state pursued by negative capability and +RP—can appear strange or mad (Civitarese, 2008, p. 1135). 'You have only to see the people going through the … rooms … on a Sunday: amused, ironically irritated, annoyed, indignant … affecting a note of pathetic despair', wrote Rilke at the great Cézanne retrospective in 1907 (Rilke, 2002, p. 52).

The session (mountain) itself

The locus for transformation and for the appearance of the new—on the canvas as within the dreaming capacity of patient and analyst—is above all the session itself.

The existence of the frame, the fact that the picture has edges, draws our attention to the 'facticity' of the session ('scéance'/sitting), during which the model has submitted to the painter's request that she sit comfortably but still. The frame insists: this here and not that there, outside; the frame brings into focus a sense of inevitability, that for all the enigmas and ambiguities that are yet to be explored, things are this way and not otherwise. Yet the frame itself, following Derrida (1978), is *parergonal*: it has the qualities of caesura, the peculiar status of being in itself neither inside nor outside (Civitarese, 2008, p. 1131, n. 5), and it is, in this sense, transcendable, permitting the boundaried session to live on in patient and analyst, just as the painting can live on in the life of the viewer.

The more the session is played out on the level of a mutual dream, the more helpful it will be in repairing the patient's α-function, their capacity to transform raw sensation into image-thought-feeling. It too is a form of (slow) cooking. The session is a potentially aesthetic object in itself, given the absolute importance of its 'form': it is 'the medium whereby the artist[/analyst] transmits to the spectator his reverie, translated into the primordial language of forms and sensations, and in this way contains his anxieties and helps him feel more integrated' (Ferro and Civitarese, 2015, p. 61). It also belongs to a series, allowing the same 'motifs' to be explored over and over again, each time from a slightly different angle and under differently changing light.

'When through the water's thickness', wrote Merleau-Ponty,

I see the tiled bottom of the pool, I do not see it despite the water and the reflections; I see it precisely through them and because of them. If there were no distortions, no ripples of sunlight, if it were without that flesh that I saw the geometry of the tiles, then I would cease to see it as it is and where it is—which is to say, beyond any identical, specific place. I cannot say that the water itself—the aqueous power, the syrupy and shimmering element—is *in* space; it is not somewhere else either, but it is not in the pool. It inhabits it, is materialized there, it is not contained there; and if I lift my eyes toward the screen of cypresses where the web of reflections plays, I cannot deny that the water visits it as well, or at least sends out to it its active, living essence. This inner animation, this radiation of the visible, is what the painter seeks under the names depth, space, and colour.

(Merleau-Ponty, 1964, pp. 70–1)

In his efforts to see if two and three dimensions could co-exist, Cézanne teaches or reminds us of the simultaneity, enmeshment, and marriage of 'surface' and 'depth'. In this light, what matters is the session's weft and warp, its aesthetically sensed rhythms, tones, and colours, the session, as Bollas puts it, as symphony (Bollas, 2007). For the picture is not a simple and lesser double of another thing. 'It is not a faded copy, a *trompe l'œil*, or another *thing*' (Merleau-Ponty, 1964, p. 22). It has a special status. It is where the action is.

Merleau-Ponty also wrote this beautiful passage on the cave paintings at Lascaux:

The animals painted on the walls of Lascaux are not there in the same way as the fissure or the swelling of the limestone. But they are not anywhere else either. Projecting a little, receding a little, they radiate around themselves without ever breaking their moorings. I should have a lot of trouble saying just *where* the picture is that I am looking at. For I do not look at it as one would look at a thing, I do not fix it in its place, my look wanders in it as in the clouds of Being, I see according to it or with it more than I see it.

(ibid., pp. 22–3)

Writing of the Chauvet cave paintings, only discovered in 1994, Robert Macfarlane notes how the horses, bison, and other animals so lovingly and hauntingly drawn on the cave walls seem to float, their habitat the darkness and the rock itself. He cites Simon McBurney, for whom the animals inhabit a present that embraces past and future, in a vast, flowing continuum. They are alive just as the rock and everything around is alive. Perhaps, writes McBurney in a thoroughly Bergsonian conclusion, what separates us from the makers of this art is our own sense of time: in dividing our lives up into milliseconds, we separate ourselves from that is all around us (McBurney, 2011, cited in Macfarlane, 2019, p. 281).

The session, like the rock and the field itself, is not a place. It is a 'frontier of dreaming' (Ogden, 2002, p.1), a time-out-of-time. I see 'according to' or 'with' it. There is no pure 'fact' outside the session and the field, and no unconscious

'other' territory, just as there is no primal purity, timeless and beyond culture, to the life of the unconscious as it manifests in the session. There is instead, in the here-and-now of the session, an 'inexhaustible reality full of reserves' (Merleau-Ponty, 1945c, p. 20), the patient's, the analyst's, and the field's, permeated by the active essence and 'inner animation' of what is not yet known or experienced. This must be respected and tempted to show itself by means of the tentative, unsaturated interpretation, or many such touches—'sensation' and reverie-derived, intuited, metaphorical, observational—so that a 'shape' inseparable from the field and contributing to its shaping may emerge. And the therapist is part of it—but with a special responsibility. She must be prepared, like the painter, to register and embody messages emanating from the field, to the extent that she is able to receive them, and to respond by finding metaphorical, interpersonally communicable equivalents for them.

Of course, writes Ferro, blinding oneself to external reality

> does not mean taking substance away from historical and external reality, but allowing it to become embodied there [in the session], in the only place where it can be transformed, and if 'my boyfriend won't answer his phone' to live through the pain of this with the patient, knowing it is we ourselves who have not answered ... too simple to interpret it. First we must 'answer'.
>
> (Ferro, 2019a, p. 35)

The session itself is new experience.

> It is no longer a question of speaking about space and light, but of making the space and light which are there speak. It is a question without end, since the vision to which it is addressed is itself a question.
>
> (Merleau-Ponty, 1964, pp. 59–60)

The session's healing function, 'to make unconscious what is overly conscious ... to transform an overly concrete reality into a reality that can be dreamt' (Ferro and Nicoli, 2017, p. 118), aims to foster 'an analysis in which there is always a chance to stay mentally alive and never to be paralysed by a concrete fact of life, not even by the most tragic ones' (ibid., p. 137): 'inconsciare'. And this I think brings us close to what Cézanne may have meant when he said: 'My method, my code, is realism. But realism, understand me clearly, that is full of grandeur' (Gasquet, 1921 and 1926, p.126): the concrete not ignored but transformed and transcended in the painting into a new awareness, 'the immensity, the torrent of the world in a little inch of matter' (ibid.).

'There can be no consciousness that is not sustained by its primordial involvement in life and by the manner of this involvement', wrote Merleau-Ponty (1945c, p. 124). This is how analyst and patient learn, just as the painter's vision 'learns only by seeing, only from itself' (Merleau-Ponty, 1964, p. 25). It is a sort of phenomenology *à deux*.

Cézanne's 'motif' might stand for 'field' itself, or 'patient', or 'session', or 'current preoccupation', or 'dream figment', since they are fundamentally related, implicated with each other: there is no such thing as a patient without a session or a session without a field. With this in mind, perhaps this commentary of Merleau-Ponty's can take on its full suggestive force. For Cézanne, he wrote, it is

the mountain itself which, from over there, makes itself seen by the painter; it is the mountain that he interrogates with his gaze. What exactly does he ask of it? To unveil the means, the merely visible means, by which it makes itself mountain before our eyes. Light, lighting, shadows, reflections, colour, all these objects of his searching are not altogether real beings; like ghosts, their only existence is visual. In fact they exist only at the threshold of common vision; they are not ordinarily seen. The painter's gaze asks them what they do to cause there suddenly to be something, and to be this thing, what they do to compose this talisman of a world, to make us see the visible.

(Merleau-Ponty, 1964, pp. 28–9)

Such is the reflectiveness and sense of wonder to which the working analyst might aspire. How is this person *making* themselves and making themselves known, coming into being, in the here-and-now with me, by what mysterious means? We have 'an emerging order, an object in the act of appearing, organizing itself before our eyes' (Merleau-Ponty, 1964a, p. 14).

What matters, wrote Civitarese, is direct evidence in the present, in the analyst's consulting room (Civitarese, 2008, p. 1134). For Bion, 'the important thing about the patient's state of mind is that it exists *at the time* he or she is seeing the analyst' (Bion, 1991, p. 645), thus 'interpretation should not be a reflection distinct from the act of seeing' (Merleau-Ponty, 1945c, p. 15). Other kinds of reflection, in psychoanalysis, 'distinct from the act of seeing', risk being merely psychologising meta-commentary, at a remove from the phenomenology of the session and the field, and the feeling between and around the protagonists.

It is also, for the analyst as for the painter, a question of embodiment, of 'a capacity for an invitational, embodied communication: being present in a conversation with oneself while thinking and speaking with another/others' (McCaig, 2019, p. 144). This is the kind of 'psychoanalytic, improvisational communication' that the psychoanalyst Julie Michael McCaig felt she was receiving when listening to a recording of Bion's 1975 'Caesura' lecture, an experience she felt was like 'listening to music and then resonating with the mind of the composer/musician as well as their emotional presence' (ibid.).

'To be a painter through the very qualities of painting, to use rough materials [de matériaux grossiers]' (Bernard, 1907a, p. 63) was Cézanne's stated aim. If the 'rough' or 'coarse' comes as a surprise in the context of our discussions, I think it is a reminder of how important it is for the analyst to hold a constant critical question mark over whatever apparent sophistication her thoughts and theories might seem to possess. It is also the roughness, the traumatic element, of the sheer fact

of our meeting with an other. Above all, it echoes the imperative, following Bion, to *be* an analyst, through the very qualities of analysis. 'You really have to be the kind of personality who will do the job', as he put it (Bion, 2018, p. 86)—to have the equivalent of what Cézanne called 'tempérament'.

Ferro and Civitarese similarly regard working analytically in the field as

> a way of proceeding that can never take its tools for granted and consider them definitive ... a radical contextualization of the construction of meaning ... more like a research activity than striving to attain a goal ... the truth of the analysis is no longer something one arrives at, it cannot be fixed or possessed ... it lies rather in the experience, it *is* the experience.
>
> (Ferro and Civitarese, 2015, p. xv (ibid., p. 59))

The task of the painter and the analyst is 'guaranteeing and safeguarding the setting, and promoting an activity of an oneiric kind' (Ferro, 2019a, p. 59). The field, writes Ferro, is an 'unsaturated waiting room', in which proto-emotions stay 'until they can be brought back to their saturated density, in the relationship and in the construction' (ibid.). What a nice analogy for the way in which, in front of a painting by Cézanne, if we can linger long enough, in patient reverie, the painter's coloured 'touches' transform themselves and the canvas takes on 'density, life and body' (Ferro, 2019a, p. 35), resolving into relationship and construction. We re-connect with the activity of our own transforming 'inner painter' (Ferro and Civitarese, 2015, p. xvii), and are mysteriously reminded of its existence.

In 1970 Bion wrote:

> Today I saw the absolute un-necessity for a session to be ... anything but a session in its own right. Progress could then mean that instead of presenting one fact in six months, the patient comes to present six facts in one session. In short, he becomes a multi-dimensional personality—a three-dimensional physical entity, and a multi-dimensional psychical identity.
>
> (Bion, 1994, p. 312)

'Characters'

The 'facts' that populate the field through the transformation of β-elements are multiple and heterogeneous. They become dynamic, active agents, in this indeterminate space that is the birthplace of Winnicott's 'cultural experience' (Winnicott, 1971). They breathe life into each other, just as the poetry of Musset and the landscape of Aix enlivened and illuminated each other for Cézanne: experiences that constitute the deeply personal essence of analysis.

Thus for Ferro, an analysis might be

> the creation of a field, or an affective theatre, in which all the characters that will eventually populate the analyst's consulting room become

three-dimensional, assume bodily form and speak their lines, thus conferring thinkability and expressibility on what had previously been exerting pressure in the form of an 'inexpressible condensate'.

(Ferro, 2005a, pp. 99–100)

D. H. Lawrence's view that Cézanne painted heads as if they were apples (Lawrence, 1929), and Merleau-Ponty's account of an 'unfamiliar world ... that forbids all human effusiveness' (Merleau-Ponty, 1964, p. 16), register Cézanne's refusal to make 'personality', the particular character traits of the sitter, his conscious focus; 'personality' emerges of its own accord through the work. For Cézanne did not 'neglect the physiognomy of objects and faces': he simply wanted to capture it emerging from the colour. Painting a face 'as an object' is not to strip it of its 'thought' (Merleau-Ponty, 1945c, p. 15).

Cézanne himself, at least according to Gasquet, appears to have had a rather different view from Lawrence's, and to be more open to animistic communions than might even be supposed from Merleau-Ponty's more nuanced reading: less a question of heads as apples than of apples as characters, in their particularity.

'False painters don't see *that* tree, *your* face, *this* dog', he told Gasquet, 'but the tree, the face, the dog. They see nothing. Nothing is ever the same' (Gasquet, 1921 and 1926, p. 126). He had been talking with Gasquet about portraits.

> People don't think a sugar bowl has a physiognomy, a soul. But it changes every day too. You need to know how to get hold of them, to woo them, these gentlemen ... those glasses, those plates, talking away among themselves. Endless confidences ... I've given up on flowers. They fade far too fast. Fruits are more dependable. They like having their portraits done ... objects interpenetrate ... they never stop being alive, you understand ... They insensibly spread intimate reflections around themselves, like us with our looks and words.
> (Gasquet, 1921 and 1926, p. 157; 1991, p. 220. Appendix 4)[27]

If unlike Georges Clémenceau, they don't dazzle by imposing their personalities too forcefully, these objects will reveal their 'characters' and enter into relation with each other. This is why Cézanne preferred to paint familiar and humble objects and people.

According to a schematic mapping of analytic models undertaken by Ferro, 'classical' psychoanalysis would accept other people and things in the patient's account as belonging to reality. Kleinians, without denying reality, would primarily see these various figures and objects as inhabitants of the patient's internal world. In the field model, in its different incarnations, they would be 'affective holograms ... functions of two minds ... actors who allow

27 This nineteenth-century trope was 'in the cultural field', and was employed in the previous generation by, for example, the poet and art critic Théophile Gautier.

us to share a dream within the session' (Ferro and Nicoli, 2017, pp. 85–6): 'characters'.

The 'character', a concept so central to Ferro's thought, is 'a narrative nodal point bringing together different emotions that can be disentangled and joined together again in a different manner in order to form new characters'. He notes that he owes this theme not only to narratology and semiotics but also 'to the personifications that Bion made of psychoanalytic concepts in his *A Memoir of the Future*' (Ferro, 2019a, p. 245).

In one of Ferro's and Civitarese's preferred metaphors, the setting—the analytic frame, the consulting room/atelier—is the dream theatre for the play of characters, and the analyst must become a seasoned theatregoer. In post-Bion field theory, 'characters', what is more, are not always objects or human figures but also qualities and patterns: geometrical, geological, relational.

> Since in a field model it is no longer meaningful to consider analyst and patient as two isolated subjects, it makes greater sense to think in terms of the field's capacity for gathering and elaborating energies and possible meanings at its different 'nodal' points. The idea of a transference-countertransference axis greatly recedes in importance.
>
> (Ferro and Nicoli, 2017, p. 70)

For the situation 'is not that the patient is the contained and the analyst the container; these are in fact constantly alternating functions. A number of container-contained relationships are simultaneously active on various levels and in different roles' (Ferro and Civitarese, 2015, p. 92).

I think of the concave and convex objects across the field of a still life by Cézanne. As well as the canvas as a whole, each apple or peach, not to mention bowl or jug, works as a 'container' in that it can bring the viewer pleasure, surely linked to a moment of respite from anxiety; in addition, there is the containing hum of conversation between them. Consider for example *Un coin de table* in the Barnes Foundation [illus. 3.1]. The fruits, plate, and folds of cloth are speaking the grammar of concave/convex which, for Ferro, is 'the basis of every more complex emotional affective grammar' (Ferro, 2019a, p. 59).

> When the analytic apparatus is activated because there is a tool, the setting, it's like being in the theatre and the lights go out, the voices fall silent, and from that moment on you only hear whispers: then begins the session.
>
> (Ferro and Nicoli, 2019, p. 41)

The patient talks about his wife; but she is no longer his wife, she is a 'character in the field', and who knows who or what the patient is talking about through that character. 'About parts of the analyst that the patient feels rejected by, about parts of the analyst that he loathes, about aspects of himself that he calls "my wife" because he cannot recognise them as his own'. Suppose he says '"My wife is violent, keeps losing her temper, is irritable". It seems pretty obvious that he's

talking about an incontinent aspect, which might be the analyst's, or perhaps the patient's: nevertheless in the field' (Ferro and Nicoli, 2017, p. 41).

Such an 'incontinent aspect' might enter the field as an important player, shaping and delimiting it, at worst through some form of enactment—until, that is, it can be 'elaborated' through reverie and play (Kleinians would perhaps theorise this as an interplay of projective identifications), and brought into relation with other 'characters'. This takes place through communication 'in colour': through affective metaphor and 'touches' of 'unsaturated' interpretation, with careful attention to the patient's response. And then there are many possible forms the analyst's answer to the patient's response might take—in the hope that they are life forms, so that the answer does not become, in a phrase of Maurice Blanchot's that Bion was fond of citing, 'the question's misfortune, its adversity' (Blanchot, 1969, p. 13).

For Bion, the value of a given session could be measured by the variety and depth of feeling it contained (Bion, 1967, pp. 17–18). The loosening and expansion that takes place 'in the field' might remind us of the ancient Greek root of the word 'analysis' itself: loosening, unbinding. Scenes in the consulting room open up 'an infinity of affective storylines' (Ferro, 2019a, p. 35). 'One would have to be able to write like Elena Ferrante', says Civitarese, 'In every line there is a character and an emotion' (Civitarese, 2019, p. 42).

Thus Ferro and Civitarese write of the 'semiotisation' of the object in the session as in the work of art, whereby it becomes hyper-inclusive: Madame Cézanne's red armchair [illus. 1.3] became, for Rilke, a painting-chair, and 'in a theatre a chair on the stage is a theatrical chair' (Ferro and Civitarese, 2015, p. 78), open to multiple uses and representational possibilities.

The analyst's role, in Ferro and Civitarese's idiom, is to 'elaborate' on these possibilities. To slightly shift the vertex of our attention to the 'field' between painting and viewer: what might happen if we take seriously and 'elaborate' the unlikely pairing, mentioned earlier, of Cézanne and Alfred Jarry, if we treat this pairing and the slight unease it produced in me as a 'character in the field', the product of a reverie? It was the outdoor portrait of the gardener Vallier [illus. 1.12], sitting on his chair, that brought Jarry to mind, and something to do with camouflage—I was tempted to dismiss it all as banal—that I remembered from Jarry's novel *Le Surmâle* (1902). I looked up the passage:

> Conformity with one's surroundings, 'mimetism', is a law of survival. It is safer to imitate individuals weaker than oneself than to kill them. The strongest are not the ones who survive, for they are alone. Great skill is required to model one's soul on that of one's concierge. But why did Marcueil feel the need simultaneously to hide and to betray himself? Both to deny his strength and to prove it? To see if his mask was holding up well, no doubt.
>
> (Jarry, 1902, p. 24)

Dappled by light and shadow, Vallier also seems camouflaged, and the 'character in the field', or perhaps it would be more accurate to say 'field function',

that is asking for a welcome is something to do with disguise and protection, perhaps working to hide something else that is feared as unruly, intrusive, or mortally dangerous (something perhaps like the anarchic, wildly inventive and self-destructive Jarry himself). It does not seem too great a poetic and interpretative leap, especially given what we can claim to know about Cézanne, to think of him identifying himself with Vallier, as Gasquet says he did, and of the painter's own wish for privacy, his fear of being intruded upon and even physically touched, his dread, for example, of being kicked in the behind (Danchev, 2012, p. 316), and of the various 'masks' he adopted—'child', 'primitive', character from a novel—to protect and define his emotional and mental working space (Smith, 2007). But further than such well aired biographical speculations we cannot go, not having the painter with us in person.

Thinking however in terms of the relationship between viewer and canvas, and carrying our thoughts over to the interpersonal, analytic field, we might think of the Barangers' 'bastions', the analyst's and the patient's shared, collusive, and maybe up to now unconscious wish to mask something feared as unruly between them and to protect themselves from it. The whole defensive process might of course also look like a sort of a harmony; the portrait of Vallier does seem to speak of a profoundly satisfying one-ness of seated man and landscape. In which case, perhaps what we now have is a wider field of binocular vision, a 'both-and' in tension: the canvas/analytic relationship as an interpenetration that is also a mask. For the passage from Jarry reminds us not just of identification but also of a life-and-death struggle for survival, of what, for Cézanne, really was emotionally at stake. The question is never closed or settled; and if the Jarry 'character' opens up a new space for appreciation of the emotional and existential depths and dimensions of a work by Cézanne, how much more might characters in the session open up the analytic space, to reveal what Politzer, in the 1920s, was calling 'unforeseen' subjectivities (Politzer, 1994, pp. 116, 125, etc.).[28]

28 In his reaching into 'the secret spring of poetry beneath the crust of fact' (Lowes, 1927, p. 37), the source of 'amorphous particles[s] of poetic protoplasm' (ibid., p. 191), John Livingston Lowes dwells on a passage in the 'Ancient Mariner'—the stanzas describing the approach of the ghost-ship—and persuades it to disclose its imaginative and associative sources:

> the road from Llangunnog to Bala, as well as the rocky declivities of Penmaenmaur, contributed its quota to a picture in which phantom sails that glanced like the floating cobwebs on the Quantocks vanished in the swift fall of a night that had descended in Norway and the West Indies and on the Nile, while a star-dogged moon came up whose horns had first hung portentous over Boston.

> (ibid., p. 212)

> A whole field transfigured and given aesthetic shape, as the heterogeneous 'characters' in a session might be, by poetic reverie.

Painter/analyst in the dream field

The analyst and the painter too are part of the field with positions in it, and with a degree of responsibility for the positions they choose to take up. At the same time, the analyst's mind, like the painter's, is 'a significant variable', varying from day to day and subject to how much the patient's material, or the motif, might exceed the analyst/painter's capacity for absorption and transformation (Ferro, 2005a, pp. 60 and 52).

Painting Gasquet *père*'s portrait in 1896 [illus. 3.3], Cézanne said to Gasquet *fils* 'I've the colours of friendship'.

'[E]ach brushstroke I make is a little of my blood mixed with a little of your father's blood, in the sunshine, in the light, in the colour, and ... there is a mysterious exchange that goes from his soul which he knows nothing about to my eye which recreates it, and in which he'll recognise himself ... if I was a painter, a great painter!... each touch must correspond, there on my canvas, to a breath of the world, to the light over there on his whiskers, on his cheek. We must live in accord, my model, my colour and I, together shading in the same passing minute. If you think it's easy painting a portrait ...'

'You make me discover things', Cézanne told his old friend. 'Between you, Henri, and me, I mean between what makes your personality and mine, there is the world, the sun ... what happens ... what we see in common ... Our clothes, our flesh, reflections of the light ... That's what I need to dip into' (Gasquet, 1921 and 1926, pp. 151–3).

Noticing that his friend's mind is elsewhere, Cézanne comments that 'a gust of sensations [une bouffée de sensations]' is coming to him from somewhere else. One of Henri Gasquet's eyes now looks different: 'an atom of light', meeting the more constant light from the window, 'has changed from the inside'. The painter makes some tiny adjustments on his canvas; but then he has to struggle with the other eye, which is ' squinting. It is looking, looking at me, while that one is looking at his life, his past, you [Joachim], I don't know, something that is not me, not us'.

The 'something that is not me, not us' that Henri Gasquet is thinking about is a feature from his and Cézanne's shared social field, very possibly in the setting of the Café Les Deux Garçons: Henri Gasquet says 'I was thinking about the trump which I held onto yesterday up to my third trick' (Gasquet, 1921 and 1926, p. 153).

The painter's and the analysts' unique individualities, shaped by their particular cultural and social fields, are an active factor in the work, contributing to the production of 'living metaphors' (Ferro and Civitarese, 2015, p. 94). The analyst must be a theatregoer prepared for audience participation. For what appears on the stage is not definitively scripted as in a traditional play (or in a model of the unconscious as a script waiting to be decoded); the audience's participation is of a kind that might promote the characters' development and intensify their interactions. For the analyst, caught up in his own defences as well as

participating in the patient's, 'continually rediscovers that he is the protagonist along with the patient of the spectacle of the analysis', on condition, of course, that he does not leave the auditorium: he only makes this rediscovery if he has 'the ability to bring everything back to the dream of the session' (Civitarese, 2019, p. 33).

For the analyst as for the painter, the capacity to 'dream' in this way is not achieved once and for all; it must constantly be protected from the analyst herself, not least her defences against overwhelm of the proto-mental real, or of sensation, or of the patient's projective identifications. Thus the analyst needs to be able to 'use[s] his own defences as well as participating in those of the patient'. In 'dreaming' the session, he is '*forced* to test each time the congruence between rational understanding and affective understanding' (Civitarese, 2019, p. 33), to gauge the state of ±RP. 'There is only one resistance, the resistance of the analyst', said Lacan (1988, p. 228).

Seen from a field perspective, 'characters' and narratives from the patient's life are 'a dream of the session … ways of subconsciously representing the functioning of the system comprising patient and analyst' (Ferro and Civitarese, 2015, p. 115). Since the dream's cast of characters includes 'those called the analyst and the patient' (Ferro, 2009, p. 428), and their on-going formation and transformation, other players must include: the analyst's mind; the countertransference; the place of formation of images (Bion's 'waking dream thought') and its derivatives; the analyst's countertransference dreams; his reveries; the internal worlds of the analyst and the patient; their histories; their relationship; enactments; projective identifications and all their vicissitudes; and the transgenerational elements of both protagonists (Civitarese and Ferro, 2013, p. 196).

The art of the analyst is also, of course, to try to apprehend the patient's point(s) of view, 'using the restrictions imposed from time to time on the field by the viewpoint that can be assumed by dwelling in one of its many different places' (Civitarese and Ferro, 2013, p. 195). This idea of there being *places* in the field is important, for as Civitarese and Ferro outline, the sheer range of places in the analytic field contributes to its fullness. And the analyst herself occupies one or several of them at any given moment. Positioning and viewpoint are not always free and conscious choices. The analyst's conscious choice must be to align herself with the dream, to allow herself to be in it while doing her best to maintain binocular vision.

The conscious attempt must be to position oneself as analyst, not as an 'outside' interpreter (as a God-like, Cartesian free-floating, disembodied consciousness) but as part of the dream field, contributing to its activity through one's own reverie (and, it is to be hoped, eventually noticing one's place and contribution to it by means of one's reverie), thus increasing the permeability of the caesurae between characters, and helping enrich the inter-relations between pictograms and 'waking dream thoughts'. The patient whose dreaming-herself-into-her-own-existence was inhibited due to (inevitable) failure of the caregiver's reverie thus has the chance of reconnecting with this primitive

proto-mental area, and to emerge anew, more substantially, out her own 'prespatial hinterland' (Merleau-Ponty, 1964, p. 73).

The analyst participates in a coming-into-being, not through the interpretation of unconscious, repressed contents, but by fostering the creation of the very capacity to dream, and thus of a 'contents' as yet only present as potential. It is a transformation *in vivo*. With one eye on the emergency lights, the analyst positions herself alongside, accompanying the patient's dream, dreaming the patient just as Cézanne, with the 'rough materials' at his disposal, dreamed the mountain into existence.

With his ability to bring everything back to the 'petite sensation', Cézanne discovered and rediscovered his implication in the person or the landscape as it unfolded on the canvas, going so far as to say: 'the landscape thinks itself in me and I am its consciousness' (cited in Merleau-Ponty, 1945c, p. 17).

Suppose the analyst's 'petite sensation' was to take the form of a reverie featuring the wolf from *Little Red Riding Hood*. The wolf would, for Civitarese, constitute a 'character', and express a function of the field, something that both is and is 'not me, not us' (Gasquet, 1921 and 1926, p.153).

> If a character from the analytic field, for example the wolf from *Little Red Riding Hood*, is seen as a 'hologram' which results from the crossing of the patient's and the analyst's projective identifications, it means that it expresses a field *function*. At any given moment, the field is filled with emotions which we can attribute to the character of the wolf—and to its conduct. It would be wrong to assign responsibility for this exclusively to the patient or to the analyst because then the field metaphor would be useless and we would be talking about the way two separate subjects influence each other.
>
> (Civitarese, 2019, p. 14)

Nevertheless, the wolf is something for which the analyst must 'take responsibility'; he 'identifies with the wolf character ... not because he does not see it anymore as an intersubjective element, but because it is his duty to take responsibility for it' (Civitarese, 2019, p. 14). It is the analyst's responsibility, in Lacanian terms, to maintain the 'desire of the analyst' (Evans, 1996, pp. 39–40), the commitment, through her own abstinence, to helping the patient find the way to his own desire.

The analyst 'elaborates' the characters in the field rather as Jungians encourage elaboration of the patient's dreams, and it her 'duty' to embody these characters. This does not necessarily mean being wolfishly explicit in the session, but rather doing some 'cooking'. Ferro and Civitarese distinguish between what the analyst may need to allow to 'cook' in himself—in relation to other ingredients—before it is served up as food in the 'restaurant' of the session, that is, what he actually says in it. Like cooking, especially Italian cooking, this is not a mechanical or soulless activity, just as for the painter, 'every stroke ... must correspond to a breath of the world' (Gasquet 1921 and 1926, p. 152, and see Ferro, 2009, p. 178). Through unsaturated interpretation, the analyst encourages joint exploration of the multiple, enigmatic inter-relations between emerging 'characters'.

For Merleau-Ponty, writing in the 1960s, the whole of modern painting has aimed in this direction.

> Modern painting's effort has consisted not so much in choosing between line and colour, or even between the figuration of things and the creation of signs, as it has in multiplying the systems of equivalence, breaking their adherence to the envelope of things.
>
> (Merleau-Ponty, 1964, pp. 71–2)

Inter-relation, interpenetration, pluriverse

For Cézanne, 'objects interpenetrate ... they never stop being alive ... they ... spread intimate reflections around themselves' (cited in Gasquet, 1921 and 1926, p. 157). 'Everything incarnate', said Merleau-Ponty, 'including the world itself, radiates beyond itself' (Merleau-Ponty, 1964, p. 81).

T. J. Clark, writing in 1995, offered this response, a descriptive prose poem, to the *Grandes baigneuses* of 1904–6 in the Philadelphia Museum of Art [illus. 3.8].

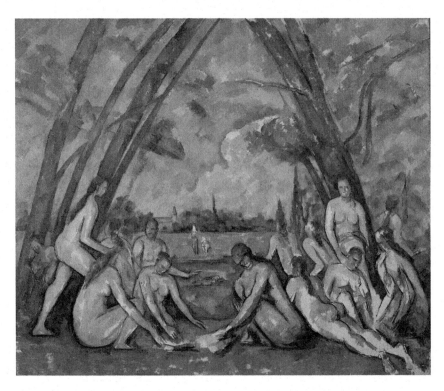

Illustration 3.8 Paul Cézanne, *The Large Bathers*, 1900–6. Oil on canvas, 210.5 × 250.8. Museum of Art, Philadelphia. W1937-1-1. Purchased with the W. P. Wilstach Fund, 1937. Open Access—Public Domain

At point after point, parts of bodies seemingly run into each other at high velocity, or a line of intersection between two or three of them becomes an expanding zone that both or all bodies lay claim to... the striding woman's hand explodes into the hair of the woman crouching in front of her; the crouching woman's face flushes and flattens; one possible contour of the back of the woman turning away from us has been allowed to stray across the arm of the figure next to it; and the whole area between the five figures ... comes to seem more and more a figure for what the five women share, almost the five figures' true physiognomy ... If one wants a simpler example ... I would choose the hand of the woman standing against the tree at right: the way her hand opens into the gray on the neck of the figure in front of her. As if reaching out to that figure's dejection. (Clark, 1995, p. 110)

Physical and emotional distance and space are overlapping and indeterminate:

no one body ever stands as an entity in a single space... The parts of a body, and the movements and positions of those parts, generate different and incompatible imaginings of space—different scales, different degrees of empathy and identification, different intuitions of distance or proximity—which simply cannot (ever) be brought to the point of totalization... we are what fills, or reaches out to, the space another body occupies; the space gets multiplied by our imagined acts, by the plurality of our own experience of our body getting beyond us.

(ibid., p. 111)

'*It's as if every part were aware of all the others*—it participates that much', wrote Rilke (2002, p. 71, Rilke's italics).

In his exploration of this mysterious question of interrelationship in space and depth, Merleau-Ponty gives what amounts to a definition of the field itself:

The enigma lies in what links [things], in what is between them—it is that I see things each in its place precisely because they eclipse one another—it is ... their mutual dependence in their autonomy. Of depth understood in this way one can no longer say that it is a 'third dimension'... Depth thus understood is rather the experience of the reversibility of dimensions, of a global 'locality' in which everything is at the same time [où tout est à la fois] ... When Cézanne seeks depth, it is this deflagration of Being he seeks.

(Merleau-Ponty, 1964, pp. 64–5; Appendix 5)

('Deflagration' is a form of combustion in which a layer of burning material heats and ignites an adjacent layer of colder material).

The relationship between elements in the field is enigmatic, but it is a relationship of mutual dependency, in which one element might hide its possible meaning and substance behind another, or partially emerge from behind it (as in the French level-crossing sign: 'Un train peut en cacher un autre'), and, at the same time, only

find its meaning in relation to another. Each element exerts a claim for attention, at the same time existing only in so far as it is in relation to other elements. The field has 'depth'; it is also a 'global "locality"' (the inverted commas a reminder that only metaphorically does it exist as a place) that both contain all other possible dimensions and offer a 'reversibility of dimensions' (Merleau-Ponty, 1964, p. 65). As in the Freudian unconscious, one dimension can become another, up can become down, large can become small, and 'everything is at the same time' (ibid.). And in the interpersonal field, as Cézanne prompts Clark to write, 'we are what fills, or reaches out to, the space another body occupies ... the plurality of our own experience of our body getting beyond us' (Clark, 1995, p. 111).

Measurable time too is called into question. Merleau-Ponty cites Rodin, in Bergsonian mode: 'It is the artist who is truthful and the photograph that lies, for in reality time never stops'. 'The photograph', comments Merleau-Ponty, 'keeps open instants which the onrush of time immediately closes up; it destroys the overtaking, the overlapping, the "metamorphosis" [Rodin] of time, which painting, in contrast, makes visible'. In this sense, Géricault's famous painting of race-horses running the Derby (1821), their fore- and hind-legs stretched out in a way that time-lapse photography has shown to be anatomically impossible, are more truthful than a photograph: they have 'durée', 'that "leaving here, going there" ... they have a foot in each instant' (Merleau-Ponty, 1964, pp. 80–1).

Fortunately, the picture and the analytic field are delimited by a frame. The analytic field is in a state of constant flux; one element oscillates against another and alters it, and this is true both of elements adjacent to and at a distance from each other. Cézanne learned exactly this lesson from Impressionism: like Monet's or Pissarro's, his brushstrokes can echo and energise each other right across the canvas. The analytic field, for Civitarese and Ferro, is delimited, but we only know about it through its effects on its diverse constitutive elements. It is constantly in contraction or expansion, 'intrinsically unstable and subjected to continuous displacements of energy' (Civitarese and Ferro, 2013, p.195). The forces concentrated at any given point in the field can have effects on other forces at different points; thus it is that the elements in the field are structured as a differential system, 'each term is defined in relation to the others in a process of constant, mutual cross-reference', in a way 'reminiscent of Saussure's conception of the structure of language, Lacan's of the system of signifiers in the unconscious, or Derrida's of the text' (Civitarese and Ferro, 2013, p. 195).

As Rilke put it, looking at Cézanne: 'In this hither and back of mutual and manifold influence, the interior of the picture vibrates, rises and falls back into itself, and does not have a single unmoving part' (Rilke, 2002, p. 72).

The very concept of the field as a developing theory in the hands and minds of different practitioners is 'a multi-group situation, constantly moving like sea-waves and in perennial constant transformation' (Ferro and Nicoli, 2017, p. 70).[29]

29 The three volumes of Bion's *Memoir of the Future* (Bion, 1991) are perhaps the most unflinching of all attempts to convey the heterogeneity, multiplicity, and fractious, interactive vividness of the 'characters' of Bion's field.

But one of its constants is that it is 'where the body is given back to the mind and where the mind can resettle in the body' (Civitarese, 2019, p. 42)—the body itself, of course, being in constant, dynamic transformation. Never rigid, an always flexible container, the field may be densely populated from the start, but its elaboration and expansion is a gradual process, for both analyst and patient, painter, and viewer.

'The moderns', wrote Merleau-Ponty, ' ... have added many a muted tone to the official gamut of our means of seeing' (Merleau-Ponty, 1964, p. 30). If metaphors, dreams, and reveries 'can gradually be introduced, that will be tantamount to adding new dimensions or worlds to the field ... the, field is, as a rule, multidimensional—it is a *pluriverse*' (Civitarese and Ferro, 2013, p. 195). Perhaps chaos theory is the best representation of the dynamism of the field, modelling as it does 'complex vectorial manifestations that give rise to turbulence, catastrophic points, and ultimately changes of state' (Civitarese and Ferro, 2013, p. 194).

Evocative objects

But some emerging 'characters' in the field, like products of true reverie, have a special attractive, combining power and particular resonances.

For Merleau-Ponty, Cézanne in his last period wanted, like Balzac, 'to understand what interior force holds the world together and causes the proliferation of visible forms' (Merleau-Ponty, 1945c, p. 18). At times the philosopher—speaking from within a tradition of Cézanne criticism that would include Lawrence and Beckett—seems to take a very austere view of the detachment the painter brought to this task, his absolute refusal of the distractions of sentiment and psychology.

> We live in the midst of man-made objects, among tools, in houses, streets, cities, and most of the time we see them only through the human actions which put them to use. We become used to thinking that all of this exists necessarily and unshakably. Cézanne's painting suspends these habits of thought and reveals the base of inhuman nature upon which man has installed himself. This is why Cézanne's people are strange, as if viewed by a creature of another species. Nature itself is stripped of the attributes that make it ready for animistic communions ... the frozen objects hesitate as at the beginning of the world. It is an unfamiliar world in which one is uncomfortable and which forbids all human effusiveness.
>
> (Merleau-Ponty, 1945c, p. 16)

This can be profoundly unsettling. There are even times when we find ourselves asking, 'what is so special about Cézanne'? He can disappoint if we are not prepared to join him in hesitating, as if at the beginning of the world.

'Only one emotion is possible for this painter—the feeling of strangeness—and only one lyricism—that of the continual rebirth of existence', wrote Merleau-Ponty (1945c, pp.17–18). In his review of the portraits exhibition, T. J. Clark drew particular attention to the upright coffee spoon in *Woman with a Cafetière* [illus. 1.10]. What are we to make of it? Perhaps it depends on what mood we are

in when we look at the painting. At first sight, not much perhaps. It is what it is, what Bollas would call a ["dumb ... fact"] (Bollas, 1995, p. 111), carrying with it 'the trauma of the real' (Bollas, 1987, pp. 122 and 145). Bollas's 'dumb facts' are, like the spoon, not symbols, stand-ins for something else, or displacements; but they do have the potential to become 'evocative objects' (Bollas, 1993, p. 33 et seq.), that is, objects invested with self. It is a transformation that happens when a 'dumb fact' meets and interacts with previous objects from the internal world.

It is perhaps a fact of all our cathected objects that they retain an element of the trauma of the real, or the proto-mental. The trauma of the real is all the more traumatic if we have this 'dumb fact' experience in front of the portraits. Perhaps it is never so keenly felt as in the encounter with an other who fails to come alive, whom we cannot 'cathect' and actively bring to life, and perhaps that can be felt especially acutely in front of a work of art.[30] Cézanne, so attuned to his 'sensa-tion', must have suffered considerably when a portrait had to be abandoned for this reason, for example, that of Clémenceau, whose insistent egotism seems to have sealed him off from the painter's imaginative investment.

'First you need the model ... The soul!' Gasquet reports him as saying. At first, all went well with Clémenceau, until the third sitting with this witty, acerbic subject: 'the model had been working away on me, inside [le modèle m'avait travaillé, en dedans] ... A wall ... I gave up the whole thing ... That man did not believe in God' (Gasquet, 1921 and 1926, p. 152).

The situation can be paralleled in the analytic field when, as Civitarese and Ferro put it, 'a quasi-autistic' type of mental functioning arises, in one or both participants. Instead of actual 'characters', full of potential for play and develop-ment, there are only 'flat, emotionless picture cards. The patient draws the analyst into an exclusively concrete world. Play is impossible. There are no metaphors, no dreams, and no reveries' (Civitarese and Ferro, 2013, p. 195). Cézanne's struggle, which was constant, can help us appreciate what an achievement it can be for the analytic couple to access a shared world of metaphor, dream and play.

How does a 'dumb fact' become an evocative object, something that is both not-me and me, and is capable of generating reverie? Perhaps Cézanne's *Woman with a Cafetière* [illus. 1.10] can give us a direct experience of this. Undeniably, objects in Cézanne carry their 'man-made', human imprint. The spoon is one of a handful of human artefacts that cannot be improved upon, like the wheel (Eco and Carrière, 2012, p. 4), and this too is one of its characteristics as a 'character' in the field.[31]

30 A painter friend said that she was anxious about visiting the great exhibition of Rembrandt self-portraits a few years ago at the National Gallery in London, in case this time they failed to come to life for her.

31 A nice serendipity of the field: *The Silver Spoon, Il Cucchiaio d'Argento*, another friend tells me, is the classic post-war cookbook (by Clelia D'Onofrio and Giovanna Mazzocchi, 1950) to be found in every Italian kitchen. I learn too that Cézanne's father's family originally came from Cesana-Torinese, a commune in Piedmont, near the border with France (70 kilometres west of Turin and 250 west of Pavia) (Danchev, 2012, p. 44).

The painting gives us an experience *both* of the trauma of the real *and* of the birth of the evocative object. If we can wait long enough and tolerate the feeling of deadness that can arise, Cézanne allows us to register this transformation, the passage from deadness to reverie, in ourselves.[32] It is the passage through which analyst and patient must find their way. Dwelling with the painting, we see the woman and the spoon as belonging to the same world and as if made from the same substance, one a potential physical extension, with a use-value, of the other (the woman is a function of the spoon just as the spoon is a function of the woman). But we may also come to wonder how far the spoon, everyday and intimate, may also be an 'evocative object' for her, invested with feeling. Woman and spoon are connected not by physical but by chiasmic 'flesh'.

Bollas's 'evocative object' is not a symbol of anything outside itself. Thinking in Hanna Segal's terms, of the passage from symbolic equation to the 'as if' quality of the 'true' symbol, does not do justice to the transition we are discussing (Segal, 1991); the evocative object is not a symbol, of the phallus for example, or of lack. If there is a sense in which it can be called a symbol, it is that which Coleridge gave the word: something that emerges 'through and in the Temporal', carrying a sense of 'the Special in the Individual or of the General in the Especial or of the Universal in the General' (Coleridge, 1894, p. 322).[33] Such a symbol has the quality of something recollected, perhaps through the mysterious contact it is able to make with other objects from the internal world of painter and viewer, in the 'container' of the canvas, or of the analytic session. It takes on a dream- or picture-existence, a numinous quality (Harris Williams, 2018; 2010; etc.). It is both particular and generic, no longer a monolithic and dead spoon or chair; it connects us to the realm of experience Bion designated as 'O'.

O

In the mid-to-late 1960s, Bion formulated the concept of 'O', his open-ended, allusive notation for the ineffable and the unknown. Within its conceptual background are the philosopher Alfred North Whitehead's elaboration on the number zero (Whitehead, 1911), and Bergson's insistence that intuition can reach the *absolute* and *infinite*, ultimate reality, and adopt 'the very life of things' (Bergson,

32 Baudelaire wrote of a dead 'Sunday feeling'—as opposed to one of his rare 'beaux jours de l'esprit' (Baudelaire, 1975–6, II, p. 596). For Lacan, it is the passage from 'empty' to 'full' speech.
33 Coleridge wrote:

> a Symbol is characterized by a translucence of the Special in the Individual or of the General in the Especial or of the Universal in the General. Above all by the translucence of the Eternal through and in the Temporal. It always partakes of the Reality which it renders intelligible; and while it enunciates the whole, abides itself as a living part in that Unity, of which it is the representative.
>
> (Coleridge, 1894, p. 322, cited in
> Harris Williams, 2018).

1903, p. 53; Torres, 2013a, p. 26; on Whitehead, 1911, see Torres, 2013a, pp. 28–34). Within psychoanalysis, it is a concept entirely original to Bion.

> Psycho-analytical events cannot be stated directly, indubitably, or incorrigibly any more than can those of other scientific research. I shall use the sign O to denote that which is the ultimate reality represented by terms such as ultimate reality, absolute truth, the godhead, the infinite, the thing-in-itself. O does not fall in the domain of knowledge or learning save incidentally; it can be 'become', but it cannot be 'known'. It is darkness and formlessness, but it enters the domain K [knowledge] when it has evolved to a point where it can be known, through knowledge gained by experience, and formulated in terms derived from sensuous experience; its existence is conjectured phenomenologically.
>
> (Bion, 1970, p. 26)

Such an introduction, simultaneously prosaic and Miltonic, could hardly be other than cryptic too; for as Bion put it more colloquially, speaking to an audience in 1967,

> we have to talk about and deal with it in terms which are not adapted to that use at all. They are adapted to something quite different; they are adapted to sensuous experience: experience which you can talk about in terms of the physical senses, but which you can't talk about in other ways because the language simply does not exist.
>
> (Bion, 2018, p. 3)

Thus 'O does not fall in the domain of knowledge or learning save incidentally', when it has evolved sufficiently somehow to enter sensuous experience. 'It is O when it has evolved sufficiently to be met by K capacities in the psycho-analyst' (Bion, 1970, p. 27).

O is a special and privileged kind of vertex: 'The analyst must focus his attention on O, the unknown and unknowable. The success of psycho-analysis depends on the maintenance of a psycho-analytic point of view; the point of view is the psycho-analytic vertex; the psycho-analytic vertex is O'.

O embraces negative capability and the 'analytic attitude' that are its necessary preconditions. More than a vertex among possible vertices, O is not just something the analyst chooses to adopt, or even to identify herself with. 'With this the analyst cannot be identified: he must *be* it' (ibid., p. 26).

Bion continues: 'Every object known or knowable to man, including himself, must be an evolution in O' (ibid., p. 27).

Around this point in Bion's text, many a reader must have come to a frustrating full stop. What does he mean? And will even Cézanne be able to help us this time?

In Civitarese's summary, O simultaneously means 'origin, zero, vagina … darkness, thing-in-itself, real, infinite void, terror (as is suggested by the sound and spelling of 'awe', \ò\)'(Civitarese, 2014, p. 1067).

> O, he continues, is one of Bion's most ungraspable, and for this reason most subtly troubling concepts. The same series of synonyms for O includes the numen, Godhead, the divine, God, Tiger [Harris Williams, 2010]; but also

the no-thing and noughtness. The no-thing is not only the persistence of the 'shadow' of the object that is no longer there, but also the thing as it *is* in the sense of real, and not as it appears.

<div align="right">(Civitarese, 2014a, p. 1067)[34]</div>

Civitarese's compatriot the psychoanalyst Luca Nicoli was hardly the first to remain baffled, so he turned to his older colleague Ferro for help. 'Here I do humanity a favour, with a question that avenges all the times we read: "We have to stay in O", "We have to achieve O"... how does Antonino Ferro explain this O'? 'Well', Ferro replies—eventually leading us into a warming, cheering kitchen—

O is the thing itself, the unknowable thing ... the underlying reason why a patient is in analysis ... the structuring identity ... something that we will never know ... O has to be progressively dreamed ... we will never know the real O, we will always know its derivatives, which take the form of a lie. In other words, O has to undergo a *transformation in lie*, which makes it tolerable ... any truth, in order to be witnessed, shared, or experienced, needs some room for lies around it. Truth without a handle of lies would look like a hot frying pan that some one asked us to hold, while inside it fries are sizzling in steaming oil and the temperature is unapproachable: we need that handle of lies in order to pick up the pan and the truth (and the excellent fries that truth offers us). Our species cannot tolerate the harsh, hard impact with reality.

<div align="right">(Ferro and Nicoli, 2017, pp. 138–9)</div>

The work of art is just such a lie, and a further visit to Cézanne's studio may help us find some more positions from which to view O. For it is precisely a painter's business to allow something ineffable to evolve to a point at which it finds form in sensuous experience. 'I see me in him', Cézanne said to Gasquet when painting his father's portrait. 'By partly substituting myself for your father, I should able to bring things together [j'aurais mon ensemble]' (cited in Gasquet, 1921 and 1926, p. 154). An act of identification was needed for Cézanne to be able to 'bring things together'. But what kind or degree of identification?

First, of course, the artist and analyst must make herself available, by means of 'negative capability', achieved through temperament and training. For Keats, this could involve an involuntary and unsettling loss of a sense of his own identity, the loss of his 'identical nature' when 'the identity of everyone in the room' pressed in on him (Keats, 1958, I, p. 387, and see Snell, 2012, p. 169). For Cézanne, it required something closer to an act of will.

Art, [he told Gasquet] is a harmony parallel to nature ... [the painter] is parallel to it. If he doesn't choose to intervene ... His whole will must be in silence. He

34 A few years later, Civitarese comments: 'This bizarre idea of Bion ... gives rise to the most absurd and hilarious interpretations' (Civitarese, 2019, p. 78). For a multi-perspective exploration see Alisobhani and Corstorphine (2019), consisting of ten sections and thirty-three chapters by thirty-eight contributors.

must silence in himself all the voices of prejudice, forget, forget, keep silence, be a perfect echo. Then, on the sensitive plate of his being, the whole landscape will inscribe itself. To fix it on the canvas, exteriorise it, craft will need to step in, but a respectful craft which is similarly prepared just to obey, to translate unconsciously [à traduire inconsciemment], so well does it know its language, the text it is deciphering, the two parallel texts, nature seen, nature felt, the nature that's here ... (*he pointed to the green and blue plain*), the one that's here ... (*he tapped his forehead*) which must amalgamate together if they are to last, live a life half human, half divine, the life of art, listen to what I'm saying, the life of God. The landscape is reflected, becomes human, thinks itself in me'

(Gasquet, 1921 and 1926, pp. 109–10. Appendix 6)

What Cézanne is describing is akin to reverie, a waking dream, out of which it is possible to 'translate unconsciously', and out of which a rhythm might establish itself, the process evoked in Civitarese's 'inconsciare', through which a 'picture reality' might be instantiated.

Rembrandt, Rubens, and Titian [said Cézanne] knew straight away, in a moment of sublime understanding, how to melt the whole of their own personalities into that flesh they had in front of their eyes, into the way other people looked, in order to celebrate their dream or their sadness.

(Gasquet, 1921 and 1926, p. 154)

The analyst's task with the patient, like the painter with his sitters, is 'to celebrate their dream or their sadness' (Gasquet, 1921 and 1926, p. 154). Ferro gives an example of what this can mean, envisaging a situation in which a patient is in a state of catastrophic grief, 'where pain is really the O ... the central theme that we do not know how to deal with'. Then,

the whole analysis will be centred on how to metabolise this boulder of pain, how to transform it into something that can indeed be dreamt, shared, and I would even say played as a game in a lofty sense. Of course, we should always consider that for a child a game is a very serious thing.

(Ferro and Nicoli, 2017, pp. 137–8)

Walter Benjamin noted 'the powerful compunction in former times to become and behave like something else', and how this permeates the mimetic play of children (Benjamin, 1978, p. 333). '[T]he psycho-analyst can know what the patient says, does, and appears to be, but cannot know the O of which the patient is an evolution: he can only "be" it', said Bion (1970, p. 27).

In one of his last notebook entries, Freud wrote that in a child, being comes before having (12 July 1938; Freud, 1938, p. 299). Ferro and Civitarese note that for Freud here the primordial mechanism of possession is identification:

'I am the breast' ... it is only later that the consciousness of having, which implies a separation, appears: 'I have it' – that is, 'I am not it' ...

This extraordinarily condensed sentence seems once again to emphasise the identity of ego and body. What is more, it also implies that the ego *is* the Other, culture, and social life, and that the first ego is a sensory ego.

(Ferro and Civitarese, 2015, p. 62)

It was not just with his sitter as remembered, but in body in the studio with him that Cézanne sought to 'bring things together' (Gasquet, 1921 and 1926, p. 154). His work implicated him profoundly in the living world. Following his early 'body work', Cézanne's notion of corporeality expanded to include apples, bowls and the landscape itself; he was, in John Berger's elegant summary, 'discovering a complementarity between the equilibrium of the body and the inevitability of landscape … his late baigneuses form ranges like mountains. The deserted quarry at Bibémus looks like a portrait' (Berger, 2015, p. 254) [illus. 3.9]. Trees dance together while houses look on [illus. 3.10].

It was not so much loss of a self as a partial return to a state of pre-selfhood, not yet of 'having' but of 'being'. And it was an 'autistic-contiguous' (Ogden, 1989) state of relative undifferentiation between bodies and objects, a reconnection with the pre-conscious, proto-everything 'chora', a parallel to the experience of art, of the

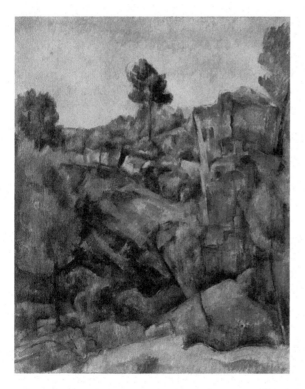

Illustration 3.9 Paul Cézanne, *Bibémus Quarry*, c. 1895. Oil on canvas, 92 × 73. Barnes Foundation, Philadelphia. BF34. Public Domain

'aesthetic object' in the sense Donald Meltzer gave the phrase, a link to the unreachable beginning of the world and the closest we might get to reliving it. 'In the beginning was the aesthetic object, and the aesthetic object was the breast and the breast was the world' (Meltzer, 1986, p. 203, cited in Ferro and Civitarese, 2015, p. 62). It might be an experience of an 'absolute fullness' (Merleau-Ponty, 1945c, p. 17). The mountain/breast is me. The experience could be multi-sensory and euphoric. 'Deep feeling unifies the whole being', says Gasquet's Cézanne.

> The rush of the world in the back of a brain [le tourbillonnement du monde, au fond d'un cerveau] resolves itself with the same motion that the eyes, the ears, the mouth, the nose discover, each according to its own lyricism … And art, I believe, puts us in the state of grace when universal emotion reveals itself to us, religiously, yet very naturally. The universal harmony, like colour, should be found everywhere.
>
> (Gasquet, 1921 and 1926, pp. 110–11).

O in this light is a process of joining and becoming an expanding pluriverse, a renewed connection with 'the rush of the world'.

A passage from Merleau-Ponty's extended commentary on Cézanne gives us this superb articulation of O, the work of visual art, and the links of both to inter- and immediately post-uterine life:

> it is the painter who is born into things, as if through concentration, and comes to himself through the visible, and the painting finally relates to nothing at all among experienced things except on condition of first of all being 'autofigurative': it is only a spectacle of something by virtue of being a 'spectacle of nothing' … Art is not construction, artifice, the meticulous relationship to a space and a world existing outside. It is truly the 'inarticulate cry' of which Hermes Trismegistus spoke, 'which seemed to be the voice of light'. And once present, it awakens *sleeping powers in ordinary vision, a secret of pre-existence.*
>
> (Merleau-Ponty, 1964, pp. 69–70, my italics)

For Julia Kristeva, the 'chora' manifests itself in 'madness, holiness, and poetry' (Kristeva, 1976, and see Lowenthal and Snell, 2003, p. 121). O, with its aura of epiphany and harmony, and its accompanying sense of deep recognition, is the conscious experience of new contact with the 'chora', through a form—a painting, perhaps, or a poem, or the subtle dance and music of a unique conversation in the consulting room—in which overwhelming too-muchness becomes bearable fullness, and it is this that can be a transformative experience of growth.

'From O the subject can "win" knowledge, thoughts, existence, but there is always risk of being devoured by it', writes Civitarese; of all psychoanalytic concepts it can 'in the most immediate way evoke the terror of the sublime in art' (Civitarese, 2014a, p. 1067): Bion's nameless dread, which assails the newborn

when reverie and the breast fail and the possibility of meaning is lost. It is the 'void, formless and infinite' of Milton's *Paradise Lost*, that with which, for Bion, 'the infant is confronted when it comes into the world, and indeed even before. And the only thing that can preserve it is the psychological distance in which its mother envelops it' (Civitarese, 2014a, p. 1067).

Cézanne—painting the 'envelope' itself—understood very well how much he needed to mobilise the maternal container of the canvas to help him preserve himself.

'Every time I stand at my easel I am a different man—myself, and always Cézanne', he said (cited in Gasquet, 1921 and 1926, pp. 152–3). Reminding Gasquet that he had recently been talking to him about Kant, he allegedly said

> it seems to me that I would be the subjective consciousness of this landscape, just as my canvas would be the objective. My canvas, the landscape, both outside me, but one chaotic, fugitive, confused, without logical life, beyond all reason; the other permanent, tangible, categorised, of the order of ideas, participating in the drama of ideas … in their individuality.
>
> (ibid., pp. 109–110)

Cézanne's visitor and correspondent the painter Maurice Denis offered this understanding of the process of bringing-together through which a picture, 'participating in the drama of ideas', might come into being.

'Synthesising does not necessarily mean simplifying in the sense of suppressing certain aspects of the object. It is simplifying in the sense of *making intelligible*' (Denis, 1907, p. 179). Denis might be talking about the emotional sense-making provided by maternal reverie and offered in adult life by one's own binocular vision.

He continues:

> It is, in short, prioritizing: making each picture submit to a single rhythm, to what is most characteristic [à une dominante], sacrificing, subordinating, generalizing … nor does [Cézanne] get lost in the ocean of variety. He knows how to elucidate and condense his impressions; his formulae are luminous, concise, never abstract.
>
> (Denis, 1907, p. 179, and see Appendix 7).

Denis might be describing the analyst's attempt to come into ever-closer alignment with O—to get in touch with the music of patient, session, and field, and to find adequate words for it: 'luminous, concise, never abstract', like, by all accounts, Bion's containing, chaos defying way of speaking in the consulting room (see, for example, Junqueiria de Mattos, 2016).

But just in case we lose sight of something essential, a reminder: Cézanne was 'utterly unforgiving about the kind of simplification that by-passed submission to Nature and reflective, progressive analysis' (Bernard, 1904, p. 34). We stay with, learn from, the patient and the field, and submit ourselves to the process.

The analyst's primary task is to *be* an analyst. Perhaps this is akin to living what Keats called a 'life of Allegory':

> A Man's life of any worth is a continual allegory—and very few eyes can see the Mystery of his life—a life like the scriptures, figurative—Lord Byron cuts a figure—but he is not figurative—Shakespeare led a life of Allegory; his works are the comments on it.
>
> (Letter of 18 February 1819. Keats, 1958, p. 67)

It is that with which the analyst cannot merely 'be identified: he must *be* it' (Bion, 1970, p. 26). It involves being able to dip into the 'chora', and out again.

'We identify ourselves with objects, we are carried away by them', said Cézanne (Gasquet, 1921 and 1926, p. 159).

> I'd like to lose myself in nature, grow again *with* nature, *like* nature, have the stubborn shades of the rocks, the rational obstinacy of the mountain, the fluidity of the air, and the warmth of the sun. In a green my whole brain would flow in unison with the sap rising through a tree's veins.
>
> (Gasquet, 1921 and 1926, p. 124; 1991, p. 168)

This is certainly Gasquet at his most poetic, and he perhaps glosses over the hard-won nature of Cézanne's achievement of 'binocular vision'. But he does catch something of O's driving essence. For, said Cézanne, 'we are attempting a piece of nature ... the artist must conform to this perfect work of art ... we exist through it ... nothing else is worth remembering' (cited in Merleau-Ponty, 1945c, p. 12).

We are all 'caught in a secret history', wrote Merleau-Ponty, adding that this history was also 'a forest of symbols' (Merleau-Ponty, 1945a, p. 22, quoting from Baudelaire's poem 'Correspondances'): the symbol as Tainian 'true hallucination' (Taine, 1870, p. 411) and 'waking ... dream' (Civitarese, 2019, pp. 48–9). This 'secret history' is also populated by evocative objects, which, like the coffee spoon, are symbols only in the sense Coleridge elaborated in 1816.

To align oneself with O would be to align oneself with the coming-into-being of such a symbol. It would be to subscribe to a Coleridgean conception of nature itself: '*Natura*, that which is *about to be* born, that which is always *becoming*' (Coleridge, 1825, p. 141, cited in Nicolson, 2019, p. 221).[35] This is what Cézanne meant when he said 'we are attempting a piece of nature ... we exist through it' (Merleau-Ponty, 1945c, p. 12).

35 Coleridge continues:

> It follows, therefore, that whatever originates its own acts, or in any sense contains in itself the cause of its own state, must be *spiritual*, and consequently *super-natural*: yet not on that account necessarily *miraculous*. And such must be the responsible Will in us, if it be at all.
>
> (Coleridge, 1825, p. 141)

'[I]t is the painter who is born into things', wrote Merleau-Ponty (1964, pp. 69–70). Concerned with 'an emerging order ... an object in the act of appearing, organizing itself before our eyes' (Merleau-Ponty, 1945c, p. 14), Cézanne told Bernard 'I am oriented toward the intelligence of the *Pater Omnipotens* ... The landscape thinks itself in me', he said, 'and I am its consciousness' (ibid., p. 17)—a transformation in O.

'In so far as the analyst becomes O he is able to know the events that are *evolutions* of O', wrote Bion (1970, p. 27). Becoming O means 'knowing something emotionally' (Civitarese, 2014a, p. 1067), when, that is, sufficient evolution has taken place for it 'to be met by K capacities in the psycho-analyst' (Bion, 1970, p. 27). Birth in the analyst happens when there has been sufficient evolution in one part of the mind, we might say in embryo, to prompt reverie in another. Where O is a boulder of pain, it is not a question of 'dealing with it' or tracing its sources, but of 'being' it, in the sense not of total identification and self-loss but of dreaming and sharing it, letting it colour the analyst's dream, 'becoming' it rather in the way a child at play might become a train, or, as Cézanne might have put it, allowing the boulder of pain to think itself in him so that he can be its consciousness. How the patient might subsequently evolve and become is part of the unknowability that must be respected.

Becoming O—or is this better expressed as 'when O is become'?—brings about a fundamental and lasting change in mental attitude. It is 'a new and transformative experience, not a new insight or a getting a form for what she experiences (a transformation in knowledge)' (Vermote, 2017, p. 153, cited in Abel-Hirsch, 2019, p. 355). Ferro and Civitarese put it like this:

> What matters ... is that something new and surprising is born, which is what Bion implies when he says that we need to make the O of the session evolve or ensure that the analyst *become O*; by this he means nothing more than letting oneself be pervaded by the waking dreams that are reverie.
>
> (Ferro and Civitarese, 2015, p. 84)[36]

Another, particularly Bergsonian passage from Bion's 1970 paragraphs, cited above, now begins to 'click'. The analyst

> knows phenomena by virtue of his senses but, since his concern is with O, events must be regarded as having the defects of irrelevancies obstructing, or the merits of pointers initiating, the process of 'becoming' O.

36 In other psychoanalytic idioms, allowing the 'unthought known' (Bollas); finding one's Desire (Lacan), or 'the hands of the living god' (Milner): the source of one's truth, always already latent in the proto-mental.

Yet interpretations depend on "becoming" (since he cannot know O). The interpretation is an actual event in an evolution in O that is common to analyst and analysand.

(Bion, 1970, p. 27)[37]

O, if we follow Gasquet's and Merleau-Ponty's Cézanne, is a sort of supra-sensible realisation of the ultimate 'undividedness of the sensing and the sensed', of which Merleau-Ponty wrote in 1964. 'Since things and my body are made of the same stuff, it means its vision must be made in some way in them' (Merleau-Ponty, 1964, pp. 21–2). Cézanne, wrote Merleau-Ponty, citing Madame Cézanne, would 'germinate' with the landscape (Merleau-Ponty, 1945c, p. 17). 'Becoming O' or being at one with O (Civitarese, 2008, p. 1131) means attunement both to the individual who moves one (the 'motif') and to the field, the 'pluriverse' of which patient and analyst, like figure and painter, are part.

'[T]he psychoanalyst's intuition of the reality with which he must be one' (Bion, 1967, p. 15) is, for some, something beyond and prior even to the first embodied, aesthetic experience of the breast. It is contact with 'the impersonal, formless, infinite real, the noumenon' (Civitarese, 2016, p. 96). O is 'the name of that which has no sound, smell or texture … that which *is* there—before sensibility comes along to tell us *what it is*' (Vitale, 2004, p. 73, cited in Civitarese, 2016, p. 96). And it is 'a participation in the being of space beyond every particular point of view' (Merleau-Ponty, 1964, pp. 45–6). It is the ineffable reality of the particular moment as we live it into the next (Reiner, 2016, p. 155).

'Not so much through patience as through love will the painter enter into possession of himself and reach the perfection of his art', Cézanne said to Emile Bernard (Bernard, 1904, p. 34). Neville Symington has conceived of O in similar terms.

Bion says that one cannot strive for this state, but that one can only 'become' it. It is possible to be receptive to pure giving. It is this and only this that moves the heart, that melts stubbornness, that dilutes the madness in whose grip we find ourselves. All the theories, all the schools of psycho-analysis or psychotherapy are dust and ashes if this purity of giving is absent. This is

37 'Embodied in the mystery of words', wrote Wordsworth in *The Prelude*. It is, as Adam Nicolson writes in a fine commentary on the poet, the 'emergence of vision in words, without looking for the words, but finding them appearing at the very moment of vision, *as* the moment of vision' (Nicolson, 2019, p. 177). Later in his account of Wordsworth's evolution, Nicolson writes of

a sense of meaning itself being beyond the meaning of words, but embodied instead in the very breathing and sensing of embodied souls alive in the world. We are neither merely receivers of the world through our senses, nor are our minds the shapers of it. We are both more and less than that, mindbodies, embedded because embodied, mentally alive because physically alive, with no boundary at the skin, perhaps even no skin, no difference between thought and being.

(ibid., p. 235)

why psychotherapy if it is anything brings healing through this giving; it only works if this generous spirit is present. The spiritual is woven then into the very fabric of what we do as psycho-analysts, as psychotherapists.

(Symington, 2008, pp. 498–9)

The aesthetic and the contingent

Ferro, always concerned to keep us in good contact with *terra firma*, has said that 'all in all, in my life I have hardly ever witnessed a transformation in O' (Ferro and Nicoli, 2017, p. 138). One occasion when such a thing did seem to happen was when a patient with an emotionally two-dimensional view of the world suddenly became able to see it in three. How this came about was not obvious to Ferro. For 'in analysis a lot more things happen than those that we know about' (ibid., p. 49); in fact, as Christopher Bollas wrote, it is this very 'urge to get to the "heart" of the matter that proves to be the greatest potential misfortune for the analysand' (Bollas, 1993, p. 131).

In art as in an analysis, no point of arrival or resolution can claim to be final, although it may be profoundly satisfying and moving. '[E]ach brushstroke must satisfy an infinite number of conditions', observed Merleau-Ponty (1945c, p. 15), and for this reason, no brushstroke can ever be the definitive or 'correct' one. The talking cure is not a quantifiable science, and the analyst's choices, like the painter's, can never, in the end, be the result of following 'scientific' criteria. Psychoanalysis is 'fundamentally an aesthetic experience' (Ferro and Civitarese, 2015, p. 62). This is not to say that it need lack precision; on the contrary, it is 'important to take account of the sphere of aesthetics for the purpose of constructing ever more flexible and precise models in psychoanalysis' (Ferro and Civitarese, 2015, p. 62).[38]

The psychoanalysis we are talking about is of course not just that of a hermeneutics of interpretation, of memory and psychic contents, but of 'transformations in and of the container', in which meaning has 'a radically aesthetic (and substantially pre-representational) matrix' (ibid.). It is that of Bion, Ogden, Meltzer, Ferro himself, and others; and it is 'aesthetic'

> because it restores emotion—*aesthesis!*—to the centre of thoughts, and because it returns thought to its oneiric foundation, to the operations identified

38　The aesthetic experience is one of being in unison, of sharing the same space-time, carrying out (almost) the same spacing in the perceptual chaos of reality. The aesthetic experience inside (and outside) analysis is the ideal balance between circular time (when the same thing is repeated) and linear time (intrinsic to aesthetic experience is the feeling that beauty is ephemeral).

(Ferro and Civitarese, 2015, p. 84)

In other words, an awareness of loss. The 'aesthetic experience' would thus be a composite of the experiences of breast-present (available for the rhythmical, repeated feeding) and breast-capable-of-absence.

by Freud in the composition of the manifest text of a dream, which are also involved in the dream of artistic creation.

(ibid.)[39]

Transformations in and of the container are also what the painter on his canvas effects. Maurice Denis offers these reflections:

> In front of ... Cézanne we don't just think about painting; neither the object represented nor the artist's subjectivity claims our attention. It is not easy to decide if it is an imitation or an interpretation of nature ... Painting oscillates eternally between invention and imitation. Sometimes it copies and sometimes it imagines. Those are its variations. But whether it reproduces objective nature or translates the artist's particular emotion, it must be an art of concrete beauty, and our senses must discover in the art object itself, all question of the subject represented aside, an immediate satisfaction, pure aesthetic pleasure.
>
> (Denis, 1907, pp. 168 and 172. Appendix 8)

The analyst's responsiveness can take many forms. Cézanne reminds us that colour can be used in more than one way. The critic Lawrence Gowing (who was also a painter) noted two distinct approaches in Cézanne's work of the late 1890s. In the oil paintings, he generally brought together

> the observations of nature—local hues, their mutual reflections, the atmosphere and light surrounding them—and presented their combinations and interpenetration in heightened form. The watercolours, on the other hand, translated form into metaphoric sequences of colour, which operated through the gradations of colour interval rather than identifying any local hue or effect of light that could be observed and transcribed from a subject.
>
> (Gowing, 1977, pp. 59–60)

Departing from the rule of close adherence to the patient's own words, post-Bionian psychoanalysis, while attending to 'mutual reflections ... atmosphere', also has room for the analyst's own metaphors—provided they respect Cézanne's criterion of fidelity to the 'sensation' generated in the field and serve 'progressive, reflective analysis' (Bernard, 1904, p. 34).

John Berger also noted how during his last 20 years Cézanne began to apply 'swabs of colour to the canvas, not where they correspond to the local colour of an object, but where they can indicate a path for our eyes through space, receding or oncoming', and Cézanne did this out of a 'conviction that what we perceive

39 The Free Dictionary has this definition. The 'aesthetic' is 'an unelaborated elementary awareness of stimulation' (https://www.thefreedictionary.com/aesthesis). Wiktionnaire, under αἴσθησις, *aisthêsis*, has sensation, sense perception, or the perception that one has senses; the action of gathering intelligence, of perception; organ of the senses, one of the senses; and (rather marvellously) the track of an animal (both sites viewed 1 November 2018). The aesthetic experience takes us back to our origins.

as the visible is not a given but a construction, put together by nature and ourselves' (Berger, 2015, pp. 253–4). This, for the materialist Berger, was the meaning behind two of Cézanne's most quoted statements: 'The landscape thinks itself in me' and 'Colour is the place where our brain and the universe meet' (ibid.).

In a powerful paper of 2001, T. J. Clark re-opened this question of the tension between imitation and imagination. He was not writing about psychoanalysis, but I think he succeeded in catching something essential about the experience of psychoanalysis from the analyst's point of view.

Clark acknowledged that Cézanne was a phenomenologist through and through: he was 'made for Merleau-Ponty to hero-worship' (Clark, 2001, pp. 102–3). But Cézanne's painting involves more than the phenomenal.[40] For, Clark continued,

> the moment at which a text or depiction reaches out most irresistibly to a thing seen or experienced is also the moment at which it mobilizes the accidents and duplicities of markmaking most flagrantly, most outlandishly—all in the service of pointing through them, and somehow with them, to another body that is their guarantor.
>
> (ibid., p. 99)

Clark's ('obviously uncongenial') starting point is to suppose that Cézanne's individual brush marks 'do not analogize or open onto "sensations" or "phenomena"'. On the contrary, in their material individuality as marks—'their atomized facticity, their separateness'—they posit 'precisely a lack or failure of any such opening or analogy' (ibid., p. 102). Clark sees, in Cézanne's work, a shifting of balance between 'a wild analogizing of paint and vision (paint and world) and an intimation, in the brushmarks themselves, of their coming to obey a different logic—not a logic of analogy at all' (ibid., p. 105). These marks can be 'Fierce, declarative, and self-canceling', not in the least 'edging toward the truth of consciousness step by qualified step' (ibid., p. 106).

For Clark, Cézanne's project was the most radical project of nineteenth-century positivism: it staked everything 'on the possibility of re-creating the structure of experience out of that experience's units' (ibid.).

> But the very radicality of the project delivers it: because this painting stakes everything on the notion of the unitary, the immediate, the bare minimum of sensation, the momentary and material 'ping'; because it goes on and on searching for ways to insist that here, in this dab, is the elementary particle out of which seeing is made; because it fetishizes the singular, it discovers the

40 Husserl himself had felt that the imagined, the free imagination, can be more important than the sensually given (Bazzi, 2018, p. 2): 'any inner fantasy, constructing in the freest of fictional modes, would serve just as well, provided it possesses sufficient intuitive clarity: indeed it serves preferably' (Husserl, 1913, cited in Elliott, 2005, p. 25). He wrote of 'the picture-life of fantasy. A thing counts as possible if it allows itself, objectively speaking, to be realised in the form of an adequate imaginative picture ... through the ideal linkage between perception and imagination' (Husserl, 1913, p. 259).

singular as exactly not the form of 'experience'. It shows us a way of world-making in which the very idea of a 'world'—the very idea of totality, or synthesis ... is not drawn from some prior texture of unit-sensations 'out there', and therefore (potentially) 'in here'. It follows that notions as seemingly basic as foreground and background may no longer apply ... Maybe not even 'inside' and 'outside'. Nor 'experience' and 'representation'. Nor 'now' and 'then'.

(Clark, 2001, pp. 106–7)

Among other things, Clark, without using this Bionian terminology, is pointing to a 'transcendence of the caesura'. He goes on to invite us to look closely at a sequence of brushmarks in *Trees and Houses*, a painting of late 1885–6 in the Orangerie [illus. 3.10]:

Part of the lower front wall of the houses, as well as the space between them, is done in upright bricks of light brown and mauve as if to imply a dusting of undergrowth. The same stroke is tilted to left and right of vertical and repeated in the midground fields, or along the path that cuts through them, and at place after place in the trees—sometimes believably as moss or foliage, sometimes as free-floating notation. I would not deny that these kinds of marks (art historians call them 'the constructive stroke') contribute to the

Illustration 3.10 Paul Cézanne, *Trees and Houses*, 1885–6. Oil on canvas, 54 × 73. Musée de l'Orangerie, Paris. Collection Jean Walter et Paul Guillaume. RF1963-8. Photo © RMN-Grand Palais (Musée de l'Orangerie)/Franck Raux

painting's overall evenness and delicacy, nor that evenness of attention is the picture's most touching quality. But the regular brushmarks are always on the verge—and sometimes over it—of not 'applying' to anything in particular. And they co-exist with other sorts of painterly activity, which make their placid atomism look not so much tentative as wilfully flimsy.

Clark invites us to look at the tall central house with the red roof, and in particular at the brush marks that are meant to put together

> into a single sequence on the flat, the line of the house's red eaves, the faint shadow the eaves cast, and the gentle curve of a branch half-concealing them, seemingly in a plane parallel to the housefront but much nearer to us.
>
> (ibid., p. 104)

He then directs our attention to the right-hand side of this small area, to the triangle of sunlit wall between the eaves and the branch, and a second branch that may be sprouting from the first and seems to be twisting toward us and downwards, crossing in front of the branch it springs from. In the angle of the two branches, Clark continues, there is an area of deep blue; it consists, when we look more closely, of

> two broad smears of gray-blue and off-white paint, the first overlapping the thicker branch and the second apparently painted over a line of blue-violet just above it—the line we are invited to take as the twisting branch beginning. The off-white ... seems to override the twisting branch; but the branch fights back. There is a final thin trace of paint—purplish, more cursive and transparent—painted in turn on top of the shadow line. And then on the underside of the thicker branch there is another kind of paintmark, pale orange-brown picked up from the top of the roof and applied more lightly and dryly, putting the thick branch in silhouette. And an oilier brown on the shuttered window just to the right, which half invades the blue-purple of the branch that hides its top edge. And all of this—trying now to move back from the local adjustments and see what they do to the wider pattern of branches and shutters and plaster and tile—all this ferocious involution of markmaking in and around the intersecting branches is constantly altering their relation to the open, more insubstantial, floating 'flats' of the other two windows to the left, and the lighter, more discontinuous brown of the branch bisecting the house below. And so on.
>
> (ibid., p. 104)

And then comes this crucial statement: 'The nonidentity of mark and marked is foundational'. But this nonidentity 'can only be glimpsed, never thematized'; the fact that mark and marked never coincide may be 'foundational', but, Clark writes, it can never itself become the basis for a working method. This nonidentity always 'shadows phenomenalism'; it cannot once and for all replace it. 'It disperses and thins it out; it reveals the logic of the singular and re-creative to have nothing to do with the subject of sensation' (ibid., p.107).

Danchev has summarised Clark's argument like this.

> Cézanne insisted that he painted things as they are, for what they are, as he saw them. The issue is what he saw—how he saw ... perceptual innocence was a chimera. Cézanne's late painting testifies to his recognition that fanatic attentiveness did not yield any greater clarity or immediacy. On the contrary, long fixation led to perceptual disintegration. The harder he looked, the more he became aware of dispersion, dissolution, destabilisation ... doubt. ... things were in flux.
>
> (Danchev, 2012, pp. 338–9)

What this may speak to in analytic practice is the inherent impossibility of the analyst's words ever coinciding with the 'experience', the phenomenology, of the patient's or even the analyst's own emotional and semantic world. Indeed the very notion of a 'world' is questionable when we are dealing not just with the 'unconscious'—in which, as Freud observed, notions of 'foreground and background', 'inside and outside', 'experience and representation', 'now and then', may no longer apply. We are instead dealing with the dynamic force field created by the meeting of at least two 'unconsciousnesses'.

Clark's article appeared in a book of essays honouring the work of Paul de Man, whose major contribution to literary studies, alongside that of his friend Derrida, was to make us aware of the inherent epistemological difficulties and contradictions in any text. Thanks to the lessons of post-Saussurian linguistics and of post-structuralism, and of Lacan on the illusions of the Imaginary, we know there can be no such thing as a wholly 'accurate interpretation'—Borges famously satirised the idea in his story of a map that was so accurate that it reproduced the territory it was mapping (Borges, 1946). There can only be an interpretation that achieves a degree of vividness for the patient—who may herself need help mourning the loss of the idea of being perfectly 'understood'. What Clark's reading of Cézanne teases out is the anguish the process involves. 'Vividness', writes Clark, 'is the vividness of defeat. The vividness of procedure. Even this, says the painting, cannot secure the phenomenality of the sign. You see why the "even this" had to be so monstrously good' (Clark, 2001, pp. 108–9).

Clark goes on to imagine the painter at work in front of his motif, and the passage catches, with an eloquence equal to anything I have read in the analytic literature, something of the texture of what it can be like to sit in the therapist's chair in daily practice, and the challenges faced. Within the complex plethora of perception and phenomena, what to choose to comment on, associate to, interpret, and how? What to remain silent on?

> I imagine him looking around, as it were, for a rule to follow for the next mark, and hesitating because he wished not to recognise that no such rule existed. He did not want to know that any next mark he might make would be accurate and inaccurate at once; and accurate above all by reason of what he would do to it—the force he would apply to it more than the sight of it in relation to whatever it was of.
>
> (ibid., p. 109)

What then of 'the aesthetic' of which Ferro and Civitarese, Meltzer, Ogden, and other analysts write, the aesthetics of the session? Earlier commentators on Cézanne, such as Bernard, in attempting to describe the painter's working method and its challenges, and to evoke the tension between imitation and imagination, emphasised his journey into 'pure painting', towards a sort of unadulterated aesthetic experience. This is Bernard:

> Such is his working method: first complete surrender to the model; careful establishment of positioning, a search for outlines, relationships and proportions; then, in very meditative sessions, heightening of colour sensations, bringing forms into relief with a view to an overall decorative conception, and making colour sing at its most tuneful. Thus the more the artist works the more his work distances itself from the objective, the more he distances himself from the opacity of the model that has served as his point of departure the more he enters the realm of pure painting [la peinture nue], which has no aim than itself; the more he makes his picture abstract, the more comprehensively he simplifies, it, having given birth to it narrow, conventional, hesitant.
>
> (Bernard, 1904, p. 34. Appendix 9)

Writing such as this predates and was easily recruited into accounts of painting in terms of 'significant form'—Clive Bell's shorthand for the formalist aesthetic that Roger Fry evolved, in the years around World War I, prompted above all by his experience of Cézanne (Bell, 1914; Fry, 1920). It also fed into a certain linear narrative, influential in the 1960s and 1970s, of the 'progress' of modernism in painting, from Cézanne to Cubism to Constructivism to post-painterly abstraction and so on.

Even Sargy Mann's thinking tended in this direction, although in his account, the tension between 'imitation' and 'decoration' generates a new and powerful experience, something more compelling than 'pure art' or 'significant form':

> Everything that Cézanne did on the canvas affirmed its reality and its presence as flat decoration. The quality of the brush marks and their directions were determined far more by the decorative unity of the pattern than the particular form they were describing. Indeed the characteristic look of his brushwork arises, I believe, from a hatred of the imitative. If he felt there was the slightest danger of a passage being seen as localised imitation, he would 'stitch' the brush marks into the flat pattern in directions perverse from the standpoint of the forms. All of this makes the transmutation into an experience of reality that much more exciting and transporting when it does occur.
>
> (Mann, 1981, no pagination)

Part of the value of Clark's writing on Cézanne is that it helps us appreciate how the aesthetic experience of the painting, as we can learn from Cézanne, is never something easily achieved or given, reducible to a procedure (as Mann almost seems to suggest), or merely self-generating.

Commenting, in an earlier paper, on the late Bathers in the Philadelphia Museum of Art [illus. 3.8], Clark noted:

> a look the figures all have of obeying a strict but obscure choreography. It is not that 'constraint' is the wrong word for the way these individuals carry themselves, and even for some of their facial expressions; but the tension and repetition seem to me generated out of the bodies—out of the effort at fixing and placing their typical states—not out of some abstract imperative.
>
> (Clark, 1995, pp. 107–8)

A wish to integrate a decorative surface, for example. Such 'imperative' as there is seems to emerge out of the figures themselves and their interactions.

> Marks respond to each other as rhymes or beats. But it was exactly this being always inside a metric or a rhyme scheme that Cézanne would not accept. Look at the way any sequence of marks, even one that strikes out for the detail of optical experience as unflinchingly as that in 'Trees and Houses', is overtaken by a logic of contrivance, not perception. Look at the way something so basic and constitutive of painting as 'calling on the accidents of process'—which no one in their right mind (certainly not Cézanne) objects to—sets off an unstoppable automatism whereby accidents become what the process is directed to as well as by. And the words we need to describe the process are contingency, performance, and will, not necessity, imagination, and 'half-conscious instrumentality'.
>
> (ibid., p. 109)

'In putting "accident, performance, and will" in place of "necessity, imagination, and openness" I look to be preaching a heartless creed', Clark says. 'But what if I settled for the words "practice, exercise, and object" rather than "spontaneity, experience, and subject"'? (ibid., p. 110).

If, indeed, we are dealing with the field created by two unconsciousnesses, what help is it to privilege what we would like to think comes most 'authentically' from our egoic and conscious selves—our spontaneity, experience, and subjectivity? We might be on safer ground if we fall back on 'practice, exercise, and object', thus giving licence to the 'unstoppable automatism' and the otherness, the apparent 'accidents', of reverie.

'By not worrying about generating meanings', writes Civitarese, 'there remains only one—but maybe the most important one of all—meaning without meaning, that of *dance*. A dance of colourful words' (Civitarese, 2019, pp. 57–8).

'Each brushstroke must satisfy an infinite number of conditions', wrote Merleau-Ponty (1945c, p. 15). So how do you know you are on the right track? Of course you don't.

Cézanne may not have been aware of the battle within him between the naturalist and the man of imagination, of the moment at which, 'concerned with

objectivity, he stepped right into the arbitrary [soucieux d'objectivité, il entrait cependant en plein arbitraire]', as a perceptive contemporary wrote. But 'he was surely one of those who sought with the greatest anguish and pathos that balance between instinct and reason that it is genius's lot to find' (Jourdain, 1950, p. 84.)

Donnel Stern, whose 'Relationalist' approach Ferro and Civitarese contest, has written of change in analysis in a way they might not dispute; it is 'an unplanned, affectively charged, transactional event' that we may (or may not) symbolise sometime after the event.

> But in the moments in which it happens, if we see it or sense it at all, it is out of the corners of our eyes ... The new meanings that come about as a result of this destabilization happen by themselves and are unpredictable.
>
> (Stern, 2018, p. 16)

'We do not know what the healing factors are', wrote Ferro and Nicoli; 'in session we perform dozens of mental operations of which we know nothing, operations we perform unawarely and unknowingly' (Ferro and Nicoli, 2017, p. 118).

Cézanne shows us all this in process, each painting a sort of snapshot of its own making. Did the struggle only become violent and disturbing when dream activity failed—when he became *too* conscious of the tension between the 'objective' and the 'arbitrary', the battle within him between the naturalist and the man of imagination? Certainly, he went to great trouble, as must the analyst, to maintain the conditions necessary for protecting this activity from intrusion; he needed privacy and solitude in order to sustain negative capability and to be able to work; even within this frame, he could blunder. A false move—not so much too wild as too willed—and 'patatras! Tout fout le camp!' (Gasquet, 1921 and 1926, p. 109).

Yet we value his 'failures' highly. For perhaps they give us some reassurance that we too can't know what we are doing. Perhaps it is not a question of 'successful' translation, but simply of the readiness, maybe not consciously willed, to go from β to α and back again, and it is this that communicates itself to the patient as to the viewer of a painting abandoned unfinished by Cézanne. The process of transformation of β to α is what generates the entire human field; the field is the totality of all our efforts, across history and geography, of our efforts to represent.

The 'aesthetic' is a living and necessary alternative to 'precision' and the search for the 'heart of the matter', and in this sense, it is far from something detached, otherworldly, or serene. 'Aesthetic' interventions by painter or analyst may be made in the heat of the moment, unconsciously or in desperation. But in so far as they are products of the unconscious, of reverie, they help knit together the field, as may only become apparent later—as might be the case for an artist who turns her canvasses or drawings to the wall, maybe in disgust, to return to look at them later (if at all), to see how they might 'speak'.

4 The art of the impossible

In 'Freud's Cézanne', his essay of 1995, T. J. Clark argued that Cézanne undertook his relentless pursuit of questions of form and equivalence in a deeply nineteenth-century way, in the spirit of 'Helmholtz, Charcot, and the *Revue encyclopédique* ... positivist and materialist in the strong senses of those words. Freudian in the way of Freud in 1895' (Clark, 1995, p. 116).

Cézanne, in this argument, stretched a materialist language of bodies as far as it could go, and the ultimate interest of his art lies precisely in its 'happening on the powers and limits of a particular system of representation' (ibid.). But his art did not simply remain within that system, 'imprisoned by it, exemplifying it'; for 'the sheer doggedness with which Cézanne tries to exercise the powers in question ... lead him continually to their boundaries and insufficiencies' (ibid.).

Clark's broader argument is that

> glimpses of alternative systems of representation are only thrown up by the most intense and recalcitrant effort to make the ones we have finally deliver the goods. It is only in the process of discovering the system's antinomies and blank spots—discovering them in practice, I mean—that the first improvised forms of contrary imagining come to light ... as *repoussoir* for the system they still belong to. They are what makes that system visible as such.
>
> (Clark 1995, p. 116)

What a succinct statement of the work of analyst and patient, which might precisely be defined as a process of 'happening on the powers and limits of a particular system of representation' (ibid.): the patient's and the analyst's particular ways of staying caught in certain representations of self, other and world.

In Clark's argument, Cézanne, like Freud, was seeking to express or 'to materialize the play of phantasy' (Clark, 1995, p. 111). He attempted this by means of 'a kind of literalization of the notion of the body's being always subject to movements of substitution, replacement, shuttling between possible places or identities. A literalization of metaphor, we might say' (ibid., p. 111).

Clark explicitly uses 'phantasy' here in the sense that Laplanche and Pontalis give the term, that is, a dimension whose structures 'are irreducible to the contingencies of the individual's lived experience', and that has 'coherence,

organization and efficiency' all of its own (Laplanche and Pontalis, 1988, pp. 333 and 332, respectively). Those, for Clark, are the qualities of the unconscious that the Philadelphia Bathers [illus. 3.8], in particular, is reaching for.

He invites us to look, for example, at 'the penis-like head of the striding woman on the left' as an example of the way the body is always subject to those 'movements of substitution'; he sees the late paintings of Bathers as contributions to such 'doomed, magnificent limit-cases in the history of materialism' (Clark, 1995, p. 101) as Freud's 'Project for a Scientific Psychology'. Both Freud and Cézanne, in Clark's compelling thesis, want to present us 'with a fully and simply physical account of the *imagination*' (Clark, 1995, p. 101).

So, in the late Bathers, we see

> bodies ... deformed and reconstituted by the powers of mind ... let them appear as they would... in a world where ... 'imagination', 'mind', 'body', 'phantasy' and so on ... would be grasped, by the bodies and imaginations themselves, as descriptions of matter in various states.
>
> (ibid.)

The interpenetration of bodies in the painting—'the shift between buttocks and shoulders'—can be understood 'as a figure of one body necessarily being in another, entering every body it encounters, always and interminably reading the configurations someone else's body takes by taking place within them' (Clark, 1995, p. 111). This is 'the final figure of Cézanne's materialism ... his plainest attempt to rewrite phantasy in material terms—as an actual (brutal, funny) displacement of one totalization of matter by another' (ibid., p. 111).

But perhaps Cézanne went further than Clark suggests—or went somewhere else as well. Clark does not follow Laplanche and Pontalis further into their discussion of the contents of the 'autonomous sphere' of phantasy, or more specifically what, following Freud, they term 'primal phantasies'. Primal phantasies—seduction, primal scene, castration—are, in Laplanche and Pontalis's definition, universal, and related to the question of origins. They are 'solutions to a major enigma for the child'—where do I come from? They are the 'original point of departure for a history', and 'the ultimate factors that psychoanalysis can uncover' (Laplanche and Pontalis, 1988, p. 333).

But suppose Cézanne was connecting to something beyond and anterior even to these 'ultimate factors', conjectured but ultimately unrecoverable by psychoanalysis, but mysteriously accessible in certain works of art? The phantasy body of Clark's argument—the shoulders and the bottoms that, in the famous Peter Cook and Dudley Moore sketch, follow you around the room - is I think better understood as the body of the 'chora', of part-objects, displacements, overlaps, condensations, penis-in-the-breast, the pre-verbal, proto-mental world of the infant evoked by Klein, Bion, Meltzer, and Kristeva. Later artists perhaps made their sense of the immanence of this world even more explicit; think for example of certain paintings and sculptures by Dorothea Tanning. But such work would have been inconceivable had Cézanne not existed.

Seen from a psychoanalytic field perspective, the question for Cézanne was not only how far he could take nineteenth-century Realism, or reconcile intuition and concept, or Poussin and Impressionism. It was also how deeply he could go in his exploration of the underworld of our common field, a journey that would necessarily also involve meeting with his own interior (the 'dedans'), without losing himself utterly, in some total regression or overwhelm. Like Bion, he knew there were 'places inaccessible to the psyche ... places of madness' (Civitarese, 2014a, pp. 1065–6). How could he keep one foot in consciousness and identity? Mostly he did. He could never unlearn a grounding knowledge of geology, for example. He understood how the landscape was formed and how it was worked. He knew much about his sitters' ordinary lives; sometimes, it can seem, in his very bones. But such was the tension, the area of risk, that he, like Bion, came to in his late work, and that has so engaged many of his successors. 'What interests me is the unease of Cézanne ... that is to say the drama of the man', said Picasso (1935, cited in Gowing, 1988, p. 63).

In one of the letters subsequently collected together as 'Letters on Cézanne', Rilke wrote:

> After all, works of art are always the result of one's having been in danger, of having gone through an experience all the way to the end, to where no one can go any further. The further one goes, the more private, the more personal, the more singular an experience becomes ... for the utmost represents nothing other than that singularity in us which no one would or even should understand, and which must enter into the work as such, as our personal madness, so to speak, in order to find its justification in the work and show the law in it, like an inborn design that is invisible until it emerges in the transparency of the artistic.
>
> (Rilke, 2002, pp. 4–5)

To expose one's 'personal madness' in this way courts the risk of diagnosis. At one point in his complex and intriguing 1995 essay (fortunately it is far from its whole point), Clark does come up with a psychoanalytic diagnosis for Cézanne. 'You will gather that if I saw it as necessary or possible to psychoanalyze Cézanne', he wrote, before going on to do just that,

> I would hazard the guess that ... the late [Barnes Foundation] *Bathers* [illus. 3.5] were his effort to reconstitute a world of sexuality which, at some level, he had never left ... There has never been a subject so constituted under the sign of loss and despondency as the figure leaning on the tree. Maybe he does not even see the phallic mother arriving. Maybe in a sense he does not want to. He is content to spend his life grieving for the body he once had.
>
> (Clark, 1995, p. 104)

Clark's Freudian-Lacanian interpretative argument hinges on the painting's 'insecurely gendered' figures. 'He will not accept the Symbolic—not accept sexuality as a structure of exchange' (ibid., pp. 103–4).

The problem with a classical psychoanalytic formulation such as this, brilliant as it may be, is that effects a closure. What can we conclude, if we take it too much to heart, that Cézanne was a great artist compromised by a basic psychological fault? The generative fecundity of his work is subtly thrown into doubt. What I have attempted throughout this essay is rather to put the painter to work for us— and perhaps the most that we can usefully say, diagnostically, and critically, is that he too put his symptom to work.[1]

The question of how far Cézanne himself feared a descent into madness and loss of bearings has been inextricably linked, for biographers, to two works of literature. In 1886, the painter's boyhood friend Zola published a novel, *L'œuvre*, *The Work*, whose main character is a painter, a composite figure partly modelled on Manet and Cézanne himself. The protagonist, Claude Lantier, after repeated rejections from the Salon, embarks on a huge canvas, a cityscape that he intends to be his masterpiece. He works and reworks it, even, strangely, adding a nude female bather, with which he particularly struggles. The painting is a disaster; Lantier grows more and more depressed; his friends drift away. He finally goes mad and hangs himself from the scaffolding around his painting.

L'œuvre belonged to Zola's great series of novels on the fictional Rougon-Macquart family, an attempt to produce an updated version of Balzac's *Comédie Humaine*, his multi-volume chronicle of an earlier generation. *L'œuvre*'s inspiration partly came from a novella by Balzac, *Le Chef-d'œuvre inconnu*, *The Unknown Masterpiece*, whose hero is a painter named Frenhofer.

Balzac's story (1831, with a final version in 1837) is set in the seventeenth century and features the real painters Poussin and Porbus alongside its fictional hero. The climax occurs when Frenhofer reveals the masterpiece on which he has been

1 Clark's account is, however, redeemed by its sheer poetry.

> The body is here and now and integral. It can still exist, naked under the trees. Women are fearful, but only these women—the women in the middle—and in a moment the mother will have come again and made them whole. The storm will break. The fruit will get eaten.
>
> (Clark, 1995, pp. 103–4)

Merleau-Ponty too had done some diagnostic work on Cézanne but it led him to a very different kind of conclusion.

> There is a rapport between Cézanne's schizoid temperament and his work because the work reveals a metaphysical sense of the disease: a way of seeing the world reduced to the totality of frozen appearances, with all expressive values suspended. Thus the illness ceases to be an absurd fact and a fate and becomes a general possibility of human existence. It becomes so when this existence bravely faces one of its paradoxes, the phenomenon of expression. In this sense to be schizoid and to be Cézanne come to the same thing.
>
> (Merleau-Ponty, 1945c, pp. 20–1)

A current within Cézanne scholarship, one which runs counter to the formalist account casting him as the father of abstraction, introduced psychoanalytic thinking as a tool for finding meaning in his work. This current flows from Meyer Schapiro's monograph of 1952 through to the work of Theodore Reff and others. Attempts from within psychoanalysis to psychoanalyse Cézanne reached a peak (or trough) in 2001 with a panel discussion at the 42nd Congress of the International Psychoanalytic Association in Nice (Rizzuto, 2002).

working for ten years (the Bathers were to occupy Cézanne for longer than that), a painting of a beautiful courtesan. But all the visitors can see on Frenhofer's great canvas is a confusing mass of colours and bizarre lines—until, coming closer,

> they discerned, in one corner of the canvas, the tip of a bare foot emerging from this chaos of colours, shapes, and vague shadings, a kind of incoherent mist, but a delightful foot, a living foot! They stood stock-still with admiration before this fragment which had escaped from an incredible, slow, and advancing destruction. That foot appeared there like the torso of some Parian marble Venus rising out of the ruins of a city burned to ashes.
>
> (Balzac, 2001, pp. 40–1).

'There's a woman under there!' Frenhofer exclaims. Porbus ventures the comment, 'Combien de jouissances sur ce morceau de toile!', 'What delights on that little piece of canvas!' (ibid.) But Poussin and Porbus cannot finally disguise the fact that apart from the foot, they see nothing. The scales now fall from Frenhofer's eyes; he berates himself as a madman and a talentless fool, and the next morning he is found dead, having burned all his canvases.

Perhaps what Porbus and Poussin saw is an intuition and glimpse of the semiotic, the proto-mental world of the infant, the first glimmerings of an object relation, but in a negative or an inverted form: something being born out of chaos rather than a fragment that has survived destruction. More literal examples from the history of painting might be found; Dorothea Tanning's 1978 *Notes for an Apocalypse*, for example, a large painting that includes a foot among other sculptural body parts, and seems to show a primitive and frightening world of part-objects, a Lacanian *corps morcelé*. A paragraph a little further on in Balzac's story indeed refers to a cheek, eyes, a breast, a rounded contour, to which Frenhofer tries to draw his visitors' attention. Yet if his unknown masterpiece is a heroic repository of vital, generative forces with which we lose touch to our emotional impoverishment, it is also a stark monument to what happens when 'binocular vision' is compromised, lost or abandoned, and a reminder of how hard to maintain it can be.

According to legend, Zola's *L'œuvre* was the cause of a bitter break between Cézanne and his old friend; in fact there is little evidence to support this (see the excellent discussion in Danchev, 2012, pp. 242-269, and Danchev, 2017, p. 224). Cézanne is not recorded to have said much about the novel. On the other hand we know that Balzac's *Le Chef-d'œuvre inconnu* spoke to him directly and profoundly. Emile Bernard recalled talking with Cézanne one evening about Balzac's story. Cézanne

> got up from the table, planted himself before me, and, striking his chest with his index finger, designated himself—without a word, but through this repeated gesture—as the very person in the story. He was so moved that tears filled his eyes.
>
> (Bernard, 1907a, in Doran, 1978, p. 65, translation
> from Ashton, 1980, p. 9).

The words Balzac put in Frenhofer's mouth were, for Cézanne, those of a painter,[2] and resonated with his own experience. Frenhofer's passion to realise a vision was Cézanne's; an examiner from the conservative École des Beaux-Arts who had said Cézanne 'paints riotously' was using an adverb Balzac had used about Frenhofer. For as Dore Ashton put it, Cézanne

> never relinquished his original vision of the driving force, the dynamic and irresistible aspect of temperament which he would later try to reconcile with the need for what Rilke called 'work of the hand'. The conflicts so urgently described in *The Unknown Masterpiece* were intense in Cézanne's youth and revisited him in his last years.
>
> (Ashton, 1980, p. 33)

In her book, *A Fable of Modern Art*, Ashton offers the fullest exploration of Cézanne's relationship with Balzac's *nouvelle*, and in the process offers yet another vertex from which we might view the painter. Where Clark argued that Cézanne was, in essence, a nineteenth-century materialist seeking embodied form for phantasy, Ashton notes how deeply sceptical he was about some of the dominant, positivist, and materialist ideas of his time, including Zola's 'naturalism' and the Impressionists' scientific aspirations. He identified himself, Ashton claims, with a different, earlier tradition, that of the Romantic generation to which Balzac, Delacroix, and a little later Baudelaire belonged.

Ashton's argument is that Cézanne can be located in a tradition that stretches from Swedenborg and Fourier to Baudelaire, Balzac, and Cézanne's contemporary Mallarmé (Ashton, 1980, p. 44), thence to Rilke, Kandinsky, and Schoenberg, who, with Picasso, occupy the remainder of her book. This essentially idealist tradition embraces the notion of universal analogy and reciprocity, of the mysterious 'correspondences' between things that so moved Baudelaire (and then Merleau-Ponty); Cézanne's own 'self-sustained' idealism never permitted him to give up on a sense that there was a 'higher and further', and it 'led him to conceive of paintings themselves as descriptive of a universe in which all is related and held within a rhyming scheme that transcends even vision' (ibid., p. 39).

Frenhofer, Ashton argues, modelled a kind of total attention, sustained by 'temperament' and primary force, which might transport him 'to the realm of unity' (Ashton, 1980, p. 40). Thus he might, like Frenhofer, 'remain solely within the dream of their ongoing work'. 'For him to rid himself of doubt, he could only reach the kind of attentive trance that Balzac had considered the optimal creative condition—the trance that was a form of second sight' (ibid., p. 40). But doubt and conflict could never be far away. For

> the kind of attention the mature Cézanne brought to bear could easily and drastically be transformed into a kind of abstract reverie where the artist is no

2 The words Bernard put into Cézanne's mouth in fact echo Balzac, Baudelaire, and Delacroix.

longer sure of what he has before him or how it is to be transformed by his eye and hand. In his last years, surely, Cézanne's doubts assailed him at every step. The old arguments became more insistent and at times he must certainly have feared that he had truly become Frenhofer. At that moment when he tearfully designated himself Frenhofer to Bernard, who was Frenhofer to Cézanne?

(ibid., p. 38)

Elsewhere he declared that Frenhofer was the fictional character he most admired (Danchev, 2012, p. 254).

'The tempted idealist hovering on the brink of the abyss was as much a part of him as the workmanlike painter of the motif', Ashton writes (Ashton, 1980, p. 31); the workmanlike painter of the motif could recoil when he found himself 'rhyming' too easily. Analytic attention too can all too easily become a kind of abstract reverie in which the analyst loses touch with what is before him.

Other writers have seen yet other irreconcilables and paradoxes in the heart of painter's work. Jon Kear, a more recent commentator on Balzac's story and its possible meaning for Cézanne, has identified Balzac's sub-text as the unresolved relationship between art and desire. Kear sees Cézanne, in a series of key pictures, as the painter-protagonist confronting the choice between artistic vocation and sexual gratification (Kear, 2006). But at stake is not just a question of ethics and the seductive pull of the naked model, which the elderly Cézanne, painting the great Bathers, avoided by working from life drawings made in his youth (had nude models even been available in respectable Aix. Bernard cited in Danchev, 2012, p. 345). For underlying the important question of sexual probity, in both Cézanne's studio and the analyst's consulting room, is a deeper and ever-live tension between proto-sexuality and adult sexuality. The challenge faced by Cézanne in those crucial final years went way beyond making some kind of choice between them, and beyond even maintaining binocular vision that might hold both in sight; it was how to register the overlapping, intertwined lives of both the pre-conscious, semiotic world of 'chora' and the insistent reality of adult sexual desire—how the former is always immanent in the latter—in a painting that, given the magnitude and time-hallowed nature of the problem, would have to be a statement as major and as classical (in the tradition of Titian and Rubens) as the Bathers. Involved was the search for a way of letting the phantasy/'chora' body find its own container, in the form of a painting.

And when adult sexuality is most insistently present in the consulting room, this is often when the analyst must recognise a kind of birth struggle: something insufficiently dreamed in the proto-mental era, and therefore deprived of some of its life-giving potential, is pressing to find expression.

The caesura-transcending and caesura-creating passage from β to α involves interplay between the inchoate and amorphous, and the dreamable and figurable. In a fine phrase, Civitarese describes transcending the caesura as a 'respiration of the mind' (Civitarese, 2008, p. 1131); artistic and analytic work requires of us repeated 'soundings', as Michael Parsons has written, drawing on Seamus Heaney (Parsons, 2014, e.g., pp. 158–160; Heaney, 2002, p. 34f), into the pre-individual

and proto-mental, the common loam of the field whose mushroom might be a dream. A model of psychoanalysis inspired by the overcoming of caesurae is thus, by definition, a field model (Civitarese, 2005, p. 1138). Transformations 'in the field' are also always transformations at the unconscious level of primitive experience.

The tension within which Cézanne and the analyst dwell can be thought about across many other poles and caesurae: for example, material-metaphysical, Dionysian-Apollonian, naturalism-abstraction. Neither term among any such possible binaries is totally lost in the process; they remain in tension. This is exemplified and clarified in late Cézanne: the Bathers, for example, depict both a recognisably 'real' scene, naked bathers in a grove, an art-historically hallowed subject, and a dream of them. But the subject, content, has equal primacy with the form, the way it comes to us. Cézanne arrived at a maximal tension between the two. At least, this is one among other possible vertices from which we might view him; Danchev concludes his masterful biography with an Epilogue—'Cézanne by Numbers'—that is a rich compendium of accounts, many contradictory, of the painter and his work (Danchev, 2012, pp. 359–73). Gertrude Osthaus's photograph of 1906 shows him literally poised on a threshold [illus. 3.2]: 'un écart du dedans et du dehors' (Merleau-Ponty, 1964a, p.177).

Civitarese, commenting on Bion from another perspective, that of the sublime, writes that the sublime lives in the tension, destined to remain unresolved, between 'sensuous/sensible' (that which we can perceive with our senses) and 'sense-able' (that which we can sense in a vague and undefined way), between what we can see and what we can only intuit (Civitarese, 2014a, p. 1068). Civitarese notes a letter to Goethe of 1794 in which Schiller describes himself as floating between 'ideas and perceptions, rules and feelings, the technical head and genius' (Schiller, 1794, p. 11). For Bion, the psychoanalytic method was also 'uncertainly poised between intuition and concept' (Civitarese, 2014a, p. 1083), and he was forever working at reconciling them. In this sense, continues Civitarese, Bion's is a 'Romantic psychoanalysis ... even if it is obvious that each pole contains elements of its opposite'. Bion's struggle to make psychoanalysis mathematical 'comes close to disciplined mysticism'; at the same time, he reclaims 'themes and procedures of mysticism' for rationality, in order to increase the analyst's receptivity to 'the events of the analysis that are not within the range of the sensible' (Civitarese, 2014a, p. 1083).[3]

3 Civitarese cites Bion's paraphrase of Kant:

When I tried to employ meaningless terms—alpha and beta were typical—I found that 'concepts without intuition which are empty and intuitions without conceptions which are blind' rapidly became 'black holes into which turbulence had seeped and empty concepts flooded with riotous meaning'.

(Bion, 1991, p. 229; Civitarese, 2014a, p. 1083)

This tension is embodied in Bion's prose style and, for Civitarese, in his writing's inclination towards the sublime:

> concise ... to the point of obscurity, sparing with adjectives, simple, energetic in expression, direct, and pathetic (in the sense of impassioned). Its silences, in itself and in words, are no less sublime. The lofty tone, as of someone speaking about dramatic things and for whom it is worthwhile to live and to suffer ... impenetrably dark sentences ... sometimes lit up by flashes of brilliant intuition.
>
> (Civitarese, 2014a, p. 1065)

The effect on the reader can be 'a mixture of persecution, reverential fear and amazement' (ibid.).

> Bion makes us visit places inaccessible to the psyche. These places of madness give us vertigo, but the same can be said of the theoretical formulations with which he probes into them, because they are always on the edge of paradox, ambiguity, a certain obscurity and indefiniteness. In his writing, Bion gives the idea of struggling incessantly with himself, alternating extreme intellectual engagement and detachment, passion and distance. He is both fired up and cold like an officer on the field of battle; and this, as we know, is one of his metaphors, and what is more, one derived from real experiences in his own life.
>
> (Civitarese, 2014a, pp. 1065–6)

It can come as a surprise, after reading Bion and struggling to tune in to his thinking, to learn that he talked to his patients and groups in an embodied 'Language of Achievement' that was 'authentic, passionate, creative, sincere, and without regard for decorum' (ibid., p. 1070).

Both Cézanne and Bion were oriented towards a realisation of 'Reality Sensuous and Psychic' (Bion, 1970, p. 26, chapter heading); we see the painter, like the psychoanalyst, 'struggling incessantly with himself' (Civitarese, 2014a, p. 1066). Cézanne obtained a tension in his paintings—a caesura or chiasm, with its own living properties—between the phenomenology of the everyday, sensuous, concrete, and particular (this chair, this tree), and the non-sensuous, unknowable, and ineffable; between, we might almost say, Merleau-Ponty and Bergson (if this did not falsify the extent to which each thinker contains elements of the other). But if Clark is right about Cézanne's 'Freudianism', and how he worked and pushed at the very limits of the nineteenth-century materialist project, his 'sublimity' (in both senses of the word) arises out of the fact that he never could resolve the tension between the sensuous-sensible and the supersensible (that which could be sensed intuitively and imaginatively). He had no choice but to live with it, implicit as this tension was in his word 'sensation', which encapsulated and embraced it.

The art historian Philip Shaw has also commented on the co-presence of naturalistic and abstract elements in late Cézanne: the naturalistic forms of trees to the right and left, and areas of pure abstraction in the upper centre of the painting *The Grounds of the Château Noir*, for example [illus. 4.1]. For some

Illustration 4.1 Paul Cézanne, *The Grounds of the Château Noir*, c. 1900–4. Oil on canvas, 90.7 × 71.4. National Gallery, London. NG6342 © The National Gallery, London

contemporaries, Shaw notes, no contradiction was involved; Joseph Ravaisou, a friend of Cézanne's from Aix and a fellow-painter, felt that 'these abstractions are inherent in the nature of the objects depicted' and that 'between abstraction and realism there is only an apparent contradiction' (cited in Cros, 2002, p. 197): in this account, in Kantian terms, there was no distinction between the sensible, what can be seen, and the supersensible, what can be assumed (Shaw, 2013, no pagination). Shaw will not, however, let this go without further interrogation, and his line of thinking is worth following. He argues that while the viewer is 'undoubtedly seduced', this process is undone by the

> return of the very distinctions—cognitive, temporal and representational—that the artwork seeks to efface. One could argue that … what is affirmed here is not the recovery of a pre-individual, Dionysian relation with the plasticity of the world but rather the return of Apollonian measure and division.
>
> (Shaw, 2013, no pagination)

With late Cézanne we are confronted, like Kant, with our 'inability to comprehend an overwhelming magnitude and multiplicity'. For Cézanne, the 'traumatic failure of sensible intuition' did not point, as it did for Kant, to a negative demonstration

of the supremacy of pure Reason, free from 'all determinations of nature'. It led rather to a realisation of 'the sensual qualities of paint' (Shaw, 2013, no pagination) itself, its materiality—just as it led Bion to a form of writing that insisted on the opacity of words (awareness of the sheer materiality and sensuousness of paint is also implicit in Clark's account of the non-phenomenological marks in the *Trees and Houses* in the Musée de l'Orangerie).

Thus Cézanne's painful awareness of the inadequacy of form to map content, of 'the impossibility of presenting a synthesis between the mind and the world', culminates in an 'acknowledgement of the mind's entanglement with the alien matter of the world' (Shaw, 2013, no pagination). Thus for Shaw too, painting 'becomes an endeavour to unveil a mode of otherness that is not simply a reflection of the knowing subject but is related to the pre-individual, inchoate drives of the body' (Shaw, 2013, no pagination).

But he also takes us further: Cézanne connects us with death. In his 'openness of the corporeal to alien otherness', the painter, writes Shaw, was close to the later Nietzsche, the Nietzsche of the shocking, uncanny 'blind autonomy' of the will to repetition, the principle of eternal return. The something bigger than us—the field—is also inhabited by death, that which, for Freud in *Beyond the Pleasure Principle*, precedes the life instincts, that 'painful drive persisting beyond and intervening in the life of the world'. This drive, Shaw suggests, is synonymous with the Symbolic Order itself. It is 'painful' because it comes close to revealing the moment in which artistic 'illusion as such ... destroys itself ... by demonstrating that it is only there as a signifier' (Lacan, 1992, p. 136).

Shaw's reading resonates with a post-Bionian valuing of the aesthetic experience, as consisting of alternating states of integration and non-integration:

> on the one hand, a poetics and an aesthetics of emotional involvement (how to allow oneself to be captured by the text of the analysis, and why), and, on the other, a poetics and an aesthetics of disenchantment (how to achieve the insight that the text is a fiction, and in view of what effects).
>
> (Civitarese and Ferro, 2013, p. 196)

Cézanne, in this light, is poised on the most impressive and terrible caesura, 'between the virginity of the world and the deathly realm of the Symbolic'. His brush marks are 'the anamorphic oozings, the traces of the Real that remain when the world submits to signification' (Shaw, 2013, no pagination).

Perhaps it is incompleteness itself that is the greatest legacy of Cézanne's commitment to telling 'the truth in painting' (Cézanne, letter to Bernard, 23 October 1905, in Doran, 1978, p. 46)—something not pathological but constitutive of our humanity. It can certainly give us a profound shock of recognition.

T. J. Clark—in tune, in 1995, with a late-twentieth-century post-modern sensibility—wrote this:

> Ever since the Philadelphia picture [illus. 3.8] entered the public realm ... people have talked of its being unfinished. The talk seems misleading to

me. Of course paint is applied more thinly and evenly than in the other two Bathers, and there is an amount of bare canvas showing. But in all senses that matter this picture is the most definitive of the three. Its unfinishedness is its definitiveness; and it is an unfinish that comes out of forty years spent meditating on what a conclusion in painting could be. This is a conclusion. It states what the conditions of depicting the body in the world now amounted to, and it does so with utter completeness.

(Clark, 1995, p. 108)

Philip Shaw, in a sustained exegesis of the sublime, has enlisted the work of the Anglican theologian John Milbank in a way that returns us to the human dimensions of the field. We are, writes Shaw, in the end, sustained by our desire for the other, an other 'separated by distance and by difference' but who must be conceived, like ourselves, as 'radically incomplete' (Shaw, 2006, p. 213). Perhaps this incompleteness is dreamed in the solitary, desire-generating foot in the corner of the sublime unknown masterpiece. 'And when, in the experience of the sublime, the other is revealed in this way, we need not despair, for on both accounts self and other "are completed in [their] very incompletion"' (Milbank, 2004, p. 231, cited in Shaw, 2006, p. 213).

My argument, deriving much of its impetus from Merleau-Ponty, has been that late Cézanne provides the closest imaginable analogue—a kind of rehearsal or repeat, in the experience of looking—for the process whereby the world comes into being out of primal, preconceptual, embodied sensation. 'Cézanne's difficulties are those of the first word' (Merleau-Ponty, 1945c, p. 19). He can pull us into something close to the experience of being psychically born, that which we were not, by definition, able to 'experience' first time round. It is the very moment of the birth of the 'thought-object', a prelude to the conception. In one sense, it is a moment of catastrophic loss, in which we are 'poised between the virginity of the world and the deathly realm of the Symbolic' (Shaw, 2013, no pagination).

The brushstroke, like the word spoken in the session, aspires to generate air, space, capacity, and it can only show these to be always compromised and unstable. Yet the painter's and the analyst's coloured marks are somehow able to form themselves, albeit sometimes only just, into a tree, an apple, a face, a figure. Brushstrokes and words provide the conditions within which an object, and desire, might come into being. In the end, the metaphysics of a Bergson or a Bion, in which intuition is central, and matter and mind are ultimately of the same substance, are not incompatible with the materialism of an account that grounds us in our proto-mental commonality, in a sublime network of intercommunicating underground spores. We are biologically creatures of 'durée' and co-becoming in an interpersonal field traversed by dream and desire.

The notion of a desiring body is not an explicit feature in Merleau-Ponty's lexicon. His concern with our shared embodiment as perceiving beings took an ethical form.

[I]f by means of reflection I find in myself, alongside the subject who perceives, a pre-personal subject … if the perceived world subsists in a neutral

state, neither verified object nor dream recognised as such... this world might remain undivided between my perception and his, the perceiving I has no particular privilege that cancels an I who is perceived, both are not so much *cogitationes* shut up in their immanence as beings who are exceeded by their world and who, consequently, may be exceeded by one another.

(Merleau-Ponty, 1945, p. 405)

Cézanne's work, though 'a blurring of the lines between painter and painting, self and Other' (Shaw, 2013, no pagination), allows us an intimation of our connection to each other and to a body larger than ourselves, an experience of 'durée' in action, evolution in 'O', the great field of the unknown, the common flow of becoming-towards-death.

A 'beam of darkness' constitutes an antidote to the tendency, often found in the human species, to carry out 'transformations in hallucinosis' [Bion, 1965], to impose meanings on what has no meaning because of our incapacity to wait for shreds of meaning to emerge.

(Ferro and Civitarese, 2015, p. 125)

In art-historical terms, Cézanne and the Impressionist and post-Impressionist generations provided just such an antidote, to the 'transformation in hallucinosis' (Bion, 1965, p.144) that was the hyper-realistic illusionism of mainstream nineteenth-century academic and 'Salon' art. What better term than 'transformation in hallucinosis' to describe this art, and what better metaphor than Bion's 'beam of darkness' for Cézanne's approach to his subjects and motifs, his capacity to bear waiting in ignorance. He was the master obliged to accept surrender of mastery, which is why he told Gasquet 'Don't call me master' (Gasquet, 1921 and 1926, p. 127).

Robert Bresson, who gave up painting for filmmaking because of Cézanne, told an interviewer in 1996: 'Painting is over. There is nowhere to go. I don't mean after Picasso, but after Cézanne. He went to the brink of what could not be done' (cited in Danchev, 2012, p. 372). In late Cézanne, the results could certainly be deeply strange—the penis-head woman, for example. Drawing on Cézanne, the Cubists threw into further question the authoritative, single-perspectival viewpoint, in favour of unsettling multiplicity. The 'analytic' Cubism of Picasso, Braque, and others, with its overlapping and interpenetrating planes, introduced a more overt kind of painter-viewer displacement with its multiple vertices. Cubism points towards a post-modern, post-Freudian de-centred or fragmented subject, towards an appreciation of the multiplicities—the multiple voices, identifications, possible inter-positionings—of the human being. Cubism discovered the aesthetic and hermeneutic potentials of collage, and enabled a new metaphor: we are, in Jean White's phrase, a 'collage of disparate, perhaps jarring, elements' (White, 2006, p. 190). Ferro and Civitarese certainly help us access this through the exploration of 'characters' in the field and their inter-relationships.

But perhaps Cubism was more closely wedded to nineteenth-century positivism and realism than was Cézanne, insofar as each viewpoint (many as they may

be) in a Cubist work is that of an authoritative narrator. Elias's 'homo apertus' (Lavie, 2011) is not a collage, any more than Lewin's 'life space' can be reduced to a kaleidoscope. Cézanne did something utterly fundamental. He reconnects us to another human fact: there are tensions and paradoxes that refuse to be bundled together within a picture of ourselves as merely composed, like the field to which we belong, of multiple elements and fragments. He connects us to our embodiment with each other and with the field because he lived it, in all its frictions, every time he worked on a painting. No wonder pictures were abandoned and that looking at Cézanne requires time. A little time, says Sargy Mann, will yield enjoyment of the decorative, often dazzling, surface. More is needed for the discovery of depth and dimensionality (Mann, 1981, no pagination); the painting unfolds but in the end never 'resolves' itself.

We meet each other, as Bion said, like 'two frightened and dangerous animals' (Bion, 1980 cited in Ferro, 2005a, p. 1541). A teacher of painting invites her students to draw the space of the studio and then to imagine that a tiger has just walked in.[4] The studio's dimensions, in the sense not of its measurement in metres and centimetres but of its relation to our bodies, depend on human reactions and feelings. A person walking into the room might have no less effect. The field expands, contracts, warps, bubbles (like, so astrophysicists tell us, inter-stellar and inter-galactic space). Actors, set designers, and theatre directors know this very well; so does anyone who has found themselves overwhelmed by 'sensation' and the semiotic, lost in the Kristevan 'chora', as in psychotic states.

Where the Cubists tended to frame the vertices and elements of their pictures within an overall stabilising structure, in late Cézanne space, the 'envelope' and the field are always on the brink of instability; time spent with the Bathers, a late portrait, or a *Mont Sainte-Victoire* will reward the viewer with an experience of how close the sense of a changeable, precarious but living and dynamic space can be to a space that is alarmingly unreliable. Not many artists since Cézanne have worked with such intensity on this brink. When the sculptor Alberto Giacometti was drawing, he found the model would recede and recede until it became a tiny figure at a vast distance at the end of his studio. In building up the plaster maquettes for his sculptures, he discovered that the figures he produced grew inexorably thinner and taller. Drawing or modelling a head, he felt that the space between his sitter's nostrils could become as vast as the Sahara (van den Braembussche, 2006, pp. 32–3). His wife Annette and his brother Diego—the flesh of his flesh—were frequent models; when they were sitting for him, he found that he did not recognise them (Giacometti, 2017).

4 Tiger. In *The Dream*, the first volume of *A Memoir of the Future*, Bion [1991, p. 112] writes that: 'Psychoanalysis itself is just a stripe on the coat of the tiger. Ultimately it may meet the Tiger—the Thing Itself—O'. The symbol of the tiger recurs in various of Bion's writings. Harris Williams [2010, p. 80] underlines how it may be the instrument of his 'most intimate identification' with Blake. But first it is still the tiger which had frightened him and his brother when he was a child in India, the tiger as a figure in fantasies of being devoured. (Civitarese, 2014a, p. 1081)

In scale and stature, like ciphers of bodies, Giacometti's haunting standing and striding figures both share and refuse to share our space. Indeed there is no longer any attempt at the illusion of a sharable Cartesian space. Space instead becomes something unfixable in representation—or rather perhaps, it is its unfixability that is represented.

Clark wrote of the Philadelphia Bathers:

> These are figures of pure outsidedness, of viewing at (from) the vanishing point, of the body of another at last put away from us, in a space we do not (and could never) occupy; and therefore these can only be diagrams of bodies, so many fallen or frozen geometries as opposed to the real thing. The real thing is here where we are—in 'the scene where the subject is a protagonist', not an onlooker.
>
> (Clark, 1995, p. 111)

Cézanne connects us to facts of existence, living, and responsibility.

Three of our interlocutors can have the last word. First, Sargy Mann:

> I think that art can be a unique, essentially non-verbal, channel of experience, by means of which one can access new and surprising experience and understanding of the infinite variety of reality … and in the case of art the process both discovers and invents a metaphor capable of communicating that experience to oneself and others … I want to say that Bach and Miles Davis, by inventing new structures of expressive sound, actually experienced depths and subtleties of emotion which possibly had never been experienced on the planet before … I think that Shakespeare's absolutely astonishing ability to structure language in the most ridiculously inventive way enabled him to plumb depths of personality and relationship which probably nobody had experienced before him … it certainly doesn't happen automatically, we've got to make a hell of a lot of effort of the right kind.
>
> (Mann, 2016, pp. 30–1)[5]

Next, Merleau-Ponty:

> It is not enough for a painter like Cézanne, an artist, or a philosopher, to create and express an idea; they must also awaken the experiences which will

5 Movingly, my copy of the booklet in which this appears belonged to Mann's widow, Frances—her name is penciled on the inside cover. On the last page, immediately following Sargy Mann's text, she has penciled this:

> Flaubert to Maupassant 'There is a part of everything that is unexplored, because we are accustomed to using our eyes only in association with the memory of what people before us have thought of the things we are looking at. Even the smallest thing has something in it which is unknown. We must find it'.
>
> The passage is cited in Danchev's biography of Cézanne,
> which Frances Mann may have been reading (Danchev 2012, p. 29).

make their idea take root in the consciousness of others. A successful work has the strange power to teach its own lesson ... The painter can do no more than construct an image; he must wait for this image to come to life for other people. When it does, the work of art will have united these separate lives; it will no longer exist in only one of them like a stubborn dream or a persistent delirium, nor will it exist only in space as a coloured piece of canvas. It will dwell undivided in several minds, with a claim on every possible mind like a perennial acquisition.

(Merleau-Ponty, 1945c, pp. 19–20)[6]

And Bion:

the intellectual leader is some one who is able to digest facts, i.e. sense data, and then to present the digested facts, my α-elements, in a way that makes it possible for the weak assimilators to go on from there. Thus the artist helps the non-artist to digest, say, the Little Street in Delft [or the Montagne Sainte-Victoire] by doing α-work on his sense impressions and 'publishing' the results so that others who could not 'dream' the Little Street itself can now digest the published α-work of some one who could digest it.

(Bion, 1994, pp. 143–4, cited in Ferro and Civitarese, 2015, p. 83)

The work of art is a new experience—'something possibly ... never experienced on the planet before'—that comes to life in the spectator, and changes her, maybe across the widest spacio-temporal field. As Merleau-Ponty put it,

The 'instant of the world' that Cézanne wanted to paint, an instant long since passed, is still thrown toward us by his paintings. His Montagne Sainte-Victoire forms and reforms itself from one end of the world to the other, differently but no less energetically than it does in the hard rock above Aix. Essence and existence, imaginary and real, visible and invisible—painting blurs all our categories in the display of its oneiric universe of carnal essences, of convincing likenesses of mute meanings.

(Merleau-Ponty, 1964, p. 35)

6 One can invent pleasurable objects by linking old ideas in a new way and by presenting forms that have been seen before. This way of painting or speaking at second hand is what is generally meant by culture. Cézanne's or Balzac's artist is not satisfied to be a cultured animal but assimilates the culture down to its very foundations and gives it a new structure: he speaks as the first man spoke and paints as if no one had ever painted before. What he expresses cannot, therefore, be the translation of a clearly defined thought, since such clear thoughts are those which have already been uttered by ourselves or by others. 'Conception' cannot precede 'execution'. There is nothing but a vague fever before the act of artistic expression, and only the work itself, completed and understood, is proof that there was something rather than nothing to be said. It summons one away from the already constituted reason in which 'cultured men' are content to shut themselves, toward a reason which contains its own origins.

(Merleau-Ponty, 1945c, p. 19)

There is an invisible dimension in which 'flesh' also sublimates itself into the flesh of ideas (Toadvine, 2016; Merleau-Ponty, 1964a, pp. 193–4). 'Chiasmically', a painting is more than something that exists only 'as a coloured piece of canvas'; it will make its claim on other minds 'like a perennial acquisition' (Merleau-Ponty, 1945c, pp. 19–20).

A link and a chasm: not a neutral ether between us but something both dynamic and unfathomable, catching both our solidarity and closeness with each other, and the immeasurable distances between us. We experience it in 'the paradoxical simultaneity of at-one-ment and separateness' of which Winnicott wrote (Ogden, 1992, p. 620), just as we do when we look at paintings made in a cave 30,000 years ago: the wider, co-created, constantly replenished historical and cultural field.

References

Abel-Hirsch, N. (2019) *Bion. 365 Quotes*. London: Routledge

Alisobhani, A. K. and Corstorphine, G. J. (eds.) (2019) *Explorations in Bion's "O". Everything We Know Nothing About*. London: Routledge

Allchin, D. (2007) 'Monsters & Marvels: How Do We Interpret the "Preternatural"?'. *The American Biology Teacher*, 69(9), pp. 565–568

Ambrosiano, L. and Gaburri, E. (2009) 'Las Meninas'. In: Ferro and Basile (eds.), pp. 107–131

Ashton, D. (1980) *A Fable of Modern Art*. London: Thames and Hudson.

Baker, G. and Morris, K. J. (1996) *Descartes's Dualism*. London: Routledge

Balzac, H. de (2001) *The Unknown Masterpiece*. New York: New York Review Books.

Baranger, M. (2005) 'Field Theory'. In: Lewkowicz and Flechner (eds.), pp. 49–71

Baranger, M. and Baranger, W. (2008) 'The Analytic Situation as a Dynamic Field'. *International Journal of Psychoanalysis*, 89(4), pp. 795–826

Baudelaire, C. (1975–6) *Oeuvres Complètes, Texte établi, présenté et annoté par C. Pichois*, 2 vols. Paris: Librairie Gallimard, Bibliothèque de la Pléiade

Bazzi, D. (2018) 'On the Origins of the Field Theory: From the Lewinian Epistemology of the 1920's to the Field Theory of the Río de la Plata Authors of the 1950s - Moving from Politzer's First Metapsychological Criticism to That of Ferro and Civitarese'. *International Journal of Psychoanalysis, IJP Open*, 5, p. 47

Beckett, S. (2009) *The Letters of Samuel Beckett*, vol. 1. Edited by M. D. Fehsenfeld, L. M. Overbeck, D. Gunn and G. Craig, 1. Cambridge: Cambridge University Press, pp. 1929–1940

Bell, C. (1914) *Chatto and Windus*. London: Art

Bell, J. (2019) 'Gauguin Portraits'. *London Review of Books*, 41(23), 5 December

Benjamin, W. (1978) *Reflections. Essays, Aphorisms, Autobiographical Writings*. Translated by E. Jephcott, Edited with an Introduction by P. Demetz. New York: Schocken Books

Berger, J. (2015) 'Cézanne: Paint It Black'. In: *Portraits: John Berger on Artists*. Edited by T. Overton. London: Verso

Bergson, H. (1903) *An Introduction to Metaphysics*. Cambridge: Hackett Publishing Company, 1912

———. (1907) *Creative Evolution*. Translated by A. Mitchell. New York: Dover, 1998

Bernard, E. (1904) 'Paul Cézanne'. *L'Occident*, July 1904. In: Doran (ed.). 1978, pp. 30–42

———. (1907a) 'Souvenirs de Paul Cézanne'. *Le Mercure de France*, 1 and 16 October 1907. In: Doran (ed.). 1978, pp. 49–80

———. (1907b) 'Réflexions à propos du Salon d'Automne'. *La Rénovation Esthétique 6*, December 1907. In: Clark, 1995, p. 102

Bersani, L. (1977) *Baudelaire and Freud*. Berkeley: University of California Press

Bion, W. R. (1948) 'Psychiatry at a Time of Crisis'. *British Journal of Medical Psychology*, 21(2), pp. 81–89

———. (1961) *Experiences in Groups*. London: Tavistock

———. (1959) 'Attacks on Linking'. In: Bion, 1984, pp. 93–109

———. (1962) *Learning from Experience*. London: Tavistock

———. (1963) *Elements of Psycho-Analysis*. London: Heinemann

———. (1965) *Transformations*. London: Karnac, 1984

———. (1967) 'Notes on Memory and Desire'. In: Spillius (ed.), 1988, pp. 17–21

———. (1970) *Attention and Interpretation*. London: Tavistock

———. (1977) 'Caesura'. In: Bion, 1989, pp. 35–56

———. (1980) *Bion in New York and São Paulo*. Perthshire: The Clunie Press

———. (1984) *Second Thoughts: Selected Papers on Psychoanalysis*. London: Karnac

———. (1989) *Two Papers. The Grid and Caesura*. London: Karnac

———. (1990) *Brazilian Lectures: 1973 São Paulo; 1974 Rio de Janeiro/São Paulo*. London: Karnac

———. (1991) *A Memoir of the Future*. London: Karnac

———. (1994) *Cogitations*. London: Karnac

———. (2018) *Los Angeles Seminars and Supervision*. Edited by J. Aguayo and B. Malin. London: Routledge

Blanchot, M. (1969) *The Infinite Conversation*. Translated with a Foreword by S. Hanson. Minneapolis, MN: University of Minnesota Press

Bleandonu, G. (1990) *Wilfred R. Bion: His Life and Works (1897–1979)*. London: Free Association Books, 1994

Bleger, J. (1958) *Psicoanálisis y Dialéctica Materialista. Estudios sobre la Estructura del psicoanálisis. (Seguido de dos Apéndices a Obras de Georges Politzer)*. Buenos Aires: Nueva Visión, 1991

———. (1963) *Psicología de la Conducta*. Buenos Aires: Paidós, 2003

Bollas, C. (1987) *The Shadow of the Object. Psychoanalysis of the Unthought Known*. New York and Hove: Routledge, 2018

———. (1993) *Being a Character: Psychoanalysis and Self-Experience*. London: Routledge

———. (1995) *Cracking Up. The Work of Unconscious Experience*. New York and Hove: Routledge

———. (2007) *The Freudian Moment*. London: Karnac

———. (2016) *When the Sun Bursts: The Enigma of Schizophrenia*. New Haven, CT: Yale University Press

Borély, J. (1902) 'Cézanne à Aix'. *L'Art Vivant*, no. 2, 1926. In: Doran (ed.) 1978, pp. 18–22

Borges, J. (1946) 'On Exactitude and Science'. In: *The Aleph and Other Stories*. London: Penguin, 2004

Boulton, J. T. (ed.) (2004) *D. H. Lawrence: Late Essays and Articles*. Cambridge: Cambridge University Press

Bronowski, J. (1973) *The Ascent of Man*. London: British Broadcasting Corporation

Brontë, E. (1847) *Wuthering Heights*. London: Wordsworth Classics, 1992

Canguilhem, G. (1952) *Knowledge of Life (Forms of Living)*. New York: Fordham, 2008

Casement, P. (1985) *On Learning from the Patient*. London: Routledge

Cassirer, E. (1923) *Substance and Function, and Einstein's Theory of Relativity*. Chicago, IL: Open Court

Cézanne, P. (2013) *The Letters of Paul Cézanne*. Edited and Translated by A. Danchev. London: Thames and Hudson.

Civitarese, G. (2008) '"Caesura" as Bion's Discourse on Method'. *International Journal of Psychoanalysis*, 89(6), pp. 1123–1143

———. (2014a) 'Bion and the Sublime: The Origins of an Aesthetic Paradigm'. *International Journal of Psychoanalysis*, 95(6), pp. 1059–1086

———. (2014b) 'Between "Other" and "Other": Merleau-Ponty as a Precursor of the Analytic Field'. *Fort Da*, 20(1), pp. 9–29

———. (2016) *Truth and the Unconscious in Psychoanalysis*. London: Routledge

———. (2018) *Sublime Subjects. Aesthetic Experience and Intersubjectivity in Psychoanalysis*. London: Routledge

———. (2019) *An Apocryphal Dictionary of Psychoanalysis*. London: Routledge

——— and Ferro, A. (2013) 'The Meaning and Use of Metaphor in Analytic Field Theory'. *Psychoanalytic Inquiry*, 33(3), pp. 190–209

———. (2020) *A Short Introduction to Psychoanalysis*. London: Routledge

Clark, T. J. (1995) 'Freud's Cézanne'. *Representations*, 52(Autumn), pp. 94–122. Berkeley, CA: University of California Press

———. (2001) 'Phenomenality and Materiality in Cézanne'. In: Cohen et al. (eds.) 2001, pp. 93–113

———. (2018a) 'Relentless Intimacy. Cézanne Portraits. National Portrait Gallery London'. *London Review of Books*, 40(2), pp. 13–16

———. (2018b) *Heaven on Earth: Painting and the Life to Come*. London: Thames and Hudson

Cohen, T., Cohen, B. et al. (2001) *Material Events. Paul de Man and the Afterlife of Theory*. Minneapolis, MN: University of Minnesota Press

Coleridge, S. T. (1825) *Aids to Reflection*. Loschberg: Jazzybee Verlag, 2017

———. (1894) *Biographia Literaria: Or, Biographical Sketches of My Literary Life and Opinions, and Two Lay Sermons : I. the Statesman's Manual. II. Blessed Are Ye That Sow Beside All Waters*. London: George Bell and Sons

———. (1956) *Collected Letters of Samuel Taylor Coleridge*, vol. 1. Edited by E. L. Griggs. Oxford: Clarendon Press, 1966, pp. 1795–1800

Corrao, F. (1986) 'Il Concetto di Campo come Modello Teorico'. In: Corrao (ed.), 1998

———. (1998) *Orme*, vol. 2. Milan: Cortina.

Craparo, G. and Mucci, C. (eds.) (2016) *Unrepressed Unconscious, Implicit Memory, and Clinical Work*. London: Routledge

Cros, P. (2002) *Paul Cézanne*. Paris: Pierre Terrail

Danchev, A. (2012) *Cézanne. A Life*. London: Profile Books

———. (2017) 'Dramatis Personae'. In: Elderfield (ed.) 2017, pp. 221–233

De Mille, C. (2013) 'Improvisations on the Theme of Cézanne'. In: Padyar (ed.) 2013, pp. 101–120

Denis, M. (1907) 'Cézanne'. *L'Occident,* September 1907. In: Doran (ed.) 1978, pp. 166–180

Derrida, J. (1978) *La Vérité en Peinture*. Paris: Flammarion

Descartes, R. (1637) *A Discourse on the Method of Correctly Conducting One's Reason and Seeking Truth in the Sciences*. Translated by I. Maclean. New York: Oxford University Press (Oxford World's Classics), 2008

Doran, P. M. (ed.) (1978) Conversations avec Cézanne. Emile Bernard, Jules Borély, Maurice Denis, Joachim Gasquet, Gustave Geffroy, Francis Jourdain, Léo Larguier, Karl Ernst Osthaus, R. P. Rivière et J. F. Schnerb, Ambroise Vollard. Edition critique présentée par P.M. Doran. Paris: Macula

Dorival, B. (1948) *Paul Cézanne*. Paris: Editions Pierre Tisne

Douglas, A. (2007) 'Monsters & Marvels: How Do We Interpret the "Preternatural"?' *The American Biology Teacher*, November 2007

Eaton, J. (2011) *A Fruitful Harvest. Essays after Bion.* Seattle, WA: The Athlone Press

Eco, U. and Carrière, J.-C. (2012) *This is Not the End of the Book. A Conversation Curated by Jean-Philippe De Tonnac.* London: Vintage Books

Einstein, A. and Infeld, L. (1938) *The Evolution of Physics from Early Concepts to Relativity and Quanta.* New York: Simon and Schuster, 1966

Elderfield, J. (2017) *Cézanne Portraits.* With M. Morton and X. Rey, and contributions by A. Danchev and J. S. Warman. Catalogue of Exhibition at the Musée d'Orsay, Paris, 13 June to 24 September 2017, the National Portrait Gallery, London, 26 October 2017 to 11 February 2018, and the National Gallery of Art, Washington, D.C., 25 March to 1 July 2018. London: National Portrait Gallery Publications

Elliott, B. (2005) *Phenomenology and Imagination in Husserl and Heidegger.* London: Routledge

Evans, D. (1996) *An Introductory Dictionary of Lacanian Psychoanalysis.* London: Routledge

Fariss, S. (2011) 'The Social Unconscious and the Collective Unconscious: The Jungian Perspective'. In: Hopper and Weinberg (eds.), 2011, pp. 295–319

Ferro, A. (2005a) 'Bion: Theoretical and Clinical Observations'. *International Journal of Psychoanalysis*, 86(6), pp. 1535–1542

———. (2005b) *Seeds of Illness, Seeds of Recovery. The Genesis of Suffering and the Role of Psychoanalysis.* Translated by P. Slotkin. Hove: Routledge

———. (2009) *Mind Works. Technique and Creativity in Psychoanalysis.* London: Routledge

———. (2019a) *Psychoanalysis and Dreams. Bion, the Field and the Viscera of the Mind.* London: Routledge

———. (2019b) 'My Indebtedness to Bion'. In: Vermote (ed.) 2019, pp. 244–248

——— and Basile, R. (eds.) (2009) *The Analytic Field. A Clinical Concept.* London: Routledge, 2018

——— and Civitarese, G. (2015) *The Analytic Field and Its Transformations.* London: Karnac

——— and Nicoli, L. (2017) *The New Analyst's Guide to the Galaxy. Questions about Contemporary Psychoanalysis.* London: Routledge

Fornaro, M. (1990) *Psicoanalisi tra Scienza e Mistica. L'Opera di Wilfred R. Bion.* Rome: Edizioni Studium

Freud, S. (1891) *On Aphasia.* Translated by E. Stengel and C. T. Madison. International Universities Press, 1953

———. (1900) *The Interpretation of Dreams. The Standard Edition of the Complete Psychological Works of Sigmund Freud*, vol. IV. London: The Hogarth Press, pp. 1953–1964

———. (1912) 'Recommendations to Physicians Practising Psycho-Analysis'. *The Standard Edition of the Complete Psychological Works of Sigmund Freud*, vol. XII. London: The Hogarth Press, 1953-1964, pp. 109–120

———. (1923) 'The Ego and the Id'. *The Standard Edition of the Complete Psychological Works of Sigmund Freud.* vol. XIX. London: The Hogarth Press, pp. 1–66, 1953

———. (1926) 'Inhibitions, Symptoms and Anxiety'. *The Standard Edition of the Complete Psychological Works of Sigmund Freud*, vol. XX. London: The Hogarth Press, 1953, pp. 75–176

————. (1938) 'Findings, ideas, problems'. *The Standard Edition of the Complete Psychological Works of Sigmund Freud*, vol. XXIII. London: The Hogarth Press, 1953–1964

Freud, S. and Andreas-Salomé, L. (1966) *Letters*. Edited by E. Pfeiffer, Translated by W. E. Scott. Robson. London: Hogarth, 1972

Friedman, M. (ed.) (1964) *The Worlds of Existentialism A Critical Reader*. New Jersey, NJ: Humanities Press

Fry, R. (1920) *Vision and Design*. London: Chatto and Windus

Gasquet, J. (1921 and 1926) *Cézanne*. Paris: Bernheim-Jeune. Extracts conflated from the two editions in Doran (ed.), 1978, pp. 106–161

————. (1991) *Joachim Gasquet's Cézanne. A Memoir with Conversations*. Translated by C. Pemberton, Preface by J. Rewald, Introduction by R. Schiff. London: Thames and Hudson

Gatti, F. and Neri, C. (2006) 'Système Protomentale et Maladie'. In: Neri, Correale and Fadda (eds.), 2006, pp. 198–205

Giacometti, A. (2017) *Tate Modern Exhibition Room Guide*. London: Tate Publishing

Gold, S. (2018) *Unthinkable Evil: Desire for and Defence Against the Internal Object*. Paper given at the ISPSO Conference. Dublin, Saturday 23 June.

Gowing, L. (1977) 'The Logic of Organized Sensations'. In: Rubin (ed.), 1977, pp. 55–69

————. (ed.) (1988) *Cézanne The Early Years*. London: Royal Academy of Arts

Green, A. (1999) *The Work of the Negative*. London: Free Association Books

Greenberg, J. and Mitchell, S. A. (1983) *Object Relations in Psychoanalytic Theory*. Cambridge, MA: Harvard University Press

Grosz, E. A. (1986) 'Language and the Limits of the Body: Kristeva and Abjection'. In: Grosz et al. (eds.), 1986, pp. 106–117

Grosz, E. A., Threadgold, T., Kelly, D., Cholodenko, A. and Colless, E. (1986) *Futur*Fall. Excursions into Post-Modernity*. Sydney: Power Institute of Fine Arts, University of Sydney

Grotstein, J. S. (2000) *Who Is the Dreamer? Who Dreams the Dream? A Study of Psychic Presences*. Hillsdale, NJ: Analytic Press

————. (2007) *A Beam of Intense Darkness: Wilfred Bion's Legacy to Psychoanalysis*. London: Karnac

Hamburger, M. (2003) Introduction to Hölderlin, 2007, pp. xxvii–liii

Harris Williams, M. (2010) *Bion's Dream: A Reading of the Autobiographies*. London: Karnac

————. (2018) 'Aesthetic Conflict'. Lecture and Discussion at Psychotherapy Sussex, Brighton, 10 February

Heartfield, J. (2006) *The 'Death of the Subject' Explained*. Sheffield: Sheffield Hallam University, School of Cultural Studies, and Createspace Independent Publishers

Heaney, S. (2002) *Finders Keepers: Selected Prose 1971–2001*. London: Faber

Herzog, W. (Producer and Director) (1974) *The Enigma of Kaspar Hauser* (*Jeder für Sich und Gott gegen Alle*). West Germany: Werner Herzog Filmproduktion

Hölderlin, F. (2007) *Selected Poems and Fragments*. Translated and Edited by M. Hamburger. London: Penguin Books

Honour, H. (1979) *Romanticism*. New York and Abingdon, Oxon.: Routledge, 2018

Hopper, E. and Weinberg, H. (eds.) (2011) *The Social Unconscious in Persons, Groups, and Societies. Volume 1: Mainly Theory*. London: Karnac

Husserl, E. (1913) *Logical Investigations, Volume 2*. London: Routledge, 2001

Jarry, A. (1902) *Le Surmâle. Roman moderne.* Viewed 28 December 2019 https://ebooks-bnr.com/ebooks/pdf4/jarry_le_surmale.pdf

Jasnow, A. (1993) *Freud and Cézanne. Psychotherapy as Modern Art.* Norwood, NJ: Ablex Publishing Company

Jourdain, F. (1950) *Cézanne.* Paris: Braun. Extracts in Doran (ed.), 1978, pp. 81–84

Junqueiria de Mattos, J. A. (2016) 'Impressions of My Analysis with Dr Bion'. In: Levine and Civitarese (eds.), 2016

Kear, J. (2006) '"Frenhofer, c'est moi": Cézanne's Nudes and Balzac's *Le Chef-d'œuvre inconnu'. Cambridge Quarterly,* 35(4), pp. 345–360

Keats, J. (1958) *The Letters of John Keats,* 2 vols. Edited by H. E. Rollins. Cambridge, MA: Harvard University Press

Kerridge, R. (2020) 'Review of Oliver, 2020'. *The Guardian Review,* Saturday 18 January, p. 18

Kristeva, J. (1976) 'Signifying Practice and Mode of Production'. *Edinburgh Review,* 1, pp. 64–77

———. (1980) *Desire in Language. A Semiotic Approach to Literature and Art.* Edited by L. S. Roudiez. New York: Columbia University Press

Lacan, J. (1947) 'British Psychiatry and the War'. In: Lacan, Laurent and Miller, 2019, pp. 13–57

———. (1960) 'The Subversion of the Subject and the Dialectic of Desire in the Freudian Unconscious'. In: Lacan, 2007, pp. 671–702

———. (1988) *The Seminar of Jacques Lacan, Book II, The Ego in Freud's Theory and in the Technique of Psychoanalysis 1954–55.* Translated by S. Tomaselli and J. Forrester. New York: W. W. Norton and Cambridge: Cambridge University Press

———. (1992) *The Ethics of Psychoanalysis 1959–1960. The Seminar of Jacques Lacan, Book VII.* Translated with notes by D. Porter. London: Tavistock/Routledge

———. (2007) *Ecrits. The First Complete Edition in English.* Edited by B. Fink in collaboration with H. Fink. Translated by R. Grigg. New York: W. W. Norton

Lacan, J., Laurent, E. and Miller, J.-A. (2019) *The Real and the Social Bond: British Psychiatry and the War.* Psychoanalytical Notebooks No. 33. London: London Society of the New Lacanian School

Laplanche, J. (1987) *New Foundations for Psychoanalysis.* Translated by D. Macey. Oxford: Basil Blackwell, 1989

———. (1992) *Seduction, Translation and the Drives.* Edited by J. Fletcher and M. Stanton. Translations by M. Stanton. London: Institute of Contemporary Arts

Laplanche, J. and Pontalis, J.-B. (1988) *The Language of Psycho-Analysis.* Introduction by D. Lagache. Translated by D. Nicholson-Smith. London: Karnac

Larguier, L. (1925) *Le Dimanche avec Paul Cézanne: Souvenirs.* Paris: L'Edition. Extracts cited in Doran (Ed.), 1978, pp. 9–17

Lavie, J. (2011) 'The Lost Roots of the Theory of Group Analysis: "Interrelational Individuals" or "Persons"'. In: Hopper and Weinberg (eds.), 2011, pp. 155–175

Lawrence, D. H. (1929) 'Introduction to These Paintings'. In: Boulton (ed.), 2004, pp. 182–217

Leon, D. (1944) *Tolstoy. His Life and Work.* London: Routledge, 2015

Levinas, E. (1982) *Ethics and Infinity. Conversations with Philippe Nemo.* Translated by R. A. Cohen. Pittsburgh, PA: Duquesne University Press, 1985

Levine, H. and Civitarese, G. (eds.) (2016) *The W. R. Bion Tradition. Lines of Development - Evolution of Theory and Practice over the Decades.* London: Karnac

Lévy-Bruhl, L. (1949) *The Notebooks on Primitive Mentality* (Explorations in Interpretative Sociology). New York: Harper and Row, 1975

Lewin, K. (1918) 'Die Erziehung der Versuchsperson zur Richtigen Selbstbeobachtung und die Kontrolle Psychologischer Beschreibungsaufgaben' ['The Education of the Test Subject to Correct Self-Observation and the Control of Psychological Description Data']. In: Lewin, 1981, pp. 153–212

———. (1934) 'Der Richtungsbegriff in der Psychologie. Der Spezielle und Allgemeine Hodologische Raum' ['The Concept of Direction in Psychology. Special and General Hodological Space']. *Psychologische Forschung*, 19(1), pp. 249–299

———. (1942) 'Changes in Social Sensitivity in Child and Adult'. *Childhood Education*, 19(2), pp. 53–57

———. (1943) 'Defining the "Field at a Given Time"'. *Psychological Review*, 50(3), pp. 292–310

———. (1981) *Werkausgabe*. Edited by A. Métraux. *Wissenschaftstheorie I*. Edited by C.-F. Graumann. Bern: Huber, and Stuttgart: Klett-Cotta

———. (1997) *Resolving Social Conflicts. Field Theory in Social Science*. Washington, DC: American Psychological Association

Lewkowicz, S. and Flechner, S. (eds.) (2005) *Truth, Reality and the Psychoanalyst: Latin American Contributions to Psychoanalysis*. London: International Psychoanalytical Association

Loewenthal, D. and Snell, R. (2003) *Post-Modernism for Psychotherapists. A Critical Reader*. Hove: Brunner-Routledge

———. (2006) 'The Learning Community, the Trainee and the Leader'. *The European Journal of Psychotherapy and Counselling*, 8(1), pp. 61–77

Lowes, J. L. (1927) *The Road to Xanadu. A Study in the Ways of the Imagination*. Boston, MA: Houghton Mifflin Company and Cambridge, MA: The Riverside Press

Macfarlane, R. (2019) *Underland: A Deep Time Journey*. London: Hamish Hamilton

Mann, S. (1981) 'On Cézanne'. *The Artist*, June 1981. Viewed 29 March 2019, http://sargymannarchive.com/sargy-mann-writings/on-cezanne

———. (1996) 'Shared Experience'. Viewed 29 March 2019, http://sargymannarchive.com/sargy-mann-writings/shared-experience

———. (2016) *Perceptual Systems, an Inexhaustible Reservoir of Information and the Importance of Art. Thoughts towards a Talk*. London: SP books

Massicotte, W. J. (2013) 'Notation, Invariants and Mathematical Models'. In: Torres and Hinshelwood (eds.), 2013, pp. 151–167

Maxwell, J. C. (1865) 'A Dynamical Theory of the Electromagnetic Field'. *Philosophical Transactions of the Royal Society of London*, 155, pp. 459–512

McBurney, S. (2011) 'Herzog's Cave of Forgotten Dreams: The Real Art Underground'. *Guardian*, 17 March

McCaig, J. M. (2019) 'The Caesura. Careful Emptiness and Improvisational Listening in Psychoanalytic Education: Elements of Bion's 1975 Recorded Caesura Lecture Not Contained in the Printed Version'. In: Alisobhani and Corstorphine (eds.), 2019, pp. 145–149

McGilchrist, I. (2009) *The Master and His Emissary. The Divided Brain and the Making of the Western World*. New Haven, CT: Yale University Press

Mehl, E. (2018) 'Ego sum qui sentio : le cogito réincarné des phénoménologues'. Methodos. Savoir et textes. 18 | 2018, Usages contemporains de Descartes.' Viewed 30 January 2019, https://journals.openedition.org/methodos/5066

Meltzer, D. (1986) *Studies in Extended Metapsychology: Clinical Applications of Bion's Ideas*. London: Karnac, 2008

——— and Harris Williams, M. (1988) *The Apprehension of Beauty: The Role of Aesthetic Conflict in Development, Art, and Violence*. London: Karnac

Merleau-Ponty, M. (1945) *Phénoménologie de la Perception*. Paris: Gallimard, 1979

———. (1945a) *The Phenomenology of Perception*. Translated by C. Smith. London: Routledge, 2002

———. (1945b) 'Le Doute de Cézanne'. In: Merleau-Ponty, 1996, pp. 13–33

———. (1945c) 'Cézanne's Doubt'. In: Merleau-Ponty, 1964c, pp. 9–25

———. (1964) *L'Œil et l'Esprit*. Paris: Gallimard, 1983

———. (1964a) *Le Visible et l'Invisible, Suivi de Notes de Travail*. Paris: Gallimard, 2004

———. (1964b) *The Visible and the Invisible*. Translated by A. Lingis. Evanston, IL: Northwestern University Press, 1968

———. (1964c) *Sense and Non-Sense*. Translated with a preface by H. L. Dreyfus and P. A. Dreyfus. Evanston, IL: Northwestern University Press

———. (1996) *Sens et Non-Sens*. Paris: Gallimard

Milbank, J. (2004) 'Sublimity: The Modern Transcendent'. In: Schwartz (ed.), 2004, pp. 207–230

Milton, J. (1667) *Paradise Lost*. DjVu Editions E-Books, Global Language Resources, 2001

Moran, D. (2000) *Introduction to Phenomenology*. London: Routledge

Morgan-Jones, R. (2010) *The Body of the Organisation and Its Health*. Additional Material by N. Torres and K. Dixon. Foreword by O. Khaleelee. London: Routledge

Neri, C. (1998) *Group*. Preface by P. Bion Thalamo. Foreword by M. Pines, Translated by C. Trollope. London: Jessica Kingsley

———, Correale, A., Fadda, P. (2006) *Lire Bion*. Présentation de F. Corrao. Ramonville Sainte-Agne: Editions Érès

Nicolson, A. (2019) *The Making of Poetry. Coleridge, the Wordsworths and Their Year of Marvels*. London: William Collins

Oliver, T. (2020) *The Self Delusion: The Surprising Science of How We Are Connected and Why That Matters*. London: Weidenfeld and Nicolson

Ogden, T. H. (1989) *The Primitive Edge of Experience*. Northvale, NJ: Jason Aronson

———. (1992) 'The Dialectically Constituted/Decentred Subject of Psychoanalysis. II. The Contributions of Klein and Winnicott'. *International Journal of Psychoanalysis*, 73(4), pp. 613–626

———. (2002) *Conversations at the Frontier of Dreaming*. London: Karnac

———. (2005) *This Art of Psychoanalysis: Dreaming Undreamt Dreams and Interrupted Cries*. London: Routledge

———. (2008) *Rediscovering Psychoanalysis: Thinking and Dreaming, Learning and Forgetting*. London: Routledge

Olkowski, D. (2002) 'Flesh to Desire: Merleau-Ponty, Bergson, Deleuze'. *Strategies: a Journal of Theory, Culture and Politics*, 15(1), pp. 11–24

Oneroso, F. and Gorrese, A. (eds.) *Mente e Pensiero. Incontri con l'Opera di Wilfred R. Bion*. Naples: Liguori

O'Shaughnessy, E. (2005) 'Whose Bion?' *International Journal of Psychoanalysis*, 8(86), pp. 1523–1528

Osthaus, K. E. (1920–21) 'Une Visite à Paul Cézanne'. *Feuer. Illustrierte Monatsschrift für Kunst und Künstlerische Kultur*, 2, pp. 81–85. Weimar: Hofer; Feuer Verlag. Translated by M. H. Doran and J. Rewald. In: Doran (ed.), 1978, pp. 96–100

Padyar, S. (ed.) (2013) *Modernist Games. Cézanne and His Card Players*. Courtauld Books Online. London: The Research Forum of the Courtauld Institute of Art. Viewed on 28 August 2019, https://assets.courtauld.ac.uk/wpcontent/uploads/2020/02/121 34702/Modernist-Games

Parsons, M. (2014) *Living Psychoanalysis. From Theory to Experience*. London: Routledge

Politzer, G. (1928) *Critique des Fondements de la Psychologie. La Psychologie et la Psychanalyse*. Paris: Presses Universitaires de France, 1974

———. (1994) *Critique of the Foundations of Psychology*. Pittsburgh, PA: Duquesne University Press

Rank, O. (1932) *Art and Artist: Creative Urge and Personality Development*. Foreword by A. Nin. New York and London: W. W. Norton, 1989

Reid, J. M. H. (1976) *The Concise Oxford Dictionary of French Literature*. Oxford: Oxford University Press, Clarendon Press

Reiner, A. (2016) 'The Truth Object: Growing the God Within'. In: Levine and Civitarese (eds.), 2016, pp. 155–169

———. (ed.) (2017) *Of Things Invisible to Mortal Sight: Celebrating the Work of James S. Grotstein*. London: Karnac

Rewald, J. (1983) *Paul Cézanne, the Watercolors*. New York: New York Graphic Society

Rhode, E. (1990) *The Generations of Adam*. London: Free Association Books

Rilke, R. M. (2002) *Letters on Cézanne*. Translated by J. Agee. New York: North Point Press

———. (2012) *Letters to a Young Poet*. Translated by C. Louty. Introduction by L. Hyde. London: Penguin

Rivière, R. P. and Schnerb, J. F. (1907) 'L'Atelier de Cézanne.' *La Grande Revue*, 25 décembre, 1907. In: Doran (ed.), 1978

Rizzuto, A. M. (2002) 'Psychoanalysis and Art: A Psychoanalytic View of the Life and Work of Cézanne. Report of Panel Discussion at the 42nd Congress of the International Psychoanalytic Association in Nice, 24 July 2001'. *International Journal of Psychoanalysis*, 83(3), pp. 678–681

Rubin, W. (ed.) (1977) *Cézanne. The Late Work*. With essays by T. Reff, L. Gowing, L. Brion-Guerry, J. Rewald, F. Novotny, G. Monnier, D. Druick, G. H. Hamilton and W. Rubin. New York: The Museum of Modern Art

Salas, C. G. (ed.) (2007) *The Life and the Work. Art and Biography*. Los Angeles, CA: The Getty Research Institute

Sandler, P. C. (2005) *The Language of Bion*. London: Karnac

Scarry, E. (1985) *The Body in Pain. The Making and Unmaking of the World*. Oxford: Oxford University Press

Schapiro, M. (1952) *Paul Cézanne*. The Library of the Great Painters. New York: Harry N. Abrams

Schiff, R. (1984) *Cézanne and the End of Impressionism. A Study of the Theory, Technique, and Critical Evaluation of Modern Art*. Chicago, IL: University of Chicago Press

Schiller, F. (1794) *The Correspondence between Schiller and Goethe from 1794–1805*. London: Putnam, 1845

Schore, A. N. (2017) 'The Right Brain Implicit Self: A Central Mechanism of the Psychotherapy Change Process'. In: Craparo and Mucci (eds.), 2016, pp. 73–98

Schwartz, R. (ed.) (2004) *Transcendence: Philosophy, Literature, and Theology*. New York: Routledge

Segal, H. (1991) *Dream, Phantasy and Art*. Abingdon: Routledge

Shaw, P. (2006) *The Sublime*. London: Routledge, 2017

————. (2013) 'Modernism and the Sublime'. Viewed 20 February 2020. https://www.tat e.org.uk/art/research-publications/the-sublime/philip-shaw-modernism-and-the-sub lime-r1109219

Simms, M. (2008) *Cézanne's Watercolours. Between Drawing and Painting*. New Haven, CT: Yale University Press

Skelton, A. E. (2018) *Infant Colour Perception*. Doctoral thesis (PhD). University of Sussex

Smith, P. (2007) 'Paul Cézanne's Primitive Self and Other Fictions'. In: Salas (ed.), 2007, pp. 45–75

Snell, R. (2008) 'Transparency'. Review of Simms, 2008. *The Times Literary Supplement*, 26 September, p. 32

————. (2013) *Uncertainties, Mysteries, Doubts. Romanticism and the Analytic Attitude*. London: Routledge

Spillius, E. B. (1988) *Melanie Klein Today. Volume 2: Mainly Practice. Developments in Theory and Practice*. London: Routledge

Stadlen, A. (2020) 'Invitation to Inner Circle Seminar No. 256, London, Sunday 9 February 2020. 'Heidegger's "Worlds" and Being-in-the-world-with-others. Early Freiburg Lectures (1919-20): A 100th-anniversary Re-evaluation. The "self-world" and other "worlds". Why did Heidegger give up his Three-"worlds" Theory? Zollikon Seminars (1959-1969): A 60th-anniversary Re-evaluation. 2. Second Seminar. 3 February 1960. "Being-with... not tea with sugar..." "The Non-Phenomenologically Applied Thematic of Intersubjectivity"'. Viewed on 18 January 2020, personal e-mail

Stern, D. (2018) *The Infinity of the Unsaid: Unformulated Experience, Language, and the Nonverbal*. London and New York: Routledge

Strachey, J. (1934) 'The Nature of the Therapeutic Action of Psycho-Analysis'. *International Journal of Psycho-Analysis*, 15, pp. 127–159

Symington, N. (2008) 'Generosity of Heart: Source of Sanity'. *British Journal of Psychotherapy*, 24(4), November 2008

Taine, H. (1870) *De l'Intelligence*, 2 vols. Paris: Librairie Hachette

Toadvine, T. (2016) 'Maurice Merleau-Ponty'. *The Stanford Encyclopaedia of Philosophy*. Viewed on 18 January 2019, https://plato.stanford.edu/entries/merleau-ponty/#VisiInvi

Torres, N. (2010) 'Protomentality'. Chapter 3. In: Morgan-Jones, 2010, pp. 53–79

————. (2013a) 'Bion's Concept of the Proto-Mental and Modern Panpsychism'. In: Torres and Hinshelwood (eds.), 2013, pp. 56–67

————. (2013b) 'Intuition and Ultimate Reality in Psychoanalysis: Bion's Implicit Use of Bergson and Whitehead's Notions'. In: Torres and Hinshelwood (eds.), 2013, pp. 20–34

————. (2013c) 'The Psycho-Social Field Dynamics: Kurt Lewin and Bion'. In: Torres and Hinshelwood (eds.), 2013, pp. 68–78

Torres, N. and Hinshelwood, R. D. (eds.) (2013) *Bion's Sources. The Shaping of His Paradigms*. Hove: Routledge

Tubert-Oklander, J. (2011) 'Enrique Pichon-Rivière: The Social Unconscious in the Latin-American Tradition of Group Analysis'. In: Hopper and Weinberg (eds.), 2011, pp. 45–67

Tweedy, R. (2012) *The God of the Left Hemisphere. Blake, Bolte Taylor, and the Myth of Creation*. London: Karnac

van den Braembussche, A. (2006) *Thinking Art. An Introduction to Philosophy of Art*. Berlin: Springe

Vermote, R. (2017) 'Reaching the transcendent position by a borderline patient in reading Beckett'. In: Reiner (ed.), 2017, pp. 43–56

———. (2019) *Reading Bion*. London: Routledge

Vitale, S. (2004) '"Si prega di chiudere gli occhi". Il Pensiero selvaggio della cattedrale.' In: Oneroso and Gorrese (eds.), 2004, pp. 45–82

Vollard, A. (1914) *Paul Cézanne*. Translated by H. L. van Doren. New York: Dover Publications, 1984

White, J. (2006) *Generation: Preoccupations and Conflicts in Contemporary Psychoanalysis*. London: Routledge

Whitehead, A. N. (1911) *An Introduction to Mathematics*. London: Williams and Northgate

Winnicott, D. W. (1960) 'The Theory of the Parent-Infant Relationship'. In: Winnicott (ed.), 1990, pp. 37–55

———. (1971) *Playing and Reality*. London: Tavistock Publications

———. (1990) *The Maturational Processes and the Facilitating Environment*. London: Karnac Books and the Institute of Psychoanalysis

Wittgenstein, L. (2009) *Philosophical Investigations*. Edited by P. M. S. Hacker and J. Schulte. Hoboken, NJ: Wiley-Blackwell

Appendix

1. Hélas, encore que déjà vieux, j'en suis à mes débuts (Cézanne cited in Borély, 1902, p. 19).
 Mais être précis au sujet de Cézanne, quelle difficulté! (Denis, 1907, p. 167).
2. Visible et mobile, mon corps est au nombre des choses, il est l'une d'elles, il est pris dans le tissu du monde et sa cohésion est celle d'une chose. Mais, puisqu'il voit et se meut, il tient les choses en cercle autour de soi, elles sont une annexe ou un prolongement de lui-même, elles sont incrustées dans sa chair, elles font partie de sa définition pleine et le monde est fait de l'étoffe même du corps. Ces renversements, ces antinomies sont diverses manières de dire que la vision est prise ou se fait du milieu des choses, là où un visible se met à voir, devient visible pour soi et par la vision de toutes choses, là où persiste, comme l'eau mère dans le cristal, l'indivision du sentant et du senti.

 Cette intériorité-là ne précède pas l'arrangement matériel du corps humain, et pas advantage elle n'en résulte. Si nos yeux étaient faits de telle sorte qu'aucune partie de notre corps ne tombât sous notre regard, ou si quelque malin dispositif, nous laissant libre de promener nos mains sur les choses, nous empêchait de toucher notre corps — ou simplement si, comme certains animaux, nous avions des yeux latéraux, sans recoupement des champs visuels — ce corps qui ne se réfléchirait pas, ne se sentirait pas, ce corps presque adamantin, qui ne serait pas tout à fait chair, ne serait pas non plus un corps d'homme, et il n'y aurait pas d'humanité. Mais l'humanité n'est pas produite comme un effet par nos articulations, par l'implantation de nos yeux (et encore moins par l'existence des miroirs qui pourtant rendent seuls visible pour nous notre corps entier). Ces contingences et d'autres semblables, sans lesquelles il n'y aurait pas d'homme, ne font pas, par simple sommation, qu'il y ait un seul homme. L'animation du corps n'est pas l'assemblage l'une contre l'autre de ses parties — ni d'ailleurs la descente dans l'automate d'un esprit venu d'ailleurs, ce qui supposerait encore que le corps lui-même est sans dedans et sans 'soi'. Un corps humain est là quand, entre voyant et visible, entre touchant et touché, entre un œil et l'autre, entre la main et la main se fait une sorte de recroisement, quand s'allume l'étincelle du sentant-sensible,

quand prend ce feu qui ne cessera pas de brûler, jusqu'à ce que tel accident du corps défasse ce que nul accident n'aurait suffi à faire ...

Or, dès que cet étrange système d'échanges est donné, tous les problèmes de la peinture sont là. Ils illustrent l'énigme du corps et elle les justifie. Puisque les choses et mon corps sont faits de la même étoffe, il faut que sa vision se fasse de quelque manière en elles, ou encore que leur visibilité manifeste se double en lui d'une visibilité secrète : 'la nature est à l'intérieur', dit Cézanne (Merleau-Ponty, 1964, pp. 19–22).

3. Scrupule devant les idées, sincérité devant soi-même, soumission devant l'objet ... Soumission absolue à l'objet ... Travailler sans croire à personne, devenir fort. Le reste, c'est de la foutaise (Gasquet, 1921 and 1926, p. 151).

4. Nous parlions des portraits. On croit qu'un sucrier ça n'a pas une physiono-mie, une âme. Mais ça change tous les jours aussi. Il faut savoir les pren-dre, les amadouer, ces messieurs-là ... Ces verres, ces assiettes, ça se parle entre eux. Des confidences interminables ... Les fleurs, j'y ai renoncé. Elles se fanent tout de suite. Les fruits sont plus fidèles. Ils aiment qu'on fasse leur portrait ... Les objets se pénètrent entre-eux ... Ils ne cessent pas de vivre, comprenez-vous ... Ils se répandent insensiblement autour d'eux par d'intimes reflets, comme nous par nos regards et par nos paroles (Gasquet, 1921 and 1926, p. 157).

5. Ce qui fait énigme, c'est leur lien, c'est ce qui est entre elles - c'est que je voie les choses chacune à sa place précisément parce qu'elles s'éclipsent l'une l'autre -, c'est qu'elles soient rivales devant mon regard précisément parce qu'elles sont chacune en son lieu. C'est leur extériorité connue dans leur enveloppement et leur dépendance mutuelle dans leur autonomie. De la profondeur ainsi comprise, on ne peut plus dire qu'elle est 'troisième dimen-sion'... La profondeur ainsi comprise est plutôt l'expérience de la réversibil-ité des dimensions, d'une 'localité' globale où tout est à la fois, dont hauteur, largeur et distance sont abstraites, d'une voluminosité qu'on exprime d'un mot en disant qu'une chose est là. Quand Cézanne cherche la profondeur, c'est cette déflagration de l'Être qu'il cherche, et elle est dans tous les modes de l'espace, dans la forme aussi bien (Merleau-Ponty, 1964, pp. 64–5).

6. L'art est une harmonie parallèle à la nature ... [le peintre] lui est parallèle ... Toute sa volonté doit être de silence. Il doit faire taire en lui toutes les voix des préjugés, oublier, oublier, faire silence, être un écho parfait. Alors, sur sa plaque sensible, tout le paysage s'inscrira. Pour le fixer sur la toile, l'extérioriser, le métier interviendra ensuite, mais le métier respectueux qui, lui aussi, n'est prêt qu'à obéir, à traduire inconsciemment, tant il sait bien sa langue, le texte qu'il déchiffre, les deux textes parallèles, la nature vue, la nature sentie, celle qui est là ... celle qui est ici ... (*il se frappait le front*) qui toutes deux doivent s'amalgamer pour durer, pour vivre d'une vie moitié humaine, moitié divine, la vie de l'art, écoutez un peu ... la vie de Dieu. Le paysage se reflète, s'humanise, se pense en moi. Je l'objective, le projette, le fixe sur ma toile (Gasquet, 1921 and 1926, pp. 109–10).

7. Synthétiser ce n'est pas nécessairement simplifier dans le sens de supprimer certaines parties de l'objet : c'est simplifier dans le sens de *rendre intelligible*. C'est, en somme, hiérarchiser : soumettre chaque tableau à un seul rythme, à une dominante, sacrifier, subordonner, - généraliser ... [Cézanne] ne se perd pas ... dans l'océan des variétés : il sait élucider et condenser ses impressions; ses formules sont lumineuses, concises : jamais abstraites (Denis, 1907, p. 179).

8. Devant ... Cézanne nous songeons seulement à la peinture; ni l'objet représenté ni la subjectivité de l'artiste ne retiennent notre attention. Nous ne décidons pas aussi vite si c'est une imitation ou une interprétation de la nature ... La peinture oscille éternellement entre l'invention et l'imitation. Tantôt elle copie et tantôt elle imagine. Ce sont là ses variations. Mais qu'elle produise la nature objective, ou qu'elle traduise plus spécialement l'émotion de l'artiste, il faut qu'elle soit un art de beauté concrète et que nos sens découvrent dans l'objet d'art lui-même, abstraction faite du sujet représenté, une satisfaction immédiate, un plaisir esthétique pur (Denis, 1907, pp. 168 and 172).

9. Telle est sa méthode de travail : d'abord une soumission complète au modèle; avec soin, l'établissement de la mise en place, la recherche des galbes, les relations de proportions; puis, à très méditatives séances, l'exaltation des sensations colorantes, l'élévation de la forme vers une conception décorative; de la couleur vers le plus chantant diapason. Ainsi plus l'artiste travaille, plus son ouvrage s'éloigne de l'objectif, plus il se distance de l'opacité du modèle lui servant de point de départ, plus il entre dans la peinture nue, sans autre but qu'elle-même; plus il abstrait son tableau, plus il le simplifie avec ampleur, après l'avoir enfanté étroit, conforme, hésitant (Bernard, 1904, p. 34).

Index

Page numbers in *italic* indicate a box and page numbers in **bold** indicate an illustration.